LADY PAMELA

LADY PAMELA

My Mother's Extraordinary Years as Daughter to the Viceroy of India,
Lady-in-Waiting to the Queen, and Wife of David Hicks

by

INDIA HICKS

RIZZOLI
NEW YORK

New York · Paris · London · Milan

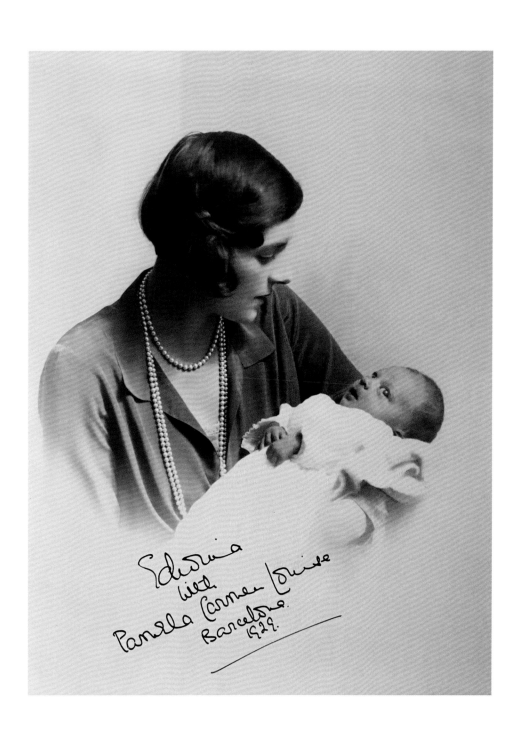

Edwina
with
Pamela Carmen Louise
Barcelona
1929.

CONTENTS

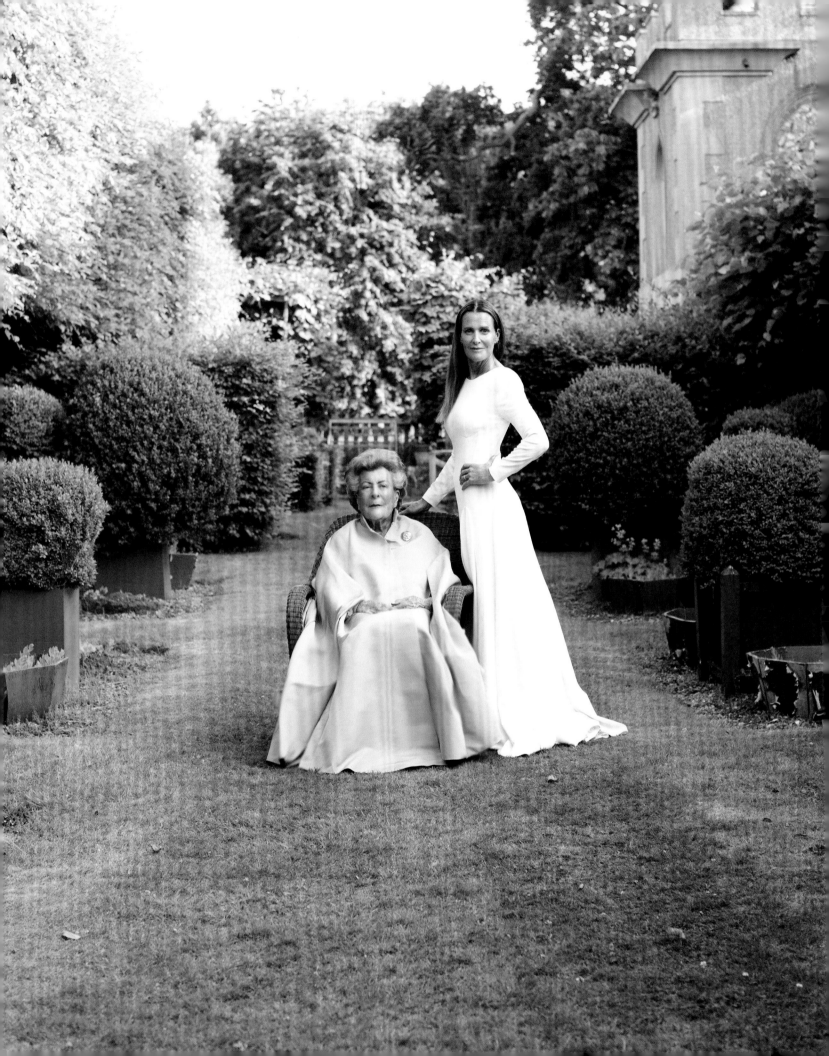

INTRODUCTION

A Persuasive Assault

A persuasive assault, my mother calls this book. "Who will be interested?" she asked when I suggested we dig deep in her muniment room, dust off photograph albums, and hunt for old golden invitations and remarkable letters. Her life, framed around the themes of loyalty and duty, the twin virtues that have kept her grounded as she lived surrounded by dazzling people, places, houses, and history, would always be of interest, I reassured her.

So, we sat together on her pink sofa, in the house I grew up in, with the grandfather clock chiming in the background as the hours slipped away. We would dip into a box of Charbonnel et Walker chocolates as she talked. Occasionally I prompted and often I interrupted. "Wait, you met Haile Selassie?" "Yes, but that was after I married. We went to Ethiopia. Your father, being a designer, was fascinated by their textiles, and I

PAGE 2: My mother photographed during the war just before being sent away to America. She and her classmates would spend a great deal of time knitting at school for the brave soldiers, sailors, and airmen who were risking their lives for them. Her own father was away fighting, and as she surveyed the raggedy scarves, socks, and balaclavas she and her classmates were making, she felt tremendously sorry for all his fellow sailors and soldiers. Being far from home and in danger was bad enough, but having to wear the scratchy, often-holey garments was not something she thought would bring anyone any comfort! PREVIOUS PAGE: My grandmother and mother in 1929. OPPOSITE: My mother and I in her very green garden in 2023.

was intrigued by their buried temples. There were panthers chained to the steps of the palace. We knelt before the emperor and had been told we must only speak French, but at the end of our audience he turned and spoke the most excellent English to us. There had been no need for the months of French lessons after all."

My mother grew up at Broadlands, set among several thousand acres of Hampshire land and a fine example of mid-Georgian architecture. The owners and many of its distinguished visitors have helped shape the course of history. It was a happy childhood with her sister until World War II saw them both shipped to America for safety due to their German Jewish ancestry.

When my mother left for India aged seventeen years old, accompanying her parents, England was in the grip of austerity. Food was heavily rationed, but when they arrived at Viceroy's House in Delhi it was very different. My grandmother took her old terrier, Mizzen, with her, because she could not bear to leave him behind in case he died before they returned. On the first afternoon they arrived my grandmother, now the vicereine of India, asked if she could have some food for her dog. Breast of chicken arrived on a silver salver and my grandmother, who had not seen anything so appealing in a long time, quickly nipped into the bathroom, locked the door, and ate it herself.

During this time my mother took on far more responsibility than would normally be required of a girl just finding her feet in the adult world, and the progression of her employment went from working long hours in the canteen, through to seeing unimaginable horrors in the makeshift medical clinic, and finally graduating to serving as General Pete Rees's PA in the war room, all the while taking Hindustani lessons to feel more included.

I am always struck by the photograph of my mother, looking terribly young, sitting next to Gandhi, while attending one of his famous prayer meetings. "Thousands of people, a remarkable atmosphere, everyone very calm. The awe in which he is held, and the power of his personality are quite extraordinary," she wrote afterward in her diary.

My grandfather always recognized the importance of records and encouraged everyone to keep a diary, which of course helps hugely to prompt the memory of any mind in its

nineties. Thankfully my mother was dutiful about writing in hers, and it's here we read about many of the moments when she had a front-row seat at historical events.

Even without the diaries, my mother's memory continues to astonish us, as do the lead characters in her stories. Jackie Kennedy and Lee Radziwill, for example, staying for the weekend. "A weekend with Jackie Kennedy? What was she like?" I asked. "So very beautiful." "Who else was memorable?" I continued. "Oh, Le Corbusier, he built a whole new town in India. Modern, very memorable. And, of course, Martin Luther King, who I also met in India. Fascinating to hear him debate the transition with Nehru. But this was long after Indian independence."

It's hard to think of my grandparents being asked to dismantle an empire. An unimaginable responsibility. However, it is not hard to imagine that from the moment they arrived they took on the job with duty and determination.

My grandparents had worked tirelessly throughout the war, and then again during the grueling transition of power—remarkable considering my grandmother's early life and her feverish dissipation as a decadent debutante who only underwent a transformation when war dawned. From then on, she embraced a life of purpose, service, and duty. My grandfather had also been born into a charmed life, but one also always anchored by purpose, service, and duty. In his early forties he held supreme command in Southeast Asia; hardly having time to catch his breath, he was then called to preside as the last viceroy and first governor-general to India.

Returning home, he climbed to the pinnacle of his interrupted naval career, the post of first sea lord. It is ironic to think that after fifty years of service to the Royal Navy and defending his country in two world wars, a man who was trying to sow the seeds of peace for future generations was brutally assassinated. At my grandfather's funeral, the country was cloaked in shock and grief.

Obviously, the murder of my grandfather changed everything. In our immediate family it was my aunt Patricia who lost so much: she lost her father, her mother-in-law, and, most heartbreakingly of all, one of her sons. Yet she led by example, showing kindness and forgiveness.

I was only eleven, too numb and too young, perhaps, to realize that my mother had suddenly found herself quite alone in the days following the bomb. The people she was closest to, the heartbeat of her life, were either dead or in critical condition in the hospital. The pain she must have felt is unbearable to think about. And yet she never faltered, not even when—only a short while later, facing a financial crisis—my parents had to sell the family home and move, and then she got a horrifying diagnosis of breast cancer. Through all this and much weightier darkness, which will remain private, my mother did as her cousin Prince Philip once advised: "Look up and look out, say less, do more."

As I listened carefully, I came to see that my mother's life of duty, loyalty, and service, inspired by her parents, was further amplified by the years she spent witnessing the queen's unwavering sense of duty. From their childhood days playing together in the gardens of Buckingham Palace to being her bridesmaid and then accompanying the young princess and her prince on the first of two Commonwealth Tours as her lady-in-waiting, one can see how my mother, content to stay out of the spotlight, content to be in the shadows and with an innate and unflinching sense of service, was a comfort and companion to her, as she was to my father for every one of the thirty-eight years they were married.

Having lived a life in the shadow of her extraordinary parents, the queen, and her husband, it felt time to dedicate a book to my mother's rich and varied life, despite her protests.

P.S. The pages in this book filled with memorabilia were each photographed with one of my mother's many beautiful scarves as the backdrop, from a very early Chanel print to a dynamic David Hicks geometric.

1929

A SURPRISE ARRIVAL

My mother's arrival was somewhat of a surprise. My grandmother Edwina Mountbatten who, in spite of being eight and a bit months pregnant, was not going to be stopped from having a few days' holiday in Spain, decided she needed the comfort of her own car. She called her chauffeur, Dancy, who dutifully drove my grandmother's Hispano Suiza from Southampton, England, to meet her in Málaga, Spain.

The suspension on her well-made car could only protect my grandmother so much from the bumps on some of the badly laid Spanish roads. This was 1929, and the country was on the brink of civil war. Seeing to potholes was not a priority. Disembarking at the Ritz Hotel in Barcelona, she was exhausted, and a little later, while she was having a rest, it became obvious to her that my mother's arrival might be more imminent than expected. A touch rattled, she called reception to say that she needed a doctor. The hotel got in a terrible flap, putting her on hold, only to come back and tell her that they could produce an ear, nose, and throat specialist.

OPPOSITE: During the First World War, the German part of my grandfather's family heritage became something of a problem for the British royal family, being direct descendants of Queen Victoria. The name was anglicized, with our original name of Battenberg becoming the rather more English-sounding Mountbatten in 1917. Here my grandmother Edwina Mountbatten holds my mother, a very young Pamela Mountbatten. FOLLOWING PAGES: In the arms of a Spanish nurse, having been delivered by an ENT doctor and given a dog basket for her crib, my mother survived her very surprising first few days *(left)*. A very busy life by eight years old, as noted in a diary from 1937: gardening, tea at Buckingham Palace, oculists, riding, and playing with the doll's house *(right)*.

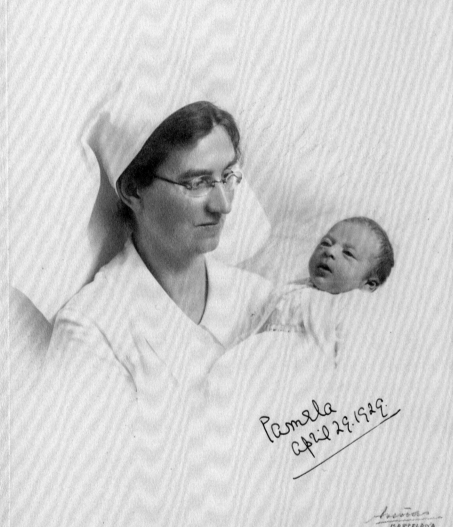

Pamela
April 29. 1929.

BARCELONA

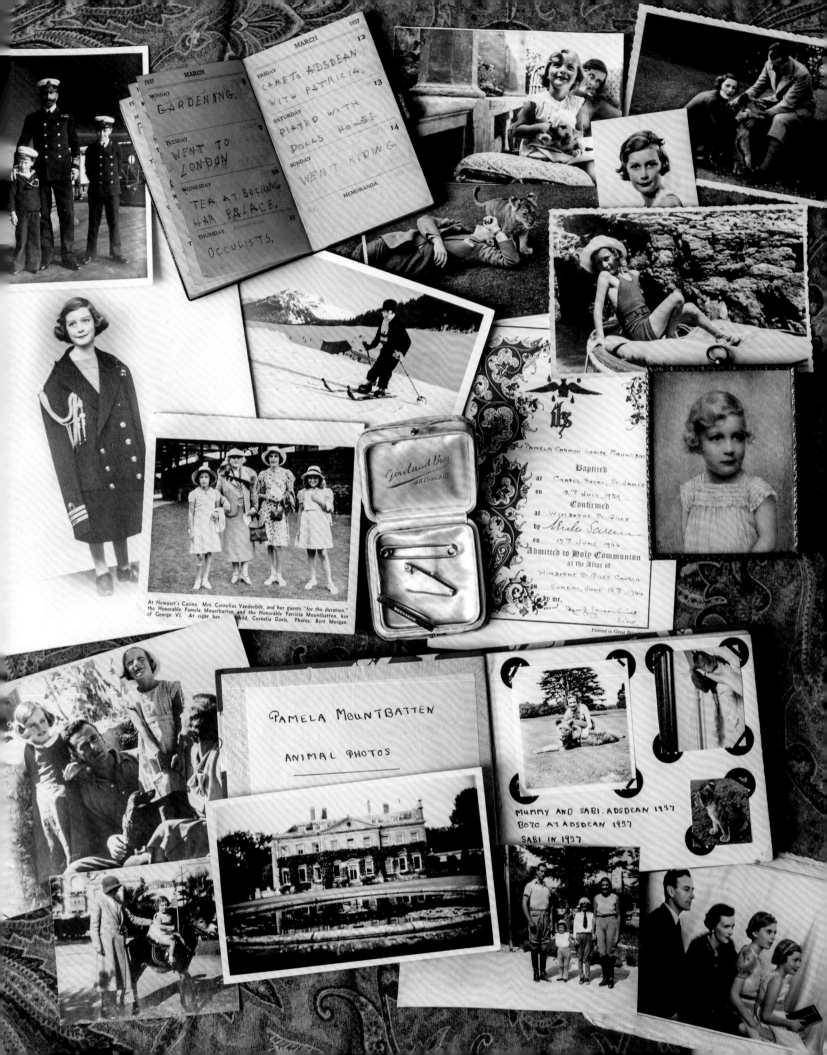

MARCH 1937

MONDAY
8
GARDENING.

TUESDAY
9
WENT TO LONDON

WEDNESDAY
10
TEA AT BUCKINGHAM PALACE.

THURSDAY
OCCULISTS.

FRIDAY
12
CAME TO ADSDEAN WITH PATRICIA.

SATURDAY
13
PLAYED WITH DOLLS HOUSE

SUNDAY
14
WENT RIDING

MEMORANDA

Gowland Bros
48. Conduit St

Pamela Carmen Louise Mountbatten

Baptized
at CHAPEL ROYAL, St. JAMES
on 12th JULY 1929
Confirmed
at WIMBORNE St. GILES
by Cecil Sarum
on 17th JUNE 1944
Admitted to Holy Communion
at the Altar of
WIMBORNE St. GILES CHURCH
on SUNDAY, JUNE 18th 1944
by me,

Printed in Great Britain

At Newport's Casino, Mrs. Cornelius Vanderbilt, and her guests "for the duration," the Honorable Pamela Mountbatten and the Honorable Patricia Mountbatten, kin of George VI. At right her ... child, Cornelia Davis. Photos: Bert Morgan.

PAMELA MOUNTBATTEN

ANIMAL PHOTOS

MUMMY AND SABI. ADSDEAN 1937
BOZO AT ADSDEAN 1937
SABI IN 1937

My grandfather, in a panic, called a cousin, Queen Ena, in Madrid. She was away, but her husband, King Alfonso, answered. "We're having a baby!" exclaimed my grandfather, Lord Mountbatten. The king, a great womanizer, got the wrong end of the stick and replied, "Oh my dear Dickie. I won't tell anyone." "Tell everyone," implored my grandfather. "It's my wife, Edwina, who's having the baby." "Leave everything to me," said the king and rang off. Within half an hour the royal guard had the hotel so surrounded, under strict instructions not to let anyone in, that the doctor rushing toward the entrance of the hotel was promptly arrested. After some panicked explanations the ENT doctor was allowed up, remembered his obstetric training, and came up trumps. After a somewhat tumultuous labor, my mother arrived safe and sound and spent her first few nights wrapped in an embroidered layette that had been brought in by some local nuns, sleeping in a little dog's basket until a more suitable arrangement could be made.

Because of this unexpected birth in Barcelona, my grandparents saw fit to appoint Carmen, the duchess of Peñaranda, as my mother's godmother. She was a magnificently scandalous Spanish aristocrat, who later ran off with a bullfighter. They must have felt indebted to the Spanish for my mother's arrival as she was also given Carmen as her middle name—the same one I gave to my own daughter, after my mother made me promise never to name her Pamela.

As young children, my mother and her older sister, Patricia, rarely saw their mother. She was away more often than not, leaving them in the care of Nanny Vera and my aunt Patricia's governess, Miss Vick.

Despite the long absences of their parents, they were happy children. Adsdean, their home in Sussex, was their paradise, with ponies to ride, dogs to walk, woods to explore, and their own tiny patch of garden on which to grow flowers and herbs.

They were also fortunate that Grandmama, their paternal grandmother, would visit often, always with her devoted ladies' maid, Edith Pye, nicknamed "the Pyecrust" by my grandfather. Even though the family denounced their German titles, and their grandmama had been made a marchioness by the king, in the eyes of her family—and her own—she was still a princess. My mother and aunt were taught to kiss her hand

and curtsy to her. Always dressed in a crisp white blouse tucked into an ankle-length black skirt, her hair immaculate in a chignon, she wore a fob watch, several gold chains, and golden snake rings on her chilblained fingers. She incessantly smoked Sobranie Balkans, a fierce-smelling brand of cigarettes, using a long glass cigarette holder stuffed with cotton wool to absorb the nicotine. She kept the holder and cigarettes in a pocket under her petticoats, so was always lifting her skirt to get at them. When she ran out, she would glance over to my mother and say, "Dear child, run up to my room and fetch more." When she decided to cut down, she simply cut the cigarettes in half, which meant my mother and aunt had to go up twice as often to collect the replacements.

When my mother's parents were home, the house would come alive. They had a wide circle of friends, and they would host a huge range of guests, from European royalty to film stars and socialites. Noël Coward was a frequent visitor, as was King Alfonso of Spain. Before their girls were born, my grandparents entertained lavishly at the house of my grandmother's grandfather in Mayfair, my grandmother famed for having played the song "The Man I Love," by her friend George Gershwin so many times at her parties that it became an overnight hit in England, having gone nowhere in the U.S. She danced the Charleston with Fred Astaire, and she and my grandfather even made a short silent home movie with Charlie Chaplin.

Marriage was a refuge for my grandmother, having met my grandfather shortly after the death of her beloved grandfather, who had meant the world to her. Rich from her inheritance, and a fabulous hostess, fashionably slim, beautiful, and happily in love, my grandmother was briefly content. But as time wore on, it became clear that being married to a naval officer meant saying, "Goodbye, darling" for most of each year, as officers were away more than they were home. Being alone made her restless and unhappy, so she and my grandfather agreed to stay together but have separate rooms and, to some extent, separate lives. Acknowledging that my grandfather's work was important to him, she promised not to complain when the navy "took him away" and agreed to play her part when her presence was required. And my grandfather recognized that my grandmother needed to look for certain things elsewhere, so as a compromise, and with her promise to be discreet about it, she had a roster of admirers who essentially flirted with and flattered her.

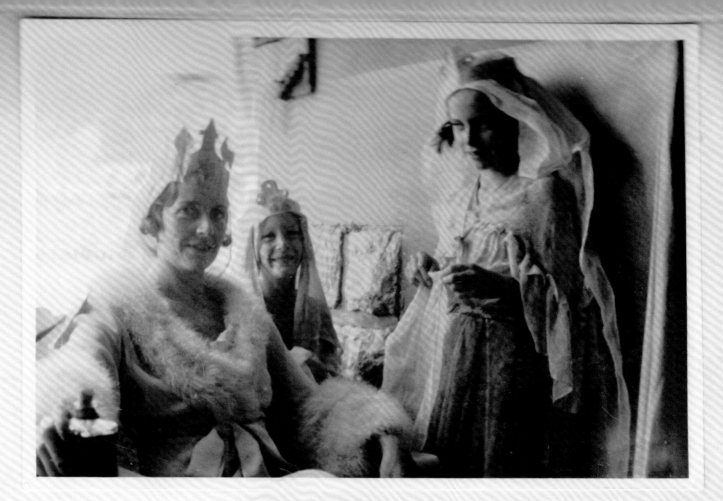

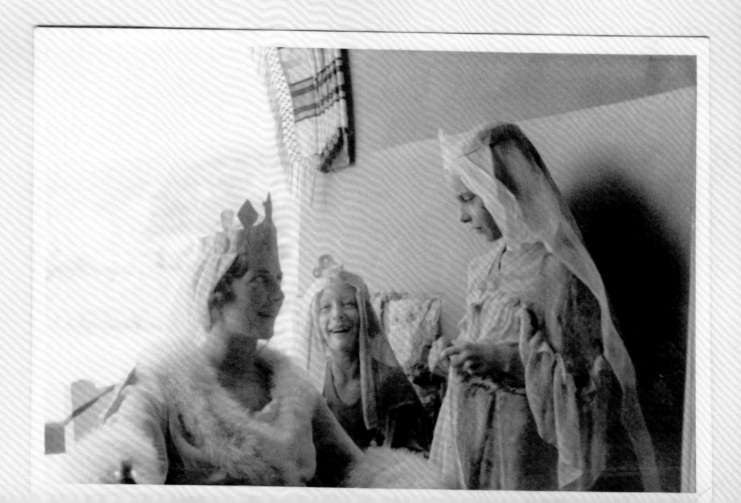

Incredibly, my grandfather possessed not an iota of jealousy and he wanted her to be happy. He was fine with these admirers being present in their lives, even when they did cross the boundary of platonic friendship. If she was happy with all these gorgeous young admirers, he thought, let her have them; he was still very much her husband. His only stipulation was that if she traveled with any of them, upon arrival in a new place they couldn't write their names in the ambassador's book. Back then, the first thing a society woman did was to sign her name in the embassy's book so word spread that so-and-so had arrived from Britain.

For a while this arrangement suited them both perfectly, and it didn't just work one way. My grandfather also had female flirts and flatterers whom he met on his travels. But while he was able to accept her lovers, she was riddled with jealousy by his. When he met Yola Letellier, who became more of a fixture, my grandmother struggled with her permanence.

On the exterior my grandmother had this enormous charisma, which was a rare thing, radiating a sense of adventure and allure. But inside, she was an introvert and sensitive and had, from an early age, learned never to bother anyone with her problems, which festered inside her.

When she was ten, her mother, Maud Cassel, contracted tuberculosis. Because it was believed to be highly contagious, my grandmother and her younger sister, Mary, were sent away, pretty much from one day to the next, without ever being told why. When they asked to see their mother, they were told she was "too busy." They never saw her again.

OPPOSITE: My grandmother's most adored lover, Bunny, invented the characters Princess Plink and Princess Plonk for the sisters. Aunt Patricia was Princess Plink, my mother was Princess Plonk (though she always wished she had been the more tinkly sounding Princess Plink), and he and my grandmother were King and Queen of the Moon. Here are the very official portraits of them taken in a Monte Carlo hotel room, appropriately dressed for their titles.

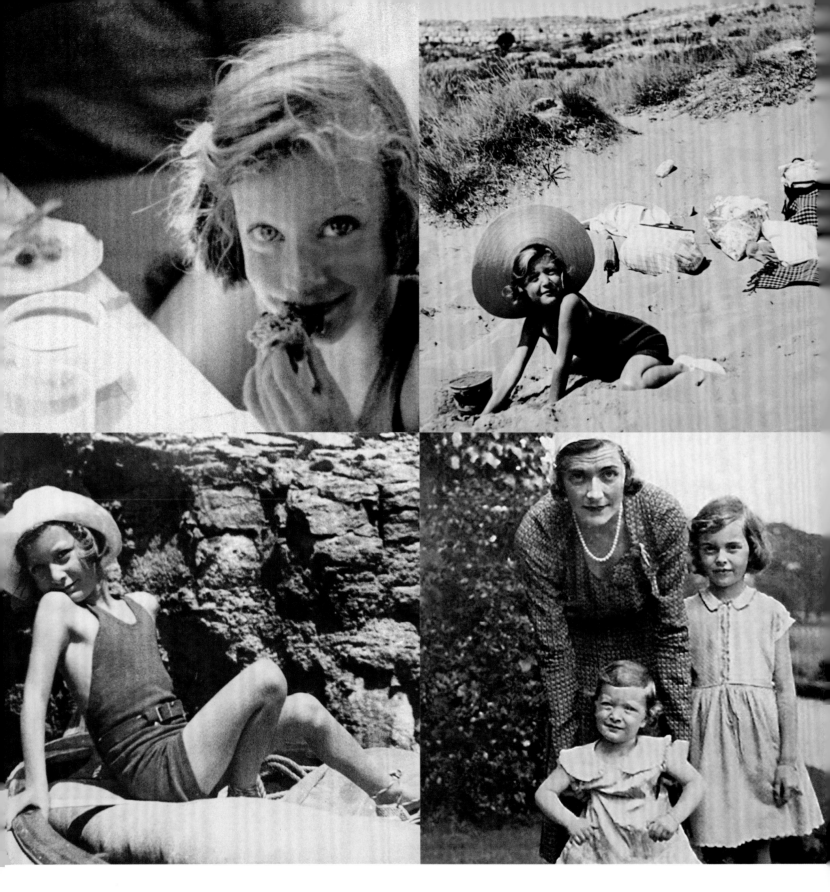

ABOVE: Early years living near the seaside meant many summers on the beach, but there was the occasional holiday in the snow. Just look at that downhill-racer position. Learning to ride came just after learning to walk. Dickie, Pamela, Patricia, and Edwina, all dressed in their jodhpurs.

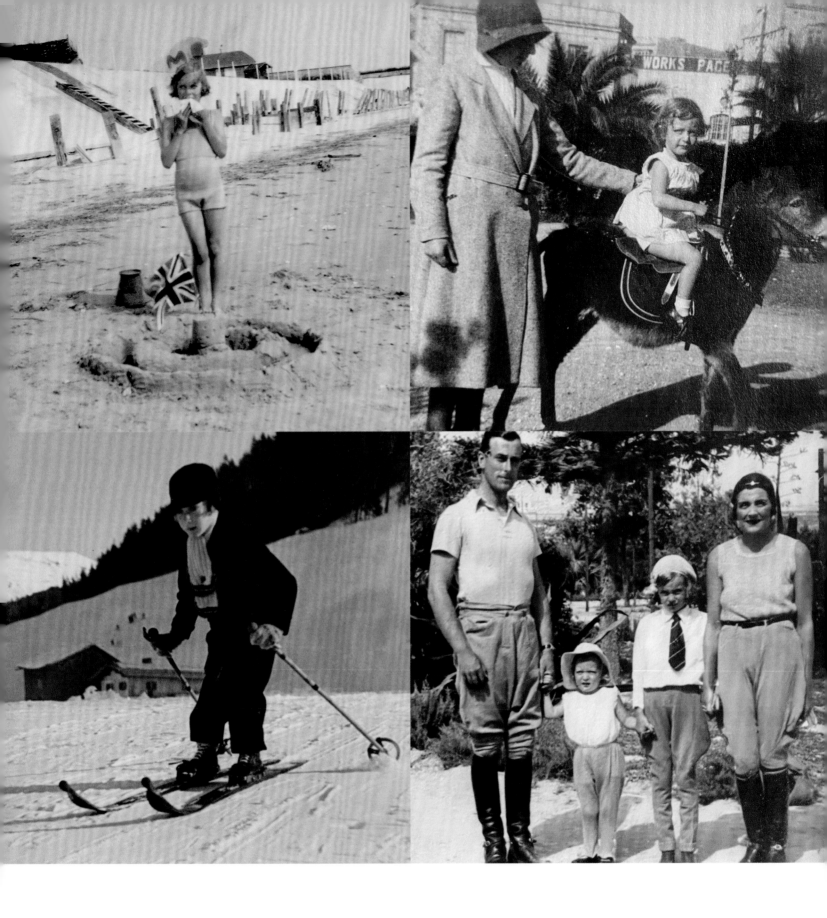

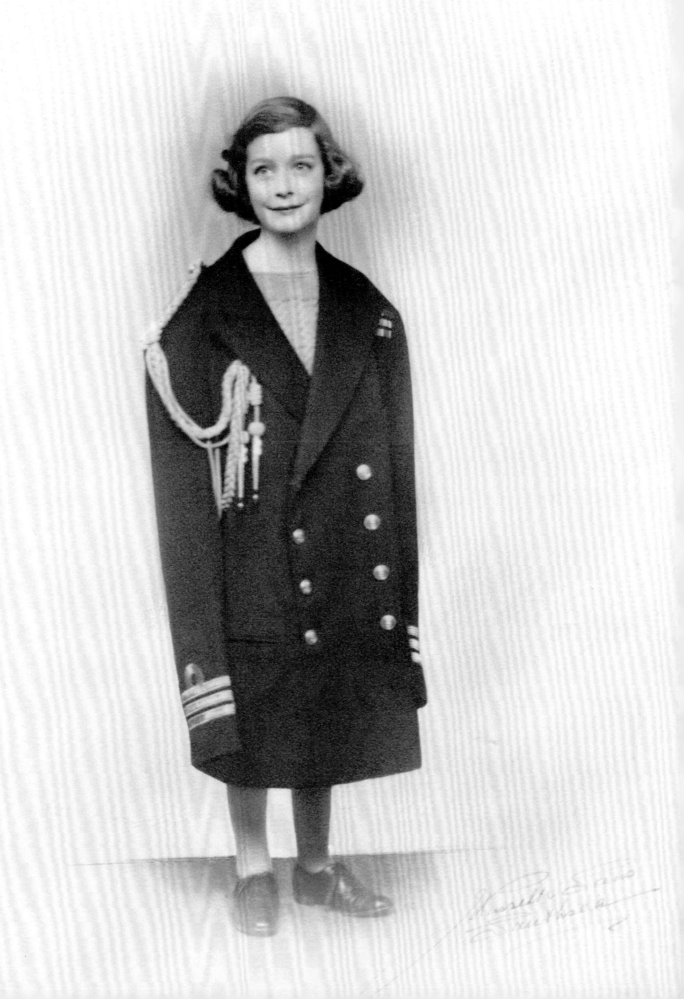

However, my grandmother met a man who changed her life. As a result, she allowed my grandfather and Yola to spend time together without her interference. Bunny, Lieutenant Colonel Harold Phillips, was an instant addition to my mother's family and it quickly became impossible to imagine life without him. He treated my mother and aunt as if they were his own children. He was kind and thoughtful and had the most wonderful imagination that he used to entertain them. He wrote them long letters when he was away, and there is a much-loved photograph in my mother's childhood album of them all sitting on a bed in a hotel in Monte Carlo, wearing homemade crowns and veils. This became the official portrait of the characters he had invented. Patricia was Princess Plink, my mother was Princess Plonk (though she always wished to be the more tinkly sounding Princess Plink), and he and my grandmother were King and Queen of the Moon.

Most importantly, Bunny made my grandmother easier to be around. Today, people are shocked by the fact that my grandparents' marriage was so open, but my mother always says that Bunny truly brought the family great joy. He and my grandfather got on very well. My grandfather referred to him as "the Rabbit" and was often heard saying, "When the Rabbit arrives, things get easier."

In 1934 my mother and aunt went to live in Malta, where my grandfather was stationed. My grandmother and Bunny had just finished a six-month trip sailing the Pacific and came to visit before departing on another long trip, this time heading east. Life in Malta was sunny and expansive, but what made it magical for my mother was Yola's arrival with "un cadeau." Lottie, named for Yola's favorite opera singer, Lottie Minkus, was a short-haired dachshund puppy, soon to become the love of her life—unlike Rastus, the family's pet black Malayan honey bear, who was terribly fierce; when he stood on his hind legs he was taller than my terrified tiny mother.

OPPOSITE: "A monkey in a monkey jacket," my grandfather called this. Every year my mother would be photographed in my grandfather's naval jacket to judge how much she had grown.

23

Their time in Malta was cut short by Mussolini's plans to invade Abyssinia (modern-day Ethiopia). It was decided that all naval families should leave the Mediterranean. It was summer 1935. My mother was eight and my aunt was twelve. It wasn't possible for them to return home, as Adsdean had been let out and the London house was being renovated. So, my grandparents decided that it would be easier if Patricia and Pamela went "somewhere in Europe." Off they set—my grandmother, Bunny, and the girls, along with Nanny Vera, Miss Vick, and, thankfully, Lottie the dog.

Upon finding a nice-looking small hotel in the Hungarian mountains a few hours east of Budapest, my grandmother thought it an ideal safe spot to leave the girls, the nanny, and the governess. Once they were settled, my grandmother and Bunny waved goodbye and set off in the car.

My mother remembers being delighted to have her beloved older sister all to herself. My aunt was going through a writing phase and wrote the most wonderful stories, and she would read them aloud inside the wigwam they had made. They wore cotton dresses, white gym shoes, and socks—flimsy outfits they had packed for the sunshine of Malta. A week turned into another week, which turned into a month. By November the snow started. As fall changed to winter, and no one came to get them, their wardrobe became rather ineffective. Nanny and Miss Vick had to go to the local village to buy them all flannel underwear.

By the time the Hungarian winter came and the hotel insisted it was time to settle the bill, they had run out of money. And still no one came to get them. Luckily a fellow guest, Dr. Toth, knew of their parents and was able to reassure the hotel that their mother was a wealthy English aristocrat and guaranteed the money.

A month or so later, my mother and aunt went downstairs and found my grandmother and Bunny in the foyer. My grandmother had lost the piece of paper on which the name of the hotel was written but had eventually retraced their original route and found them.

OPPOSITE: Sitting with my grandmother, my mother clearly thrilled with the puppy in her hands. Whose it was, no one can remember.

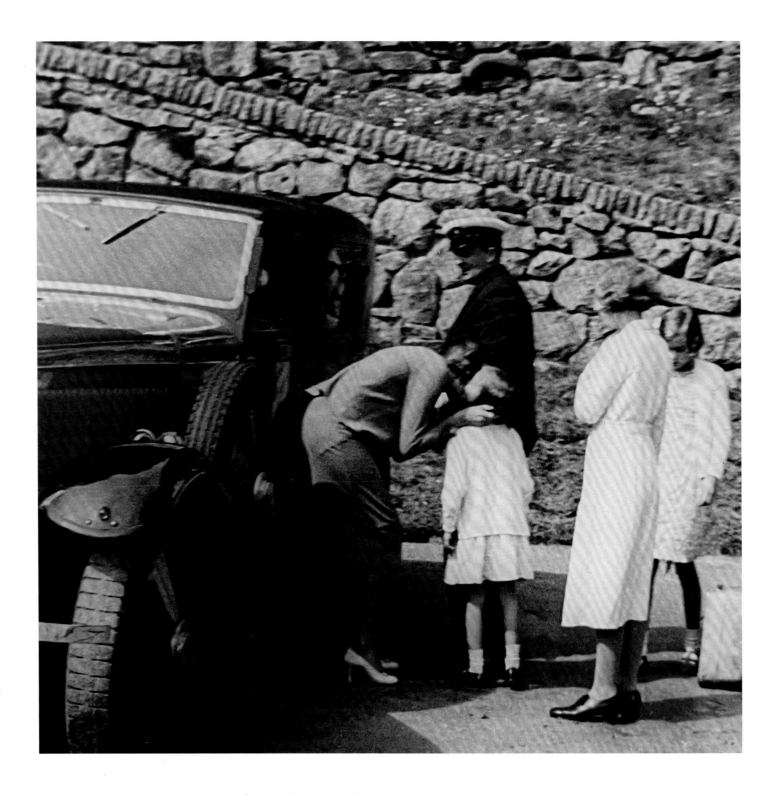

ABOVE: In the summer of 1935, Edwina Mountbatten kisses my eight-year-old mother goodbye, as my twelve-year-old aunt looks downcast. It had been decided that the girls should be left "somewhere in Europe." Unfortunately, my grandmother forgot where she had left them, and only returned six months later after retracing her steps. The nanny and governess were even more appalled as they disliked each other intensely. OPPOSITE: My mother was delighted to have her sister all to herself, especially as my aunt would write wild, wonderful stories and build wigwams for her and her dachshund, Lottie, to hide in.

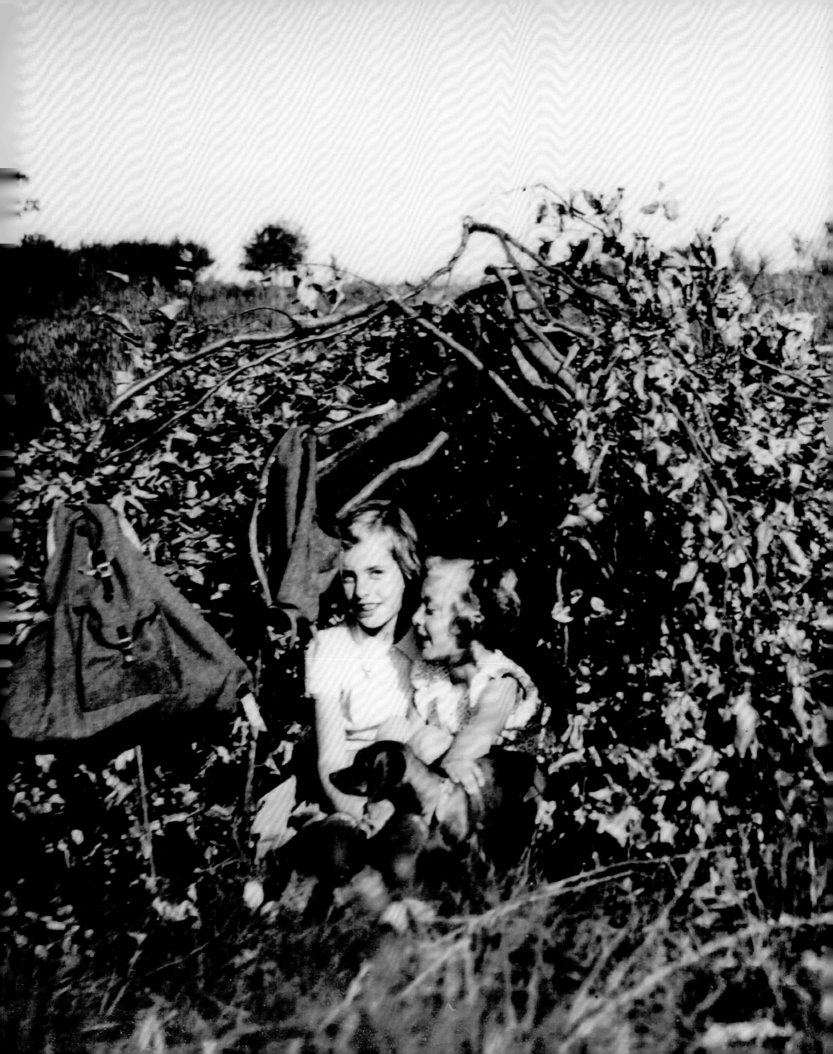

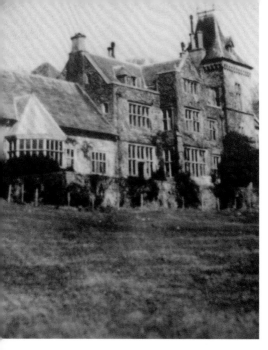
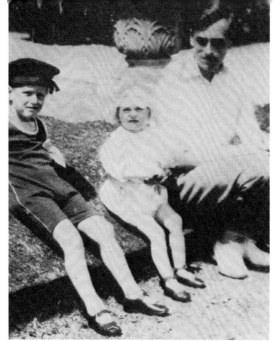
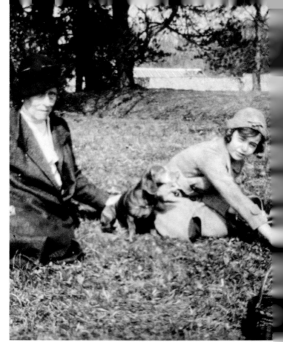

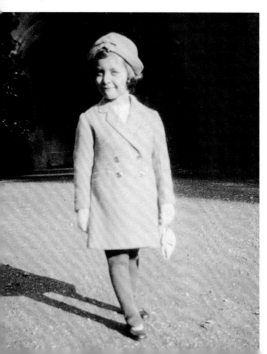

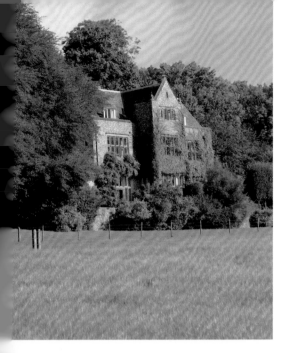

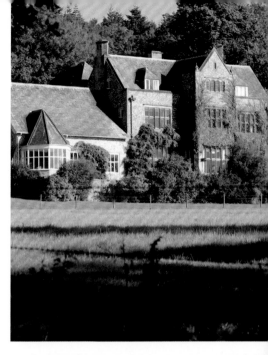
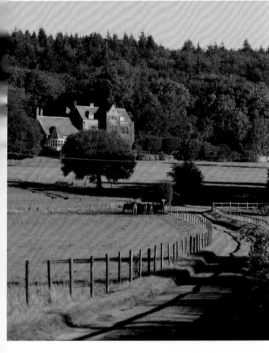

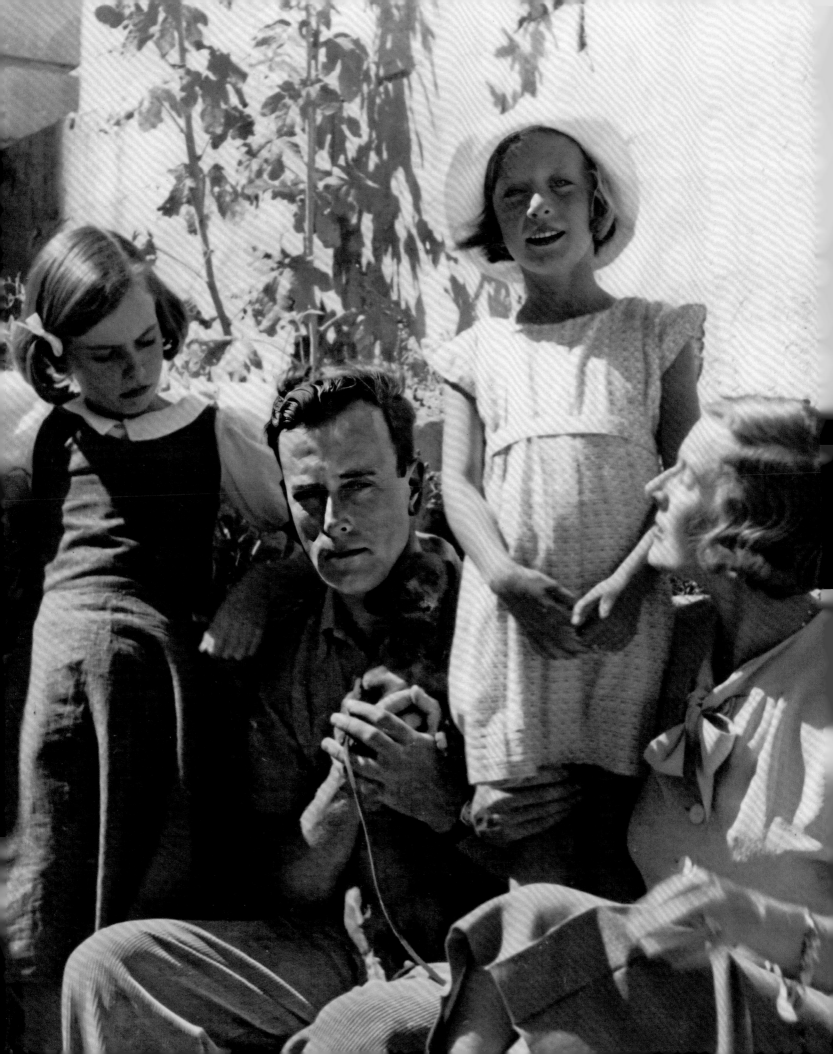

My grandmother and Bunny weren't quite finished with their travels, though. From Hungary, they took my mother, my aunt, Nanny, and Miss Vick to stay in Darmstadt, Germany, with their great uncle Ernie, the Grand Duke of Hesse. My grandfather, still in Malta, wrote them long letters. Christmas came and went, and my mother contracted measles. She felt wretched and wished for her mother, her father, Bunny, or Yola to be with her. During her stay with her great uncle, she learned to speak German and also to knit. A great deal of knitting and a constant stream of visiting cousins and uncles and aunts distracted her.

By late spring 1936 they were back in Adsdean, as was my grandfather, who had been appointed to the admiralty, a prestigious role, which meant he was needed in England. The house in Malta was packed up and my grandmother had to put her travels on hold to join them. By now my mother rode well, and her memories of this time are of blissful mornings when her father, sister, and she went riding up to the Downs.

Coming home meant they could also spend more time with their cousins. After the abdication, the young princesses Elizabeth and Margaret moved to Buckingham Palace, and my mother and aunt went to visit them. They were pleased to be reunited and soon resumed their pretend gymkhanas, moving seamlessly to the corridors and clipped lawns of the palace, where red-jacketed footmen stood motionless watching over the princesses as they played. Rather different from the wilder races they'd held at rambling Adsdean.

PREVIOUS PAGES: Adsdean Park, then and now. Located near the Sussex Downs, it was the home my grandparents lived in while my grandfather was serving in the navy. A constant stream of guests and visitors made the house buzz with life, and included Prince Philip sitting beside my mother and grandfather, who was his uncle *(left page, top center)*. Another frequent guest was my great-grandmother *(left page, top right)*, accompanied by her devoted lady's maid, who ensured her "princess" was correctly attired at all times with her neat white blouse and ankle-length black skirt, in the hem of which my great-grandmother hid her cigarettes. Adsdean has been through many alterations since my mother lived there but is much loved to this day, cushioned by rambling woods and long views of unspoiled countryside *(right)*. OPPOSITE: The sisters with their parents, and most importantly with Lottie, my mother's dachshund puppy named after the opera singer Lottie Minkus.

The princesses had their very own Girl Guides troop with their own troop leader, who came to the palace and helped them start their own chapter, the 1st Buckingham Palace Guides. Aunt Patricia was invited to be a patrol leader. They used a greenhouse on the grounds for their base and did all the usual Girl Guide activities, such as making fires and camping out on the palace grounds. My mother was too young to be a Guide, but she joined in as a Brownie, along with Princess Margaret and a number of the daughters of the staff at the palace. Guiding remained extremely important to both my aunt and the queen, who much later went on to be the patron of the Girl Guides. Their motto, Be Prepared, never seemed to be far from her mind.

When Aunt Patricia turned twelve, she was sent away from Adsdean to go to boarding school in London, only returning home on the weekends. Miss Vick left and, shortly after that, Nanny Vera. My mother overheard mutterings that this was a good thing because Nanny Vera had become a "little too possessive" of her. My mother, however, was lonely without her three constant companions, particularly when her mother and Bunny then left for another long trip. Through winter 1937, my mother struggled to get used to Zelle, the new governess, as postcards rolled in from their travels to Kenya, Uganda, and the Congo. My mother added them to her album of postcards, but she didn't feel very happy.

By the time she started school later that year, she had become quite a morose child, used to spending quiet hours on her own. This wasn't to say she was lonely. She made friends and enjoyed the schoolwork, but going home was always a relief. Her first summer back at Adsdean coincided with a visit from her cousin, Philip, of whom she was a bit in awe. Eight years older, he was a first cousin, the son of her father's sister, Princess Alice of Battenberg. Philip was great fun but a little bit frightening to be around; he inspired them to play all sorts of boisterous and daring games, including his favorite, bicycle polo, which caused all sorts of havoc.

But this was the end of the days of innocence and play. My mother detected rumblings of unease in the conversations the adults were having, and she knew there was something serious going on. Nothing confirmed that more than the afternoon of September 3, 1939, when my mother and aunt were sent for. It was explained that the prime minister, Mr. Chamberlain, had announced that England was at war.

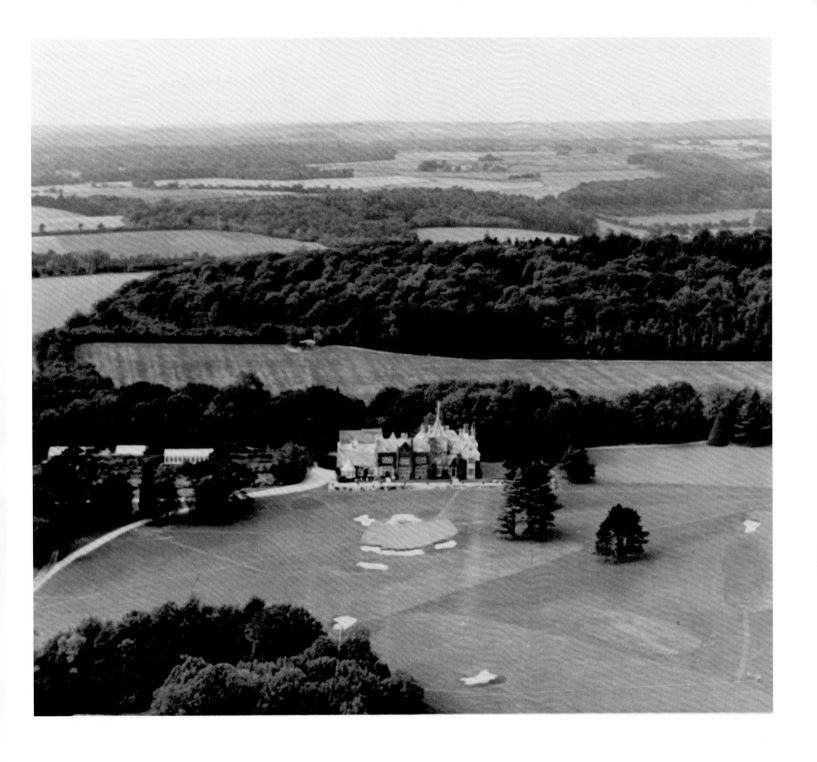

ABOVE: An aerial view of Adsdean. FOLLOWING PAGES: My grandmother commissioned a new dress for King George VI's coronation, a glamorous slinky column of silver sequins. My mother also had a new dress made. It was long and white with silver threads, but most thrilling of all was the vibrant apple-green cloak. Considered a little bit too young to attend, my mother did not go with her sister and parents to Westminster Abbey but joined them afterward at Buckingham Palace *(left)*. My mother was very proud of the photographs she took of the procession and catching sight of her father riding just behind the king's golden coach, amid all the dancing flags and cheering crowds *(right)*.

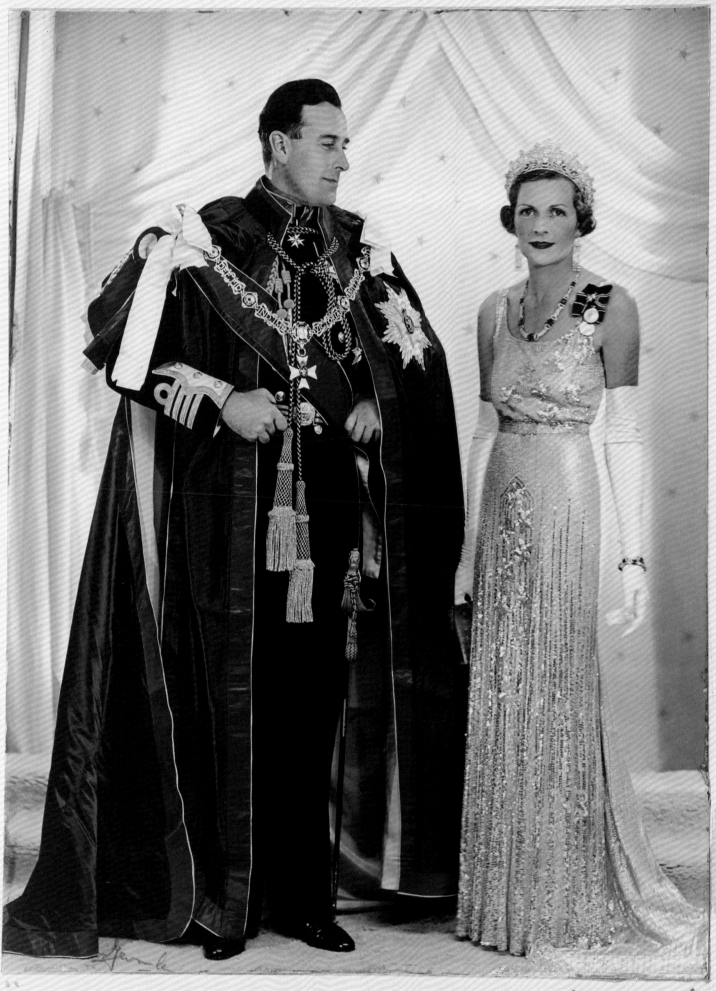

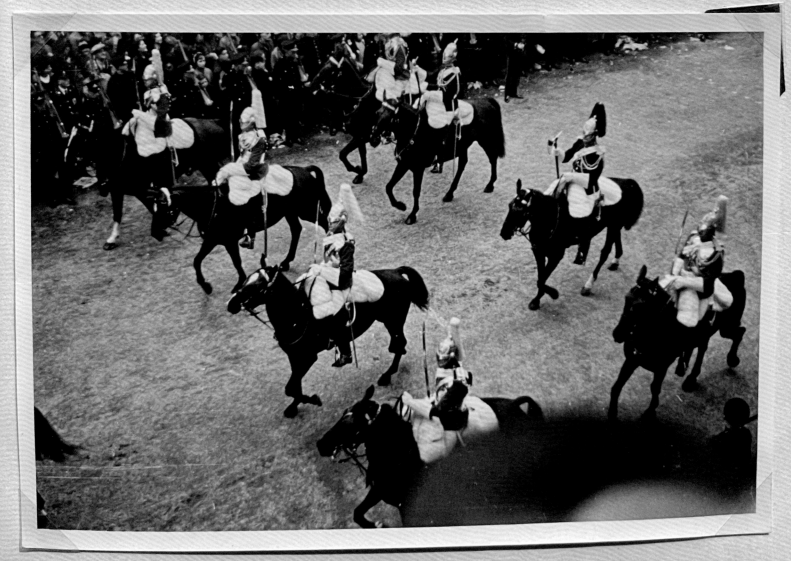

Mars 1937

OPPOSITE: My aunt and mother holding tightly onto each other's hands, as they did for all of their lives. Almost inseparable. My mother even went on her sister's honeymoon; my aunt could not bear to leave her behind. ABOVE: Outside Adsdean, my mother with her grandmother, her sister, a friend, and Bunny. My mother loved having Bunny in their somewhat unconventional home; he enriched all of their lives. My grandfather (whose lack of jealousy prevented the family from fragmenting) affectionately called him "the Rabbit."

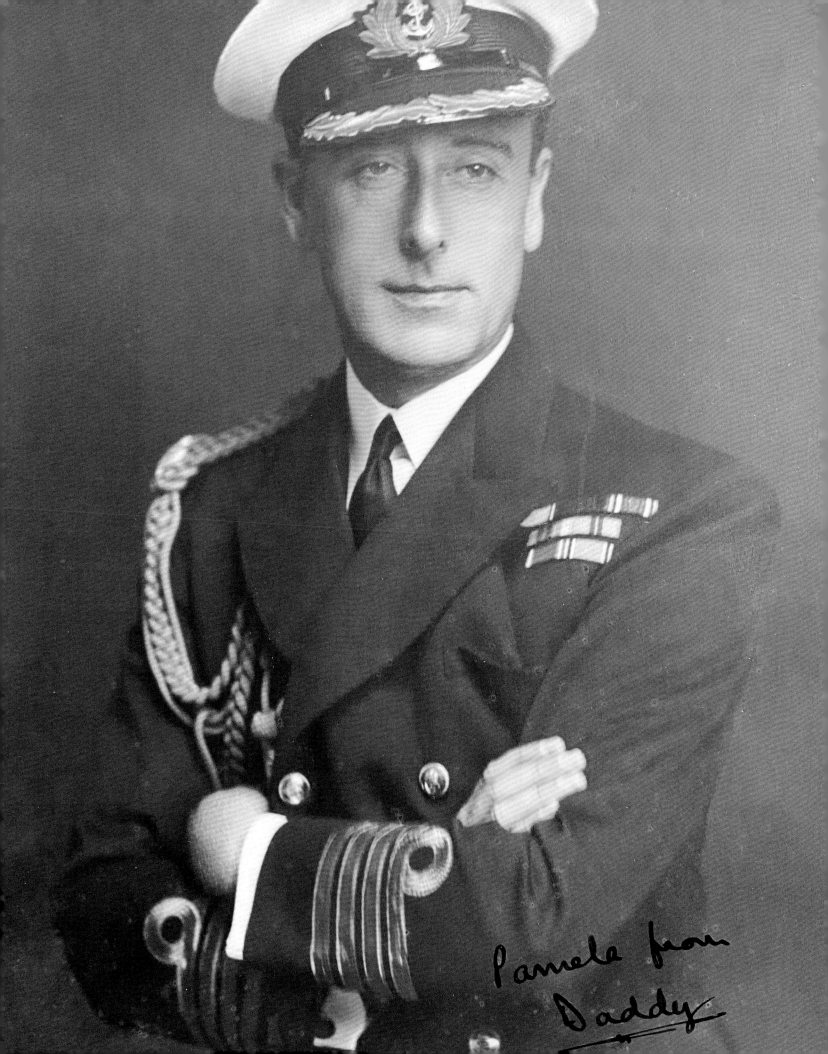

Pamela from Daddy

1940-45

HOMESICK AND AT WAR

For a while my mother's life was unaffected by the country being at war. My mother and aunt got used to my grandfather's drills, instigated a few months before the declaration of war: gas masks covering faces as they assembled on the lawn to be counted. My grandfather, on the contrary, was on high alert, waiting to be recalled to HMS *Kelly* at any moment. In the mornings, he was keen to ride with my mother and aunt, in case it was his last day at home. He would ride with each of them in turn, leaving the other to stay close to the telephone and act as a "dispatch rider." One morning, my mother heard Frank Randall, the butler, telling the head groom, Mr. Birch, to "saddle up and ride out to fetch his lordship." She was thrilled when Mr. Birch told him in no

OPPOSITE: As a child, my mother was fairly insulated from the details of the war, but in 1940, when the Battle of France was brewing and her father's ship HMS *Kelly* was ordered to sea, the reality of it came closer. My mother and my aunt were taken to Southampton to say goodbye to their father. He showed them around the ship and into his cabin, but my mother picked up on the unease. As soon as she got home, she wrote in her diary, "Daddy has gone to sea. Good luck to him." FOLLOWING PAGES: Saved letters and postcards sent by friends and family. My mother points out how frustrating it is when the authors don't note the year. And a pack of postcards from my mother's school, St. Giles, which was also the home of her cousin, Mary Anna, whose grandparents lived in one wing and would often pop into the girls' classrooms in the other wing to say good morning or leave out food for the mice *(left)*. Despite the beauty of the inside of the house, it was the outside of Broadlands that captured my mother's imagination. The River Test flowed beside the front lawn and through the magical gardens that had been shaped by Capability Brown for the 1st Viscount Palmerston in the eighteenth century *(right)*.

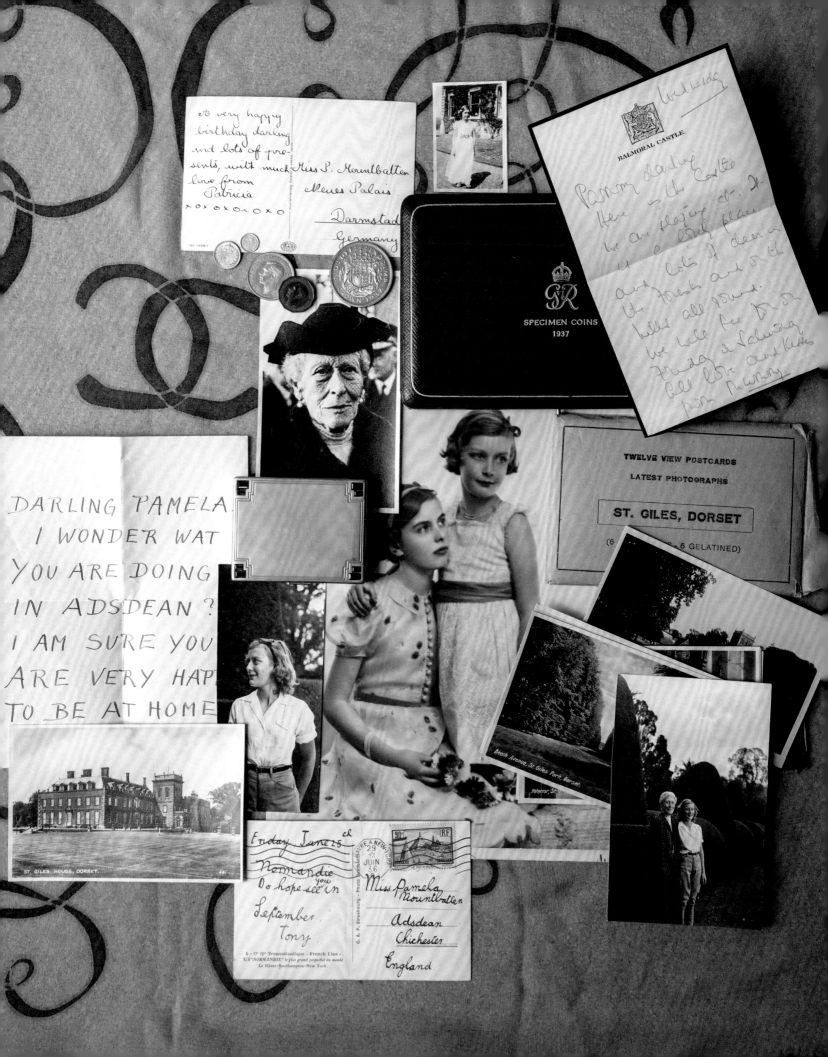

A very happy
birthday darling
and lots of pre-
sents, with much
love from
Patricia
xox oxoxoxo

Miss P. Mountbatten
Neues Palais
Darmstadt
Germany

SPECIMEN COINS
1937

BALMORAL CASTLE

Wednesday

Pammy darling
Here is the Castle
We are staying at. It
is a lovely place
and lots of deer in
the forests and on the
hills all round.
We will be back on
Friday d Saturday
All love from
from Mummy

TWELVE VIEW POSTCARDS
LATEST PHOTOGRAPHS
ST. GILES, DORSET
(6 ... & 6 GELATINED)

DARLING PAMELA
I WONDER WAT
YOU ARE DOING
IN ADSDEAN?
I AM SURE YOU
ARE VERY HAPP
TO BE AT HOME

Beach Avenue St Giles Park Dorset

Interior, St Giles

ST. GILES HOUSE, DORSET.

Friday June 25th
Normandie
Do hope see you in
September
Tony

Miss Pamela
Mountbatten
Adsdean
Chichester
England

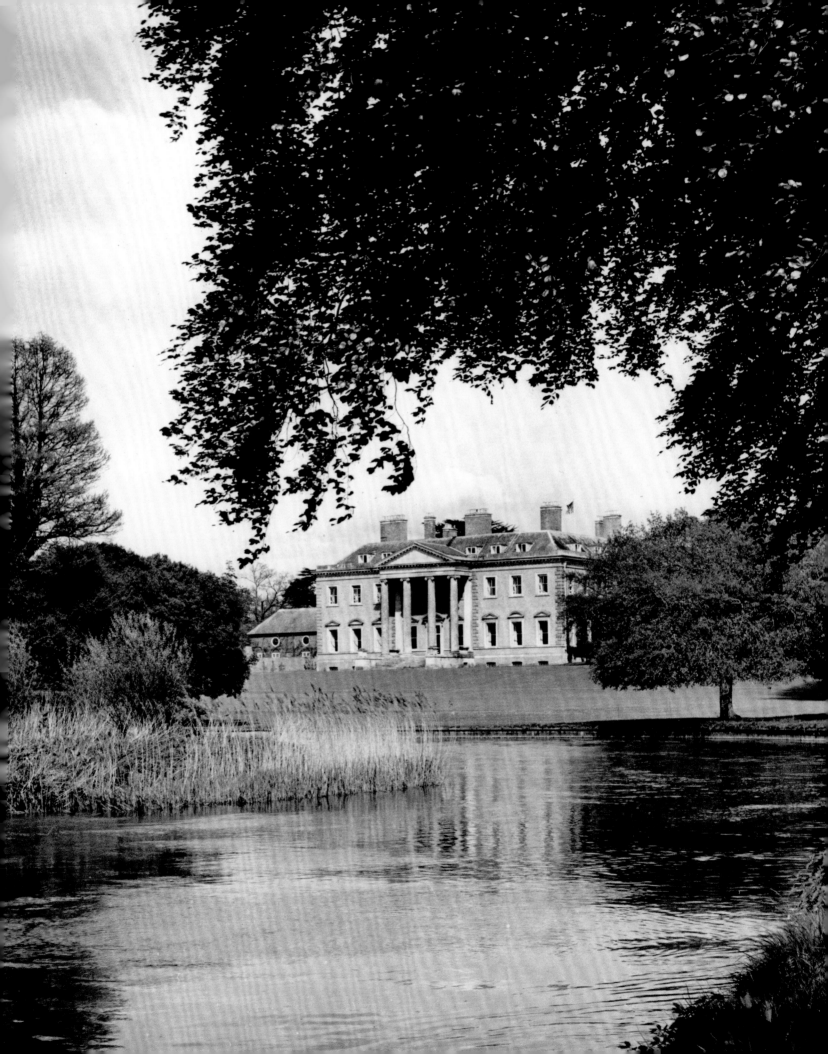

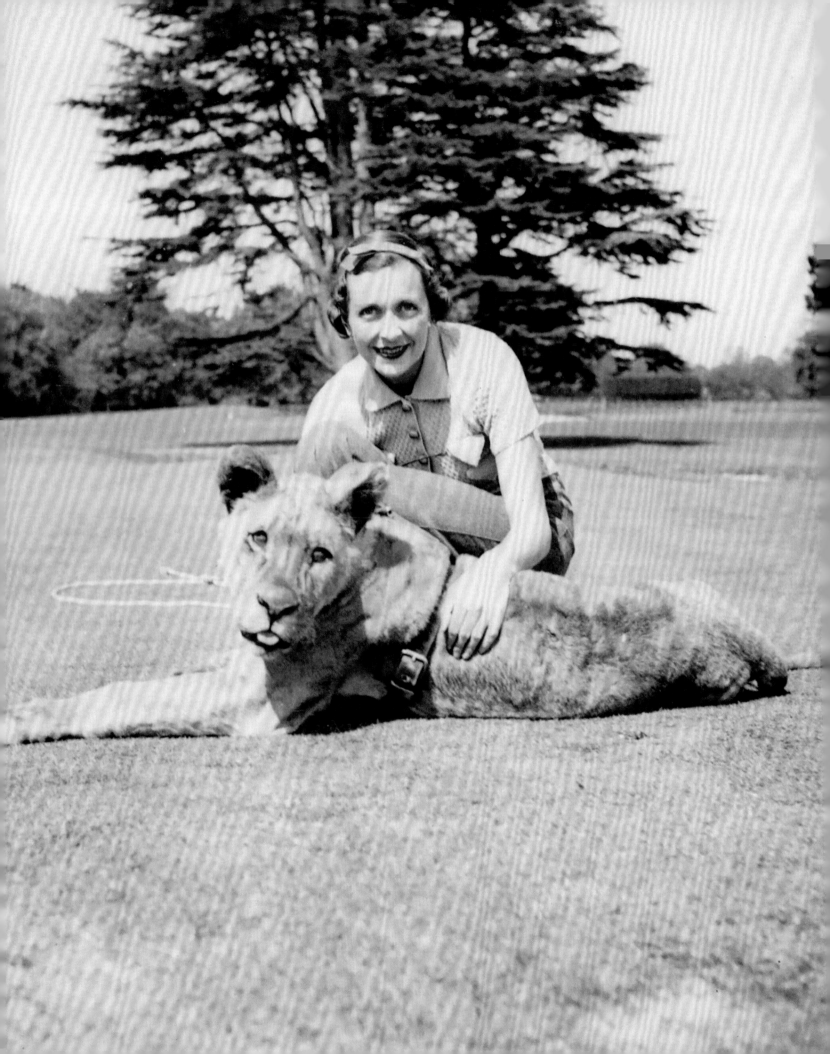

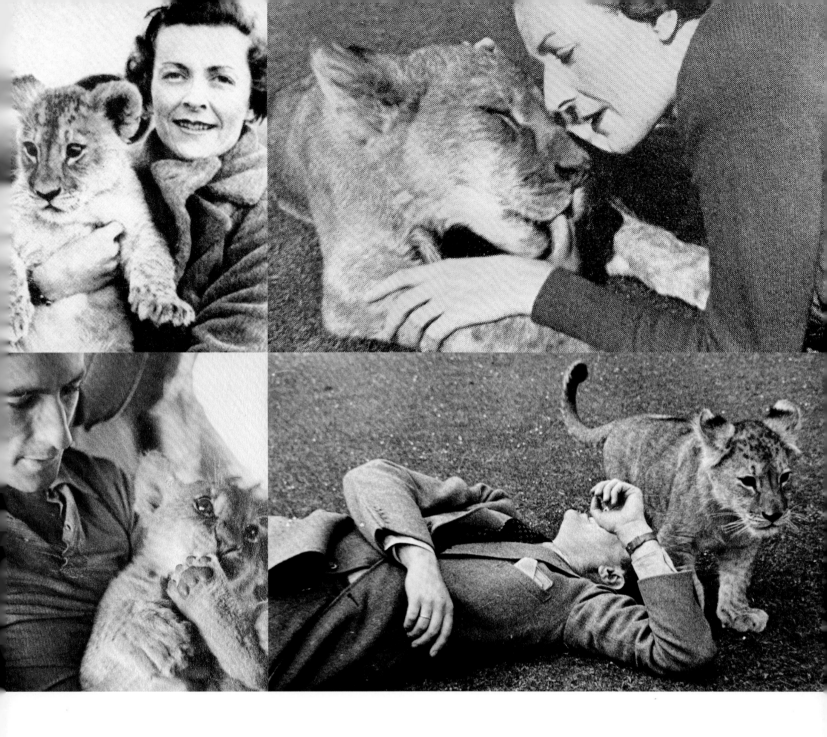

OPPOSITE AND ABOVE: Returning from one of her many adventures, my grandmother descended from the plane with a three-month-old lion cub in her arms. His name was Sabi. His mother had been shot and my grandmother felt she simply had to bring him back. It had been easy enough to get the lion cub on a plane in Africa. There was a momentary hiccup, however, when she disembarked in London and the airport authorities told them that Sabi needed to go into quarantine. My grandfather, suppressing his shock at my grandmother's cargo, reassured the authorities that Adsdean could become an official site for lion quarantine, and all was fixed. Soon Sabi became a treasured member of the menagerie. He was as small as the family's Sealyham terriers, and guests were often surprised to bump into him outside having a tussle with one of the dogs. He loved to sun himself on the sand pits of the golf course, although he unfortunately also liked to use them as a litter box. He also enjoyed lying in wait on the high banks surrounding the croquet lawn, then suddenly propelling himself from his hiding place and charging down the players, scattering croquet balls everywhere.

43

uncertain terms that he was under "strict instructions" to let Miss Pamela act as the courier. Jumping onto her pony, Puck, she took the ride of her life, careering across the Downs until she caught up with my grandfather and aunt. "Daddy," she wheezed. "The call has come. You have to go back to your ship." "Good work, Pamski," my grandfather called, as he turned and galloped back to the house.

It was after the half-term holidays that things changed for my mother and aunt. They did not return to Adsdean but instead went to my great-grandfather's house, Broadlands, that had been bequeathed to my grandmother. Having never been before, they were astonished to find that it was a proper stately home, set among six thousand acres of land. With war very much on their minds, my grandparents pointed out the inscription that my great-grandfather commissioned for a wide stone plinth on the left of the walled garden. Carved on the left-hand side were the words LEST WE FORGET. THE GREAT WAR 1914–1918. Much later, with all the horrors of the next few years, my grandfather told them he was tempted to carve, AS WE FORGOT. SECOND WORLD WAR 1939–1945, into the right-hand side.

In 1940, my mother was only eleven years old when it was unexpectedly announced that she and my aunt were being sent to America until the end of the war. They were going to stay in New York with someone called Mrs. Cornelius Vanderbilt. They were going, it was explained, because their great-grandfather, Ernest Cassel, was Jewish. My mother nodded wisely but didn't really understand why that meant they had to leave. She imagined it had something to do with Hitler, but she didn't know for sure. My grandparents booked them passage to the United States aboard the SS *Washington*, the last ship to take children across the Atlantic before the crossing became too dangerous. The ship was so full that some of the passengers had to sleep in the drained swimming pool.

After a week at sea, they woke at dawn to see the Statue of Liberty. Much taller than my mother had imagined, seeing it up close was really thrilling. Clearing customs, my mother was given her first taste of what being an "alien" meant. Having been born in Barcelona, she was made to stand in a different line from my aunt and the rest of the British evacuees. The customs official told her that under no circumstances could she work in America.

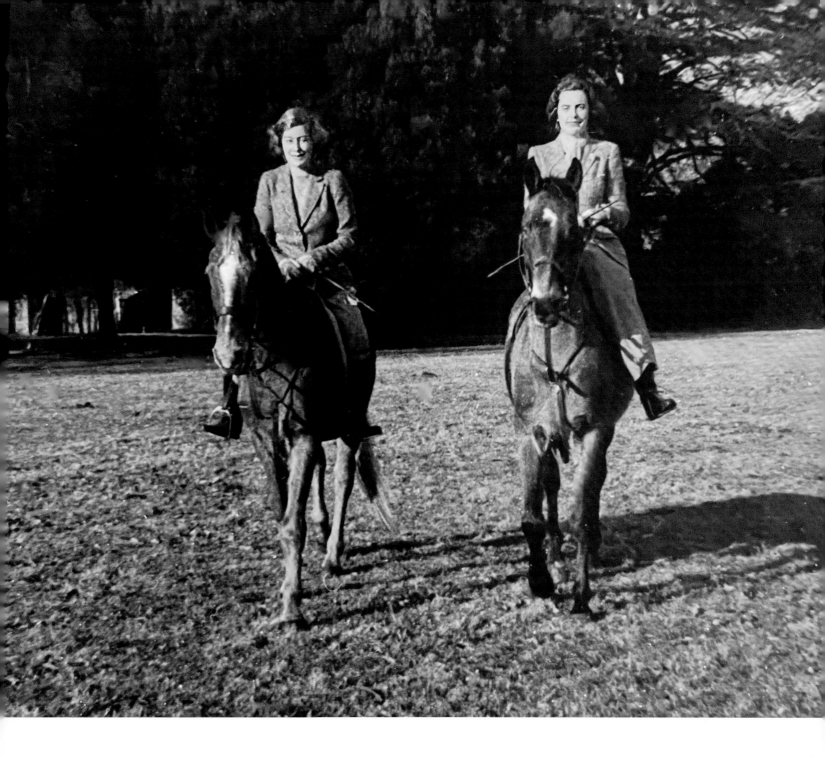

ABOVE: My mother and her sister were excellent horsewomen, even mastering sidesaddle at an early age. Sometimes spectacular gymkhanas would take place when they went to play with their royal cousins, Princess Elizabeth and Princess Margaret. The games were imagined in a world of make-believe that they all shared, and they never had to explain the reasons or the rules. They instinctively knew what to do. Much to the chagrin of the younger sisters, though, they were always the ponies while the older sisters were always the riders.

An extremely well-dressed woman introduced herself as Mrs. Vanderbilt's secretary. Even my mother's young eyes could see how fashionably she dressed—far better than anyone back home. The woman guided them into a waiting car, and they were whisked toward 640 Fifth Avenue. The facade of Mrs. Vanderbilt's residence was enormous and imposing and the inside was no less so. The hall was cavernous, all marble floors and surfaces, and featured a huge malachite vase that was even taller than the girls. (My mother took me once to see this years later, in the entrance hall of the Metropolitan Museum of Art.)

A small, queenly form, Mrs. Cornelius Vanderbilt wore a long silk dress with a bandeau swathed around frizzy gray curls. "Girls," she said, "you must call me Aunt Grace." All through that hot summer of 1940, my mother and aunt were shunted among the Long Island summer houses of New York's kind society hostesses, getting used to their new surroundings, unfamiliar American expressions, and new routines. My mother wrote copious letters to my grandparents from Mrs. Vanderbilt's villa-style Newport, Rhode Island, residence on Bellevue Avenue. My grandparents insisted that all letters be numbered in case some of them arrived out of sequence or were lost at sea. As the war progressed, my mother and aunt felt guilty being so safe when their parents were not. My mother couldn't unburden her feelings of homesickness to my grandmother, as she was so easily upset; in their home life, it was always best to share worries with my grandfather. Thus, my mother drew a picture for him and posted it with letter number 14, showing "Pamela Carmen Louise Mountbatten (still, stranded on a raft floating to you!!)" There were three flags on this vessel: one simply had the word HELP, the second displayed the Union Jack, and the third was a pair of billowing bloomers labeled "white pants (sign of distress!)" The jolliness was a poor attempt to hide the ever-growing homesickness she was feeling.

OPPOSITE: It wasn't just Sealyham terriers or stables of ponies or Sabi, the pet lion, who shared my mother's childhood. There were other unusual pets, including a Malayan honey bear and a wallaby called Babo, who gave birth during the bombings to a baby they christened Bombo. There was a teeny nocturnal bush baby and, later, when my mother returned from India, she brought home Neola, her pet mongoose.

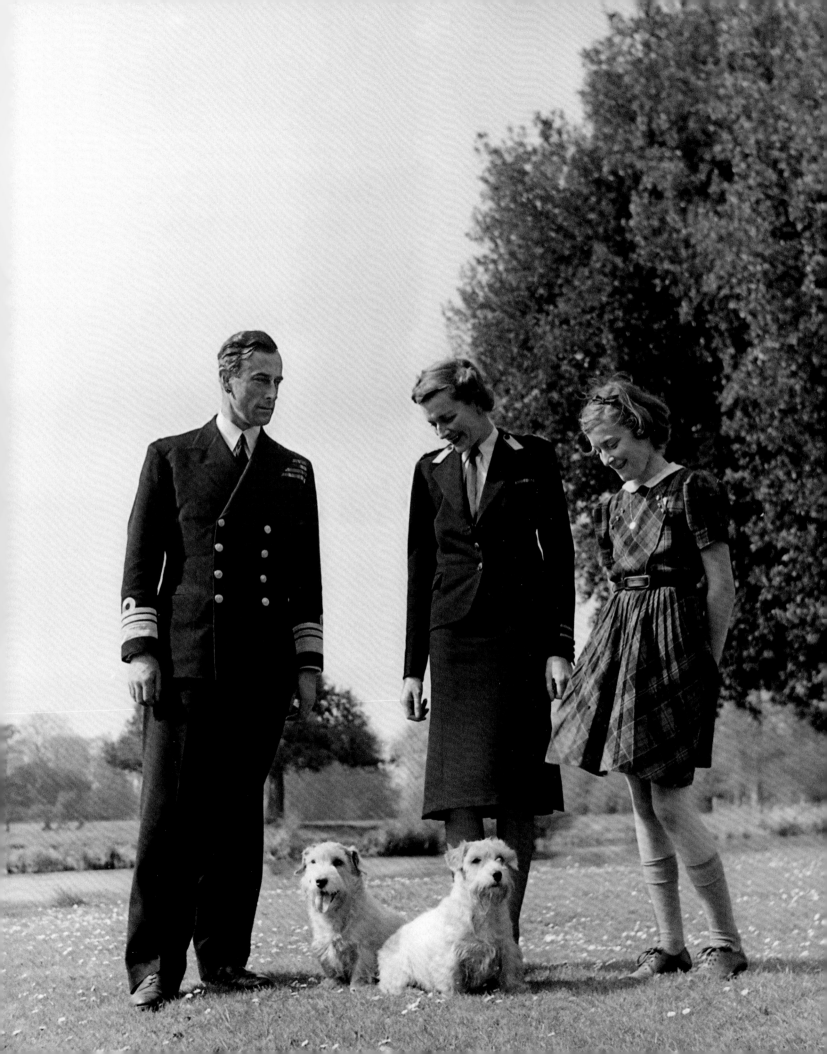

Despite attending school, being with my aunt, and receiving the kindness of the impeccably behaved New Yorkers, my mother couldn't settle, especially as news of my grandfather's "adventures"—family code for life-threatening events—reached them, namely when his ship, HMS *Kelly*, was bombed and he was presumed dead, news that was luckily dispelled.

My mother felt bad, living in what seemed like another world and thinking she should be back at home suffering like everybody else in England. She wasn't exactly unhappy, though—there were too many new experiences and things that made my aunt and her laugh. For example, it was important for Mrs. Vanderbilt to be seen at the opera and she decided to take my aunt, the eldest, with her—that is, to some of the opera. Eager to make an entrance, Mrs. Vanderbilt would arrive at the end of the first act, whereupon she would enter her box with the diamonds of her sumptuous necklace ablaze as the lights went up for the intermission. After she felt that she had been noticed sufficiently, she would take her seat. At the end of the second act, Mrs. Vanderbilt felt she had done her bit and would go home, so my aunt got to know only the second act of each opera. Letters from home were becoming less frequent and they often arrived in a mixed-up order. My grandmother wrote to tell the girls that the baby wallaby had died, then they received another letter from her that said he was doing very well. A week or so later a third letter arrived to say that it had been born.

By some miracle, my grandparents were able to visit my mother and aunt that summer. When my mother first heard this news, it seemed too good to be true and the heartache of the last twelve months lifted. She looked out of the window from her summer bedroom on Long Island, at the great yachts and the little sailing boats bobbing on Oyster Bay, and realized that for the first time in a very long while she was happy.

My grandparents arrived in mid-August 1941, and they drove to upstate New York and spent six glorious days together. When they left, my mother became so miserable in America that it was agreed she would be far better off facing the bombs in England than to stay and feel so wretched. My aunt, on the other hand, only had six months until she graduated from high school, so she decided to stay.

On December 8, 1941, my mother, grandmother, and aunt arrived early at what is today New York's LaGuardia Airport. The press was there as well, to photograph the "royal refugees." Their presence rather curtailed an emotional goodbye between the sisters, but my mother gripped my aunt's hand, hard, as if she never wanted to let it go. The day before, the Japanese had attacked the American fleet at Pearl Harbor, and as my mother boarded the plane to take her home, the country that had hosted her for more than a year and the country to which she was returning declared war on Japan.

Broadlands, their home, was now an annex to the Royal South Hants Hospital, buzzing with patients in slippers and dressing gowns, civilian ambulances, and nurses in starched white uniforms. My mother wished she could be of some use, but she was told the best thing she could do was to stay out of the way. It was wonderful to be reunited with her dog, Lottie, but many of the familiar faces at Broadlands had gone to serve in the war. Eager to play his part, Frank Randall, the butler, was too old to be called up, but he was eligible to serve in the Home Guard. He proudly showed my mother the top of his uniform and told her he was waiting for the trousers to arrive.

Upon returning to England in the wake of her successful speaking tour across the U.S. and Canada raising awareness about what was going on in wartime Britain, my grandmother was appointed superintendent-in-chief of the St. John Ambulance Brigade Nursing Division, the highest position a woman could hold. Responsible for the supervision of mobile medical units, rest centers, and first aid and medical posts in underground shelters, she was always somewhere else in the country, overseeing the organization of the service's sixty thousand volunteers and ten thousand cadets. And for the first time in his naval career, my grandfather, Dickie Mountbatten, was on land, having been appointed chief of combined operations, a strategic role that required tact, diplomacy, and a great deal of secrecy.

As busy as they were, it hadn't escaped their attention that my mother still had to finish school, so she was sent to Miss Faunce's School, which had been evacuated from London to the Dorset home of Lord and Lady Shaftesbury in southwestern England.

When she came home for the Easter holidays that year, she was picked up from the train not by someone from Broadlands but by a rather dashing flag lieutenant, who met her on the platform and told her that her father had sent him, so that she could be taken immediately to the set of Noël Coward's latest picture, *In Which We Serve*, a patriotic film that he had written for the Ministry of Information. As Coward's mother had come from a naval family, he had chosen to set it on a ship, basing the story on the HMS *Kelly*.

The king and queen and princesses Elizabeth and Margaret were also visiting the set and my mother joined the princesses in the car to the studio. It was good to see them after the separation of war, and even though she was now more conscious of their status, and felt slightly in awe of them, she soon found herself joining in, chatting away, and catching up.

They were allowed to stand on a specially made moving deck as a storm scene was being filmed, struggling to keep their balance on the floor as it pitched and rolled in the swell. They all felt rather queasy after a short while and asked if they could please disembark.

Fortunately, my great-grandmother understood my mother's need to get involved with the war effort, and together they requisitioned and restored an old dogcart to which my mother could attach Chiquita, her new black-and-white pony. They were in business almost immediately, circumventing the fuel shortage by running errands, picking up visitors from the local station, and trotting in and out of the town of Romsey delivering bunches of homegrown flowers to raise funds for the St. John Ambulance Brigade shop. My mother also worked alongside the Italian and German prisoners of war. They were held in what was known locally as "Ganger Camp" while they helped to gather the harvest. Her grandmother's chilblained old fingers were so stiff and swollen that my mother had to tie her grandmother's hay bales as well as her own.

OPPOSITE: My grandmother standing in the morning room *(top)* and friends chatting in the drawing room at Broadlands *(bottom)*. FOLLOWING PAGES: Beaulieu House, one of the famous Newport "cottages" owned by Mrs. Cornelius Vanderbilt and where my mother spent the summer of 1941. Mrs. Vanderbilt made it her business to know everybody; in turn, she was known by everybody as the kingfisher, because if any king came to New York, he was bidden to lunch. Mrs. Vanderbilt was not exactly a fan of children, but my mother and aunt were still to go and kiss her on the powdered cheek whenever they saw her. She and her society friends were initially horrified by how badly the sisters were dressed, and within days of their arrival in New York, as evacuees, new outfits arrived. My mother was thrilled, but her aunt was very disapproving; their country was at war, which she reminded my mother, and they could not possibly accept such lavish gifts.

Letter 1

640

Sunday 27th
October
1940

White pants
(sign of
distress!)

HELP!

640
Fifth Avenue
New York city

Pamela Carmen Louis
Mountbatten →
(still, floating to you!!)
Stranded on a raft

Darling Daddy,

Thank you very much for y...
letters. one arrived on October 22nd with two of...
number 16. Written on october 10 and the othe...
not numbered and was written on the 14...

It must have been...
back home to Broadlands again. Conel...
of her oz books so it will seem...
as you always used to read them...

To day we had...
... up to about 190 street. We...
... very new building, with AN...
... countries. Yester...
... the opposite...
... saw the...

Letter 5

Beaulieu
Bellevue Avenue
Newport
Rhode Island.

5

Darling Mummy,
I write to...
I am going to start at...
it was lovely and rou...
huge. I have great f...
I come up to soon a...
there is a sand conf...
together, it is the fir...
with the american a...
and an anchor inside...
the bottom, I am doi...
cornelia is doing t...
In the afternoon w...
on Wednesday we...
Black Point, it is...
climbing the roc...
... saw a...

Letter (My darling...)

My darlinge...

our last day...
it was thursd...
with...

Letter 7

Beaulieu
Bellevue Avenue
Newport
Rhode Islan...

My darling Mummy,

I am starting my letter at...
days before they said that a hurricane was...
two years ago and no one took much notice of...
it did quite a lot of harm, so of course eve...
excited as the radio said it was coming...
all it was to arrive at about 10 clock, then...
7:30. All the furniture outside had been tak...
was ready but the hurricane! of course ju...
... went out to sea!

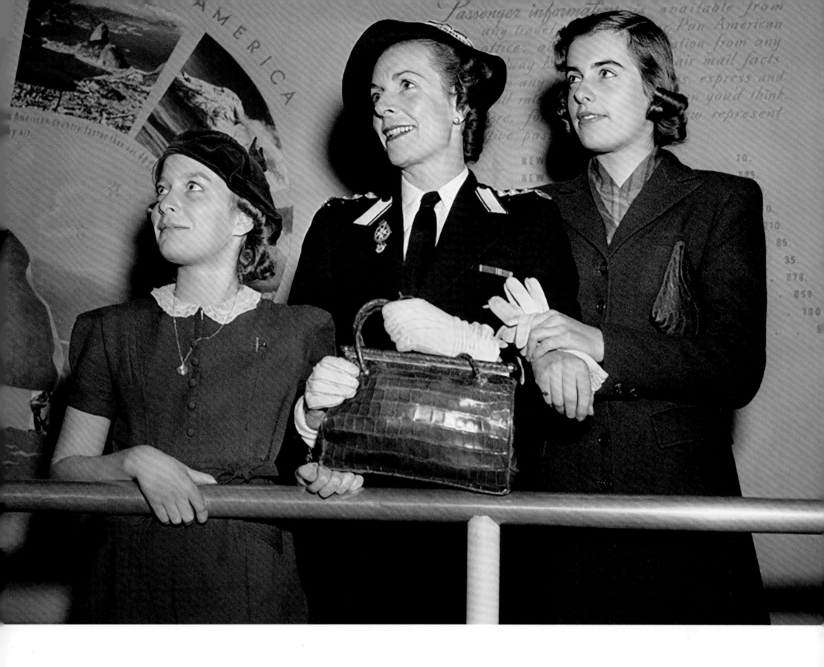

OPPOSITE: Homesick letters from my mother to her parents. ABOVE: Later, my mother was overjoyed to be allowed to return to England, traveling back with her mother, who had been on a speaking tour of the United States. Ostensibly the tour was a goodwill gesture to thank the American Red Cross for all their help. Her actual intention was to inform Americans about the war and what was really going on in Britain.

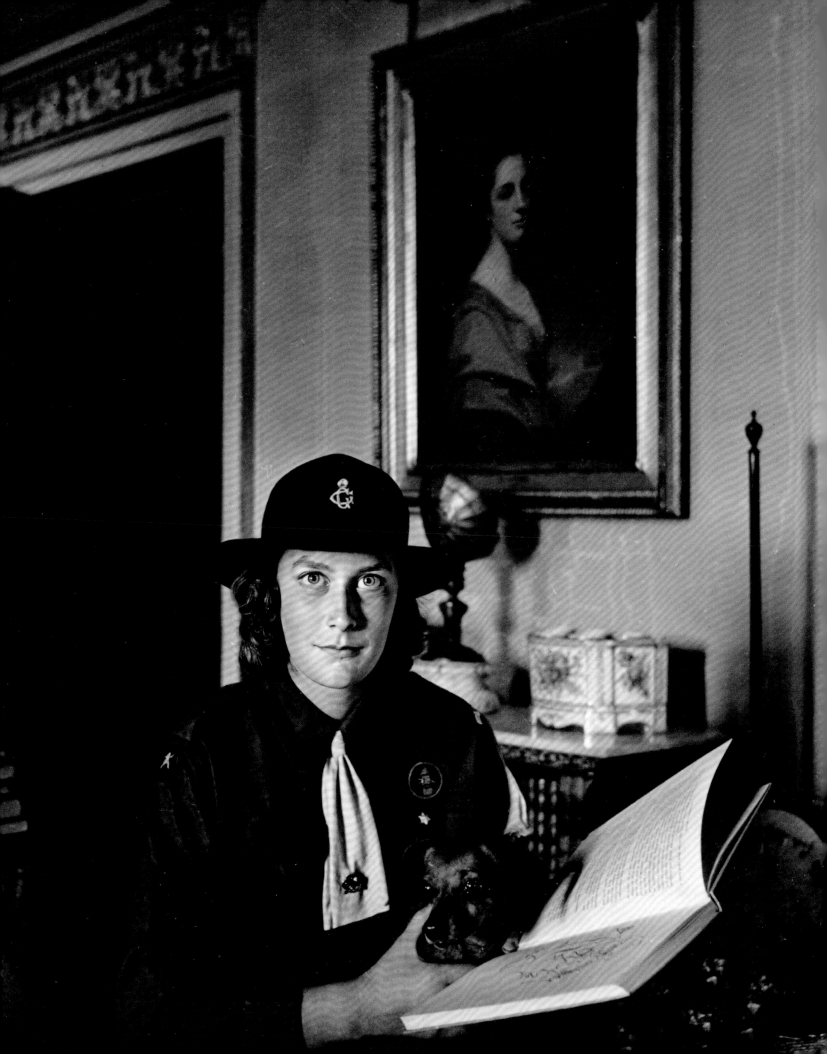

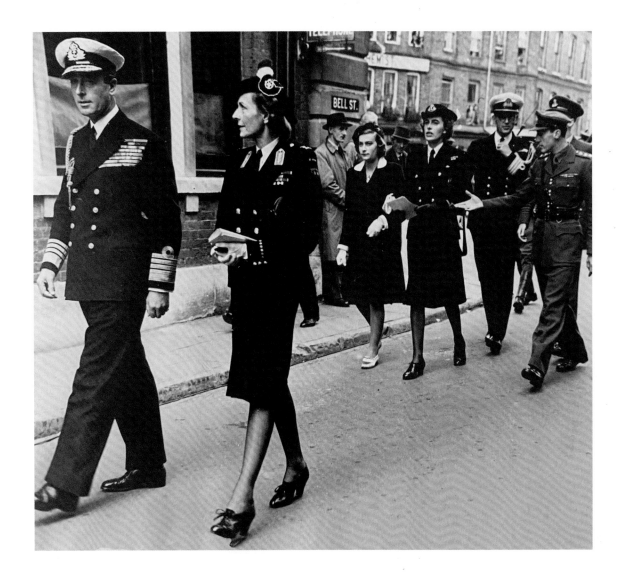

OPPOSITE AND ABOVE: Back home, it was impossible not to be aware of the loud drone of German bomb-ers returning from their missions over London; the bombers would jettison their unused bombs over the park at Broadlands before flying back across the English Channel. My grandmother was now superintendent-in-chief of the St. John Ambulance Brigade, the highest position a woman could hold, and for the first time in his naval ca-reer, my grandfather was neither at sea nor bound for it. As chief of combined operations he was a commodore, with a dazzling broad gold stripe on both his sleeves. On my aunt Patricia's return from America, she joined the Women's Royal Naval Service. My grandfather was thrilled to see his whole family in uniform, even if my mother's was only that of the Girl Guides.

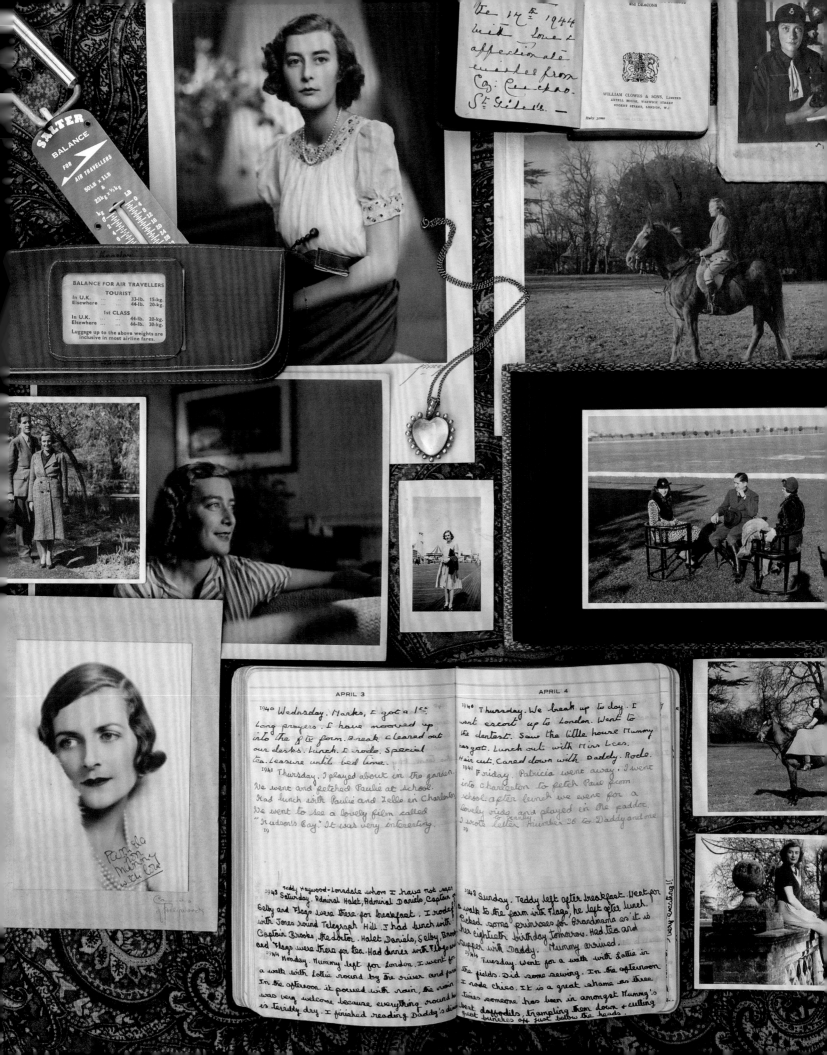

SALTER
BALANCE
FOR
AIR TRAVELLERS
50LB × 1LB
&
23kg × ½kg

BALANCE FOR AIR TRAVELLERS
TOURIST
In U.K. 33-lb. 15-kg.
Elsewhere 44-lb. 20-kg.
1st CLASS
In U.K. 44-lb. 20-kg.
Elsewhere 66-lb. 30-kg.
Luggage up to the above weights are inclusive in most airline fares.

WILLIAM CLOWES & SONS, Limited
AXTELL HOUSE, WARWICK STREET
REGENT STREET, LONDON, W.1

APRIL 3

1940 Wednesday. Marks, I got a 1st.
Long prayers. I have moved up
into the 6th form. Break cleared out
our desks. Lunch. I rode. Special
tea. Leisure until bed time.
1941 Thursday. I played about in the garden.
We went and fetched Paulie at school.
Had lunch with Paulie and Zelle in Charleston.
We went to see a lovely film called
"Hudson's Bay." It was very interesting.
19

1943 Teddy Haywood-Lonsdale whom I have not seen
Saturday. Admiral Halet, Admiral Daniels, Captain
Selby and Flags were there for breakfast. I rode
with Jones round Telegraph Hill. I had lunch with
Captain Brooks, the doctor. Halet, Daniels, Selby, Brooks
and Flags were there for tea. Had dinner with Flags and
1944 Monday. Mummy left for London. I went for
a walk with Lottie round by the cruiser and farm.
In the afternoon it poured with rain, the rain
was very welcome because everything around us
is terribly dry. I finished reading Daddy's diary

APRIL 4

1940 Thursday. We break up today. I
went escort up to London. Went to
the dentist. Saw the little house Mummy
has got. Lunch out with Mrs Lees.
Hair cut. Cared down with Daddy. Rode.
1941 Friday. Patricia went away. I went
into Charleston to fetch Paul from
school. after lunch we went for a
lovely ride and played in the paddock.
I wrote letter number 36 to Daddy and one
19

1943 Sunday. Teddy left after breakfast. Went for
a walk to the farm with Flags, he left after lunch.
Picked some primroses for Grandmama as it is
her eightieth birthday tomorrow. Had tea and
supper with Daddy. Mummy arrived.
1944 Tuesday. Went for a walk with Lottie in
the fields. Did some sewing. In the afternoon
I rode chico. It is a great shame as three
times someone has been in amongst Mummy's
best daffodils, trampling them down + cutting
great bunches off just below the heads.

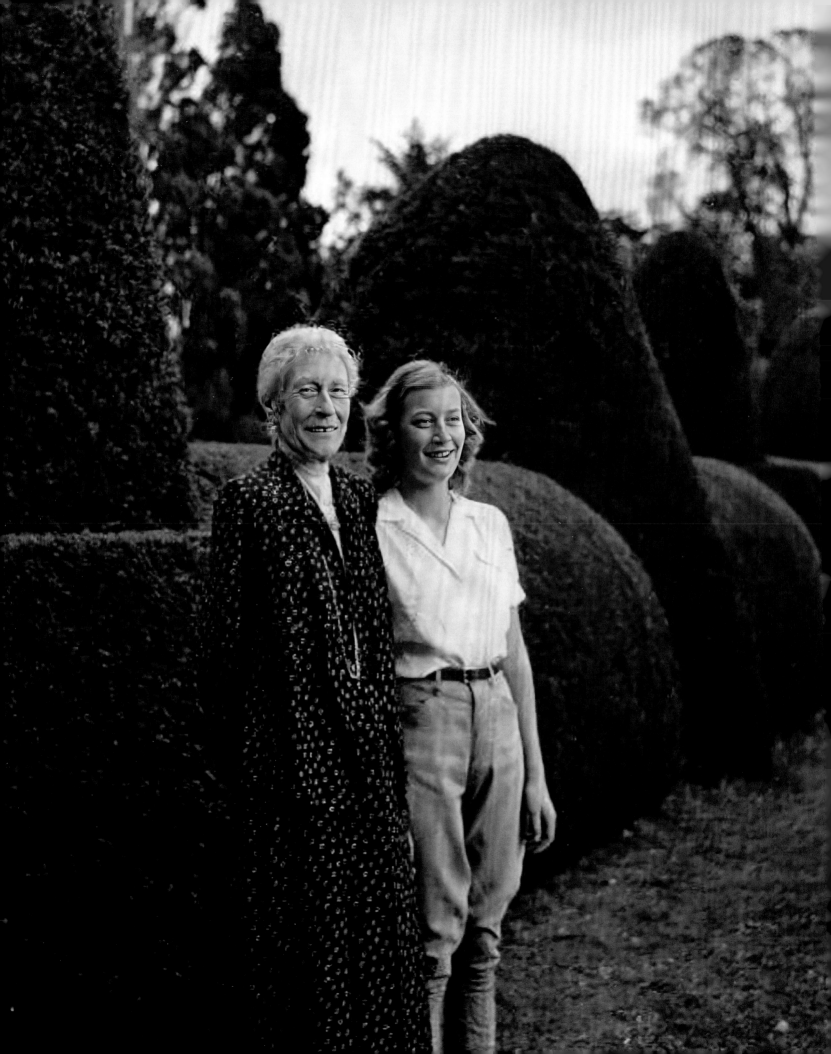

At the beginning of 1942 my grandmother was awarded the Commander of the Order of the British Empire (CBE) honor, my aunt became a full-fledged WREN (Women's Royal Naval Service), and my grandfather had to take a brief break as he contracted jaundice and pneumonia. Broadlands became even busier, expanding from being a home and a hospital annex to a training encampment for the U.S. troops of the 4th Infantry Division. The Americans were fun to have around, despite the imposition of watertight security that meant my great-grandmother was no longer able to visit.

For several months after the Americans arrived, the whole area around Broadlands and Southampton was closed to anyone not living or working there. The build-up of troops, the springing up of temporary camps, and the constant coming and going of military vehicles all contributed to a mighty expectation of some sort of maneuver. One early morning in June 1944, as quickly as they had arrived, the American soldiers left Broadlands en masse, leaving the patients, medical staff, and what remained of the household to wonder what was going on. The invasion of Europe had begun.

OPPOSITE: One afternoon when my mother was out riding, she watched two planes locked in a fight high above the Hampshire Downs; a few weeks later, a German Heinkel crashed on nearby Green Hill, killing all the crew. As soon as my mother's grandmother heard the news, she rushed out with the sole intention of taking the propeller and was terribly annoyed to find someone else had gotten there before her. My mother's grandmother did salvage several chunks of metal from an enemy plane that was shot down, which were mounted on silver boxes as tiny trophies for her granddaughters. PREVIOUS PAGES: They ran out of fuel at Broadlands and had to live without heat and hot water. They learned what to do in bombing raids, and their gas masks were tested from time to time. This was nothing, my grandparents would remind my mother, compared to the discomfort suffered by the troops.

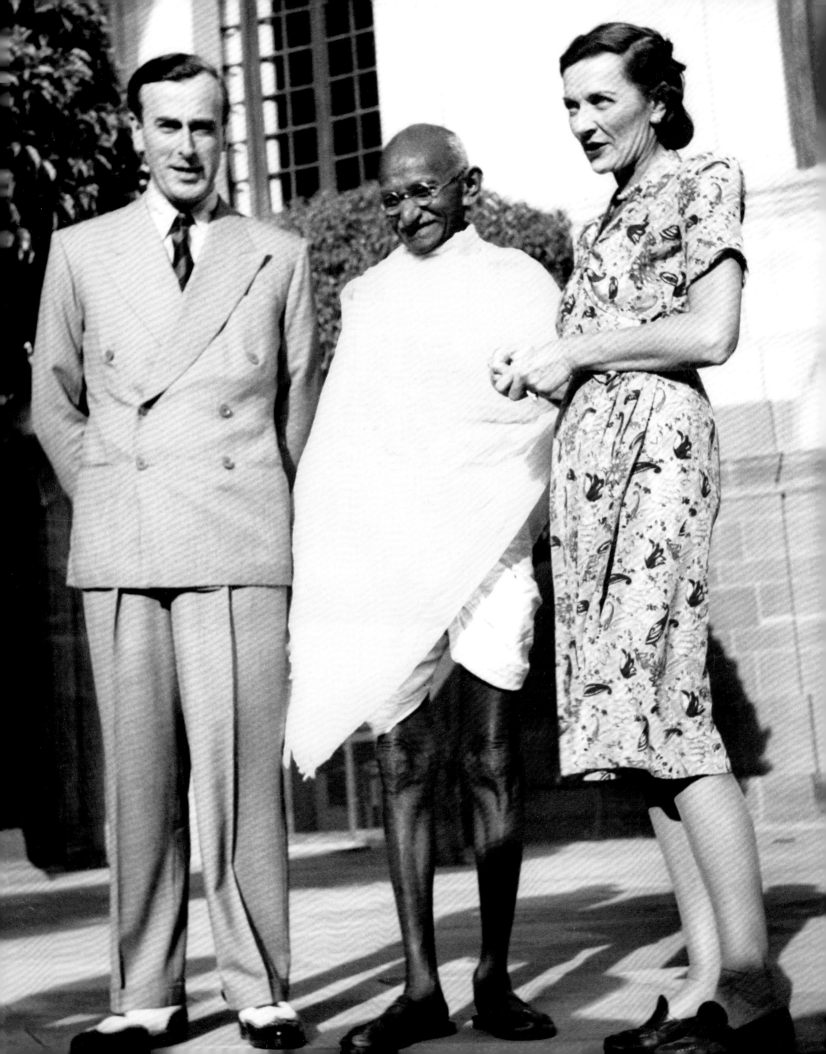

1947-48

India, Amid Turmoil and Change

My mother and her family all hoped that D-Day would be the end of the war, but on it dragged. She found herself particularly unsettled by the ongoing threat of being bombed, the V-1 "doodle bugs" (cruise missiles) menacing as they droned slowly above them. Getting to sleep was difficult.

My grandmother was offered an official posting to the South East Asia Command, an appointment welcomed most by my grandfather, who was in Burma trying to reverse the gains made by the Japanese. The journey was long and arduous. On the train from Calcutta to Rangoon, she wrote, it was so crowded in the carriage there was nowhere to sit or stand, so she swung herself up into the luggage rack and slept "surprisingly" well.

When the war in Europe finally came to an end, in May 1945, everyone else was out celebrating, but my mother lay in bed thinking about her parents. She was fifteen, and from the weekly war briefings at school she knew they were still in danger. My aunt was now a cipher officer in a secret underground establishment at Chatham and wasn't allowed home. My mother never thought of questioning her family's dedicated service

OPPOSITE: Gandhi on his first visit to Viceroy's House, standing between my grandparents.

and sense of duty, but alone with her grandmother in her apartment in Kensington Palace, or at school doing her exams, she was somewhat wistful of friends whose families had already been reunited.

When, a few months later, my grandfather took the surrender of the Japanese in Singapore, his priority was the repatriation of the British troops in Japanese prisoner-of-war camps. He was in need of someone to lead an expedition to assess the situation on the ground, and my grandmother agreed that she would do it. Accompanied by an Indian officer, an assistant from the First Aid Nursing Yeomanry, she set off on what was another incredible journey. The British had not yet reached the camps, so they had to be escorted by Japanese soldiers. She managed to gain their respect as they searched for the unmarked camps in which thousands of soldiers had endured horrific conditions. After weeks in the harshest environments and uncovering the most terrible of human suffering, she returned with the vital information my grandfather needed.

By the time of the Allied Victory Parade, on June 8, 1946, my mother, grandparents, and aunt were reunited. My mother had that year gained the highest marks in the school certificate exam at Miss Faunce's School, and her father, somewhat deflatingly for her, wired, "EXPECTED NOTHING LESS."

When they were back in Broadlands for Christmas later that year, she learned that my grandfather had been offered a new job. The new prime minister, Clement Attlee, wished my grandfather to succeed Lord Wavell as the viceroy of India, overseeing the transfer of power to an independent India. The process was to begin as soon as possible and be completed by June 1948.

My mother's grandmother was opposed to his accepting the role, believing he was being sacrificed to do the dirty work of politicians.

Early in the new year of 1947, out on their morning ride, my grandfather told my mother that she shouldn't go back to school; instead, she should accompany my grandparents to India. He needed her, he said, to get to know the student leaders who had been released from jail and wanted their voices heard. India, he told her, was a country on high alert, the people wanting independence more than ever. British rule was weakened

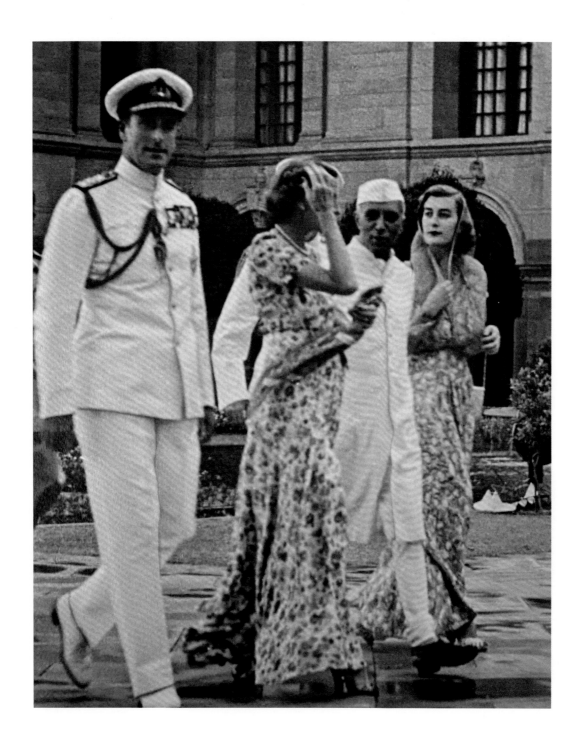

ABOVE: My grandfather walking with Nehru, my grandmother, and my mother. My grandfather's mother had been very opposed to his accepting the role of viceroy, believing he was being sacrificed to do the dirty work of the British politicians. FOLLOWING PAGES: A gathering of memorabilia from my mother's time in India during the transition of power, including photos snapped with a fortune teller, the Chinese delegation, standing at attention as the national anthem played, and a newspaper clipping showing Gandhi's arm resting on my grandmother's shoulder, which caused quite a stir *(left)*. My grandfather, as viceroy, inspecting the Guard of Honour *(right)*. PAGES 70 AND 71: My mother spent her crucial late teenage years in India, living among Muslims, Sikhs, Christians, and Buddhists. She never felt any division, although these were politically heavy times.

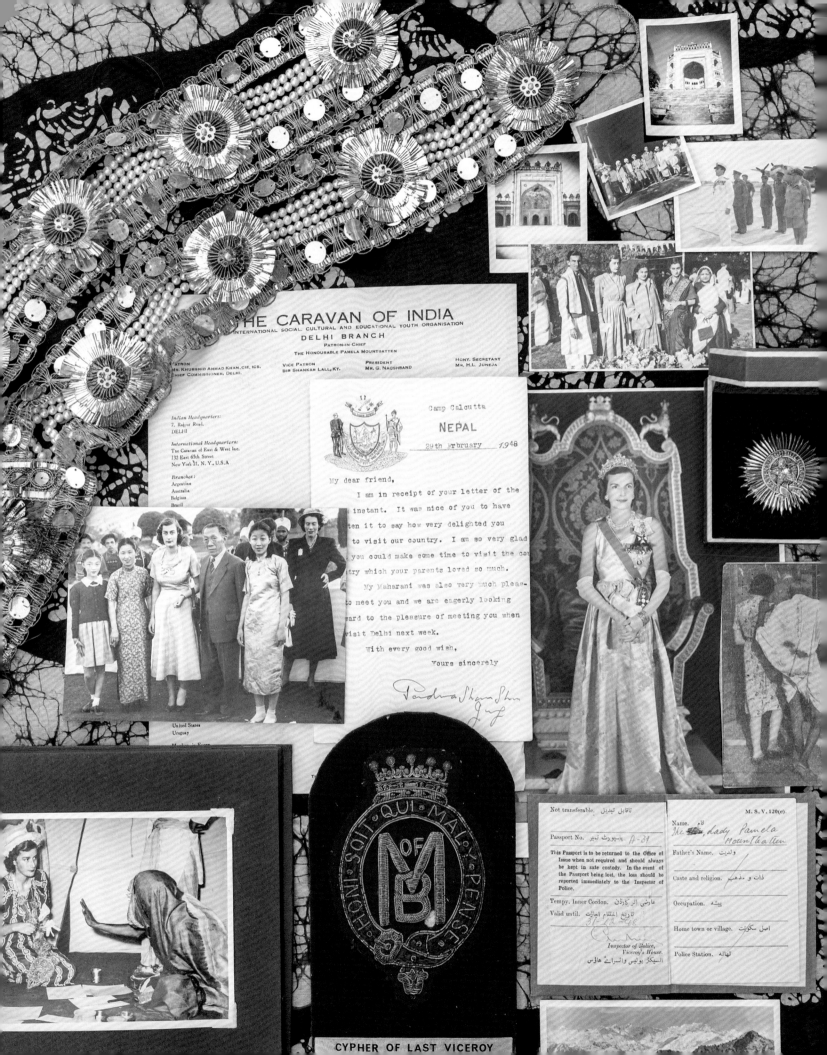

THE CARAVAN OF INDIA
INTERNATIONAL SOCIAL, CULTURAL AND EDUCATIONAL YOUTH ORGANISATION
DELHI BRANCH
PATRON-IN-CHIEF
The Honourable Pamela Mountbatten

PATRON
Mr. Khurshid Ahmad Khan, CIE, ICS,
Chief Commissioner, Delhi.

VICE PATRON
Sir Shankar Lall, Kt.

PRESIDENT
Mr. G. Naqshband

HGNY. SECRETARY
Mr. H.L. Juneja

Indian Headquarters:
7, Rajpur Road,
DELHI

International Headquarters:
The Caravan of East & West Inc.
132 East 65th Street
New York 21, N. Y., U.S.A

Branches:
Argentina
Australia
Belgium
Brazil

United States
Uruguay

Camp Calcutta

NEPAL

29th February 1948

My dear friend,

I am in receipt of your letter of the
instant. It was nice of you to have
written it to say how very delighted you
to visit our country. I am so very glad
you could make some time to visit the ca
try which your parents loved so much.

My Maharani was also very much pleas-
to meet you and we are eagerly looking
ward to the pleasure of meeting you when
visit Delhi next week.

With every good wish,

Yours sincerely

Padma Shamsher Jung

HON • SOIT • QUI • MAL • Y • PENSE

Not transferable.

Passport No. A-31

This Passport is to be returned to the Office of
Issue when not required and should always
be kept in safe custody. In the event of
the Passport being lost, the loss should be
reported immediately to the Inspector of
Police.

Tempy. Inner Cordon.

Valid until.

Inspector of Police,
Viceroy's House.

Name. The ~~Lady~~, Lady Pamela Mountbatten

Father's Name.

Caste and religion.

Occupation.

Home town or village.

Police Station.

CYPHER OF LAST VICEROY

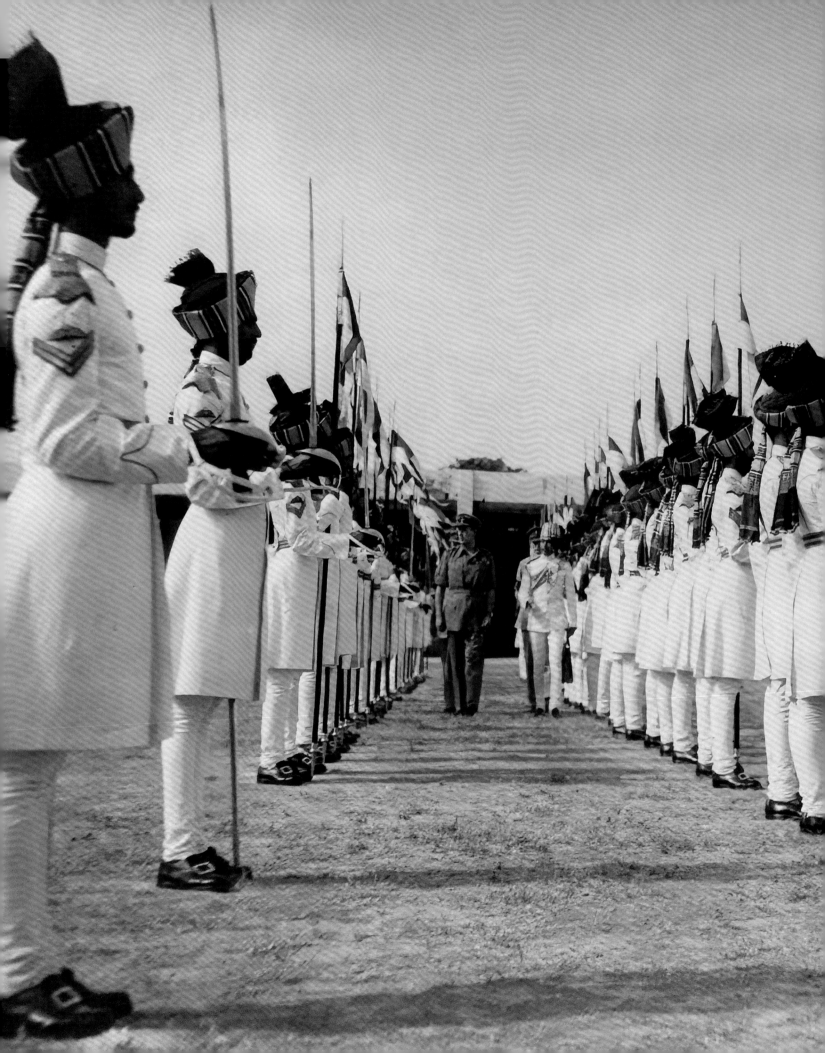

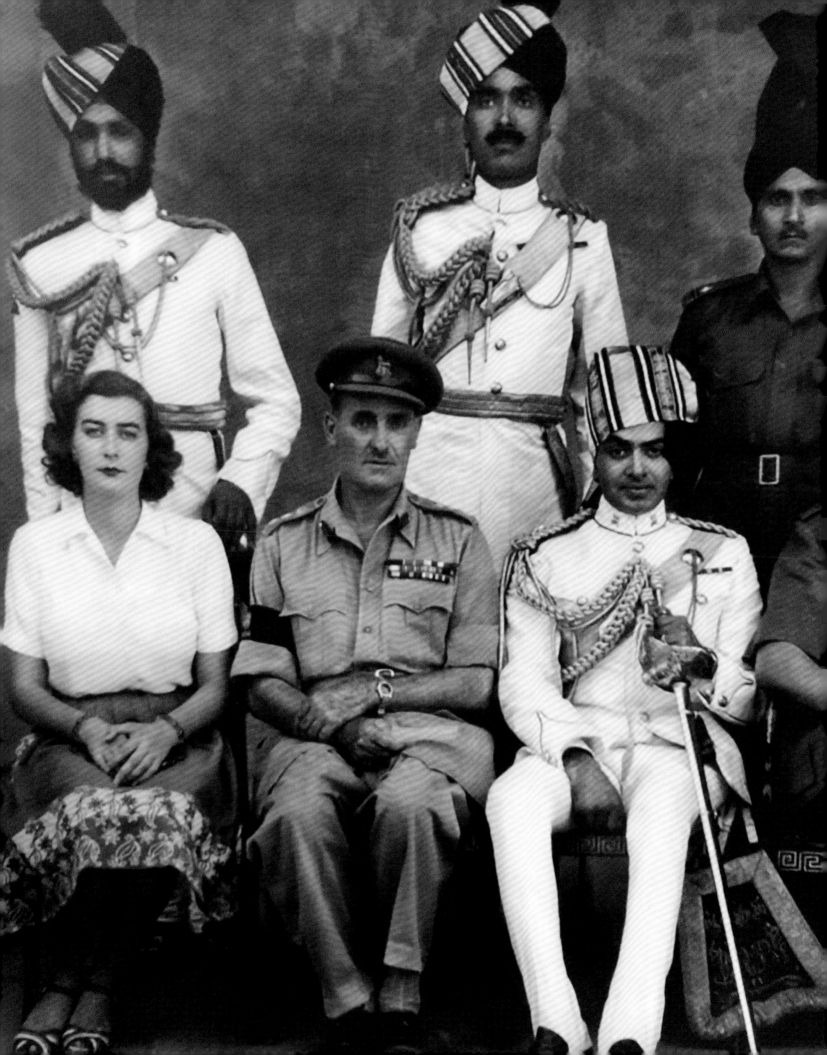

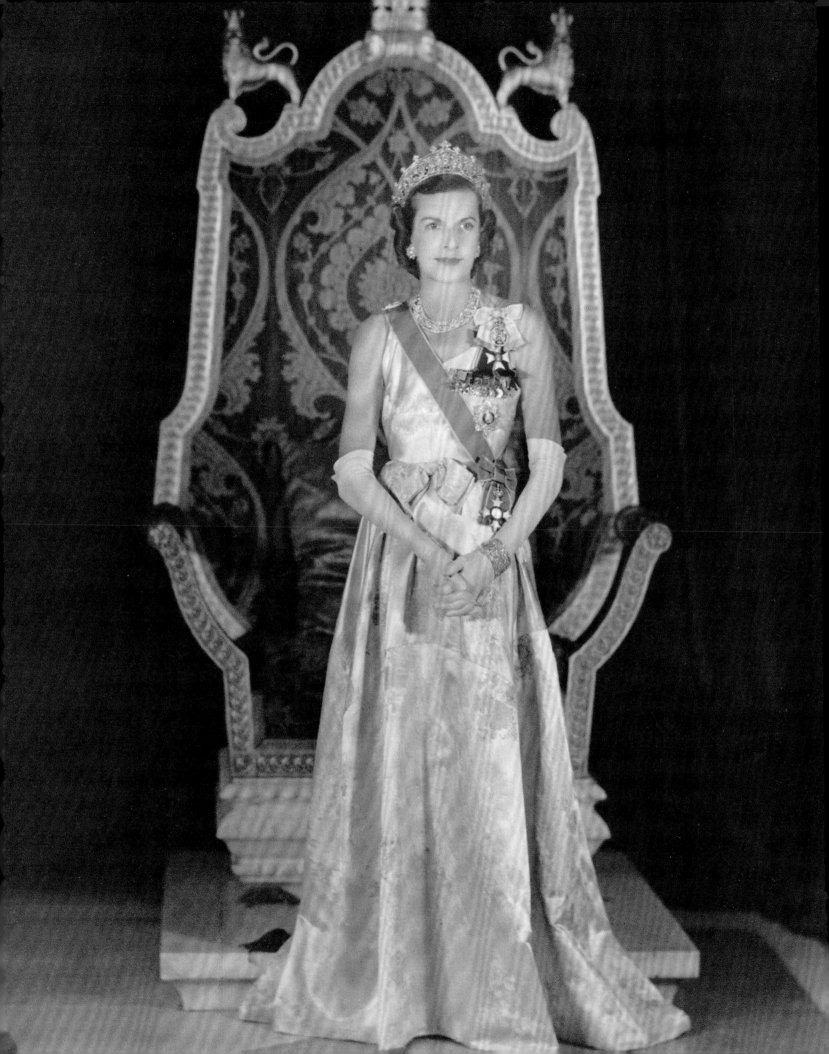

during the First World War, and Mahatma Gandhi, who came to be known as the Father of the Nation, tried to urge his country to seek independence via peaceful protest. But Muslims had been campaigning for their own sovereign state for over a decade. The situation reached a critical state following the Calcutta Killings of 1946, which left thousands of people—Muslim and Hindu—dead. Momentum to see the British out of India was continuing to gather, and after further riots and more calls for a Muslim nation to be created, it was decided that Indian independence could no longer be delayed. Unlike their predecessors at Viceroy's House in Delhi, my grandfather told my mother they were not there to bolster the pillars of empire but to pull them down.

They had a month in which to get ready for their trip to India, and it was all hands on deck. My mother and grandmother dashed around trying to find clothes fit for a vicereine and her daughter but, even allowing for some extras they'd been allocated, the wartime clothing coupons didn't stretch that far. They ended up getting some alterations to existing dresses, which felt new, as they hadn't worn anything even vaguely glamorous throughout the war.

On March 20, 1947, as ready as they could ever be, my mother and her parents drove to the Northolt airport in a car packed with bags and dogs. My mother was conscious that she was leaving behind a life perhaps more suitable to a seventeen-year-old like herself, but ironically, she was about to spend more time with her parents than she ever had.

India was tense, fractious, and still reeling from the horror of the Calcutta Killings; the renewed calls for independence were getting louder. My grandparents' swearing-in ceremony, which took place at Delhi's Durbar Hall, was short. After all, they were there

PREVIOUS PAGES: The official portrait of my grandmother as vicereine of India. She had met a fortune teller at a ball in the 1930s, and the mystic told her she would one day be sitting on the throne, "not an ordinary throne but a real throne nonetheless." At the time my grandmother had characteristically dismissed it as "absolute bunkum! *(left)*" Viceroy's House, Delhi *(right)*. OPPOSITE: Standing on the steps of Government House, my mother and grandmother share some wonderful joke with Nehru.

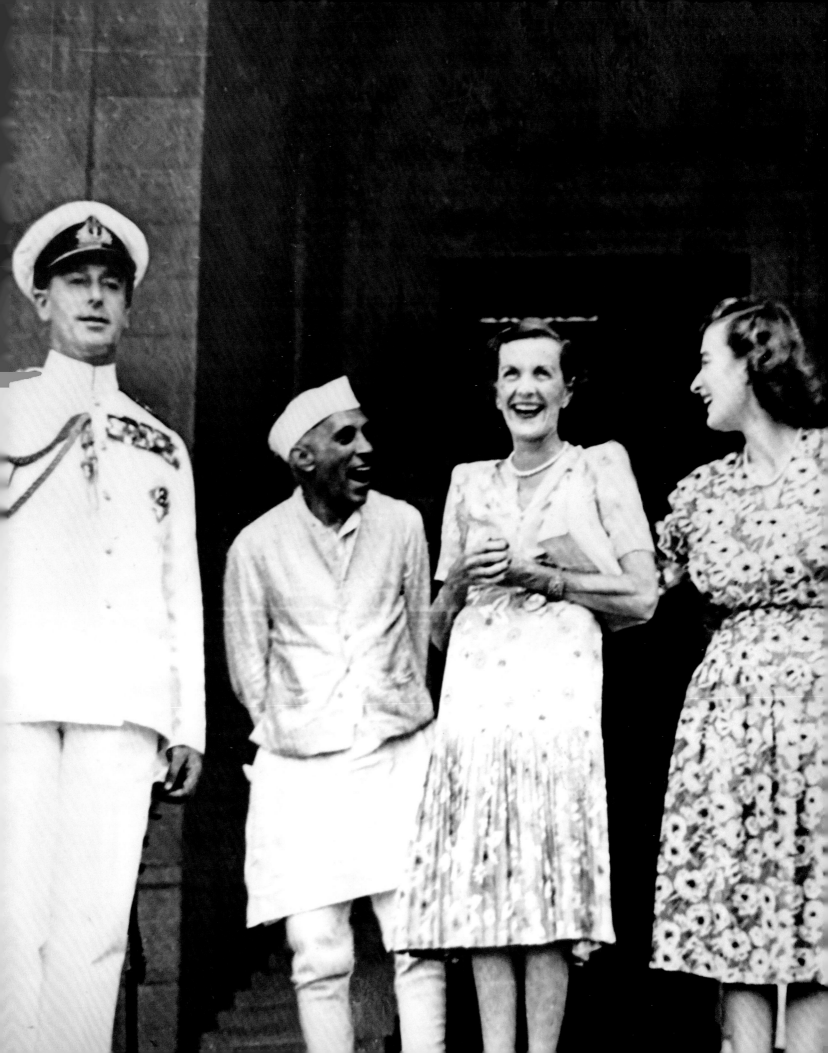

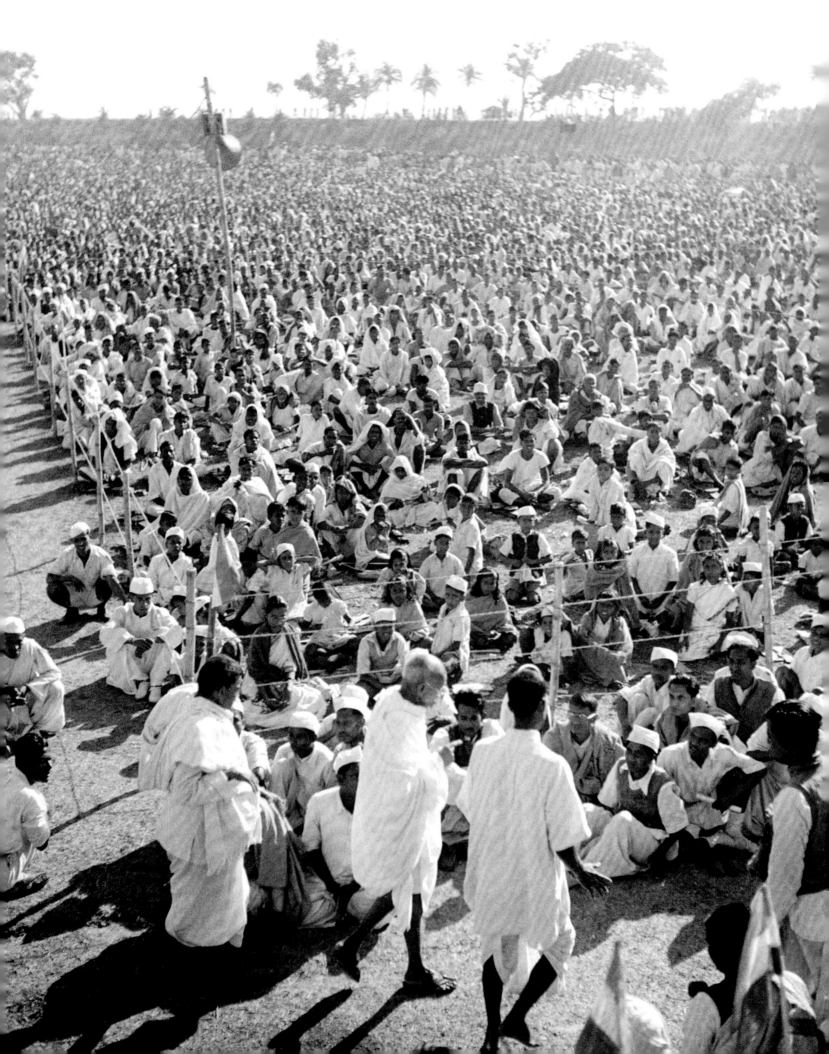

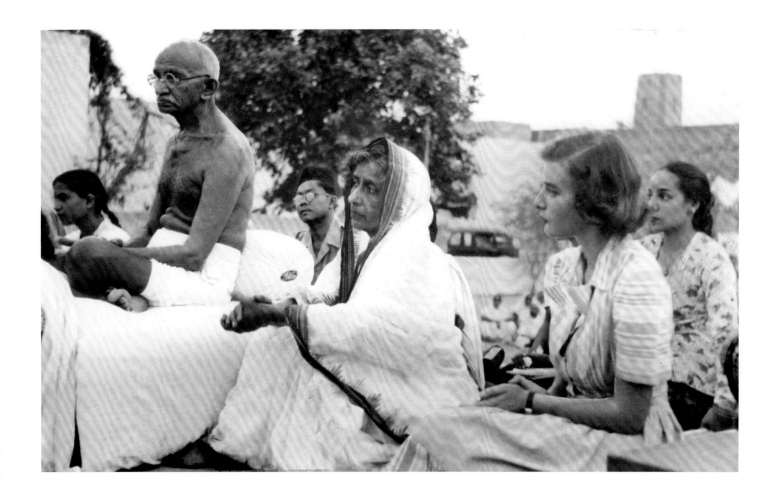

OPPOSITE AND ABOVE: My mother attending one of Gandhi's prayer meetings in Bhangi Colony. The thousands of people in attendance fell silent as soon as he appeared. After Gandhi read a verse from the Koran, sang both an Arabic and a Christian hymn, and called for a two-minute silence, he spoke in Hindi for forty minutes. The crowd was silent and unmoving the entire time. My mother knew she was part of something singular and historic.

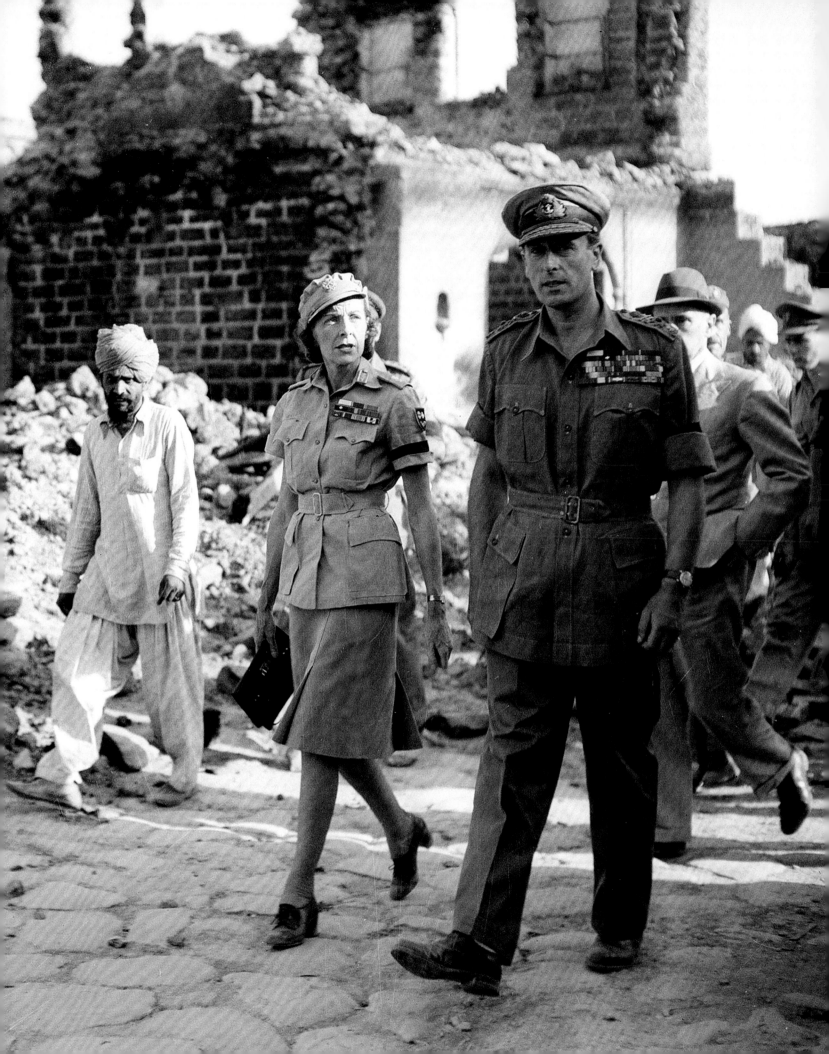

to oversee the end of British rule and the beginning of self-rule. My mother sat watching them, her father in his full white naval uniform and her mother in a long, white column dress. The photographers' bulbs flashed nonstop as they took their places on their "thrones," and my mother remembered a story Yola, my grandfather's friend, told her, about a reading my grandmother had with a fortune teller at a ball in the 1930s. The mystic told her she would one day be sitting on a throne, "not an ordinary throne, but a real throne nonetheless." At the time, my grandmother had characteristically dismissed it as "absolute bunkum."

The heat in Delhi was unlike anything they had ever experienced; often it was unbearable, especially as they were arriving from the coldest winter on record in England to the hottest weather India had experienced in seventy-five years. However, the early mornings were reasonably fresh, so my mother and grandfather were able to continue their early morning routine of riding together, now on the ridge above Delhi. At first they were accompanied by an entire cavalcade of ADCs (aides-de-camp) and police. But my grandfather thought that level of protection was ridiculous and after that they took only two policemen with them.

Arriving back at Viceroy's House, my grandfather would go straight to work and my mother would prepare for the day ahead. She met with students from Lady Irwin College, all in their late teens like her, and by asking questions and listening carefully to the discussions ignited by their answers, she began to understand more about how directly and deeply religion affected politics. They were a mixed group of Muslims, Hindus, Christians, Sikhs, and Buddhists and my mother particularly enjoyed how they all worked to understand each other.

My mother also started working in the Allied Forces Canteen as well as a clinic and dispensary set up in a huge tent just outside Delhi. There wasn't time to give her any training, as the clinic was always so busy. People from the surrounding villages lined up

OPPOSITE: My grandparents witnessing the riot devastation in the Punjab. A letter arrived from the British prime minister, Clement Attlee, around the same time. "I am very conscious that I put you in to bat on a very sticky wicket to pull the game out of the fire," he wrote.

from early morning until late at night, seeking help for everything from cuts and bruises to smallpox and TB. She had to learn fast, and because the male doctors could not examine the Muslim women, she was given the job—with the women's permission—of examining them and describing what she could see.

She was also asked to take on more public roles. Of course, she had seen her parents carry out endless public duties so she knew what to expect, although she was amused to read an interview of Princess Elizabeth in *Life* magazine about the time when her parents, the king and queen, visited her while she was training as a mechanic at Aldershot in 1944. "I never knew there was so much advance preparation for a royal visit," she told the writer. "I'll know another time."

Meanwhile, the important and serious business of effecting the handover of power was happening at pace, a constant stream of political leaders, princes, and maharajahs coming in and out of Viceroy's House. One unforgettable morning, my grandfather introduced my mother to Mahatma Gandhi before they headed into his office for their meeting. As they walked through the house, several members of the household fell to the floor in Gandhi's honor, and a crowd of well-wishers remained outside the house for the duration of his visit.

Jawaharlal Nehru, the leader of the Congress Party, also came, a most eloquent and gentle man. My mother was struck immediately by his impeccable attire, a white button-down tunic with the famous Nehru collar and always a rosebud in his buttonhole. He was tremendously charismatic, quick to laugh or make her laugh. Later, when they were up in the hills of Shimla, he gave them all a yoga demonstration, turning effortlessly onto his head and beaming at them from upside down.

My grandfather gave my mother a pet mongoose, Neola. She fell in love with Neola immediately, although he was rather a menace, rearing up at every corner as if he were about to tackle a great beast and biting any man who tried to touch him. But he seemed to like my mother, and after a while she had trained him to ride on her shoulder as she

OPPOSITE: The last of the viceroys.

LAST OF THE
VICEROYS

walked about the house. He was less biddable with my grandfather, and at breakfast would leap onto his lap and try to steal his eggs. Nehru told my mother that in India, mongooses were popular companions for prisoners, something he had witnessed himself during his own long years of incarceration. When she said how awful that must have been for him, he simply said that it had allowed him precious time for reflection and writing.

After Gandhi and Nehru met with my grandfather, their colleague Vallabhbhai Patel (known as Sardar Patel), a tough pragmatic and a good antidote to them, came. He was followed by Muhammad Ali Jinnah, president of the All-India Muslim League. What became clear after meeting all four was that a divided India was more likely than ever. The wheels started turning faster, and a referendum was taken in the North-West Frontier Province to see whether its people wanted to join India or not. There was also a need for a commission to determine the boundaries of the provinces of Assam, Punjab, and Bengal. And there would need to be talks with all the leaders of the 565 princely states, most of them princes and maharajahs who had seen their power decline during British rule, but who still held great sway over their people. Talks went on behind closed doors for days. From time to time, someone would emerge looking dazed or determined or both. The world's eyes were on India, and there was a huge crowd of media camped outside Viceroy's House.

On June 4, 1947, my grandfather gave the first press conference ever by a viceroy. He explained to the crowd and all the cameras that due to the complete and constant disagreement, it had not been possible to make plans for a united India. Two self-governing states, India and Pakistan, would now be formed. Much to the surprise of everyone, the date for partition was set for August 15, little more than two months away.

Almost immediately, Viceroy's House became a place of frenzy. My grandfather had a calendar made that counted down the days and distributed copies around the offices. The arguing between the Indian Congress Party and the Muslim League went on, and disagreements over boundaries and who would set them continued to flare up. My mother was still working at the canteen and the clinic, where news of partition was the only subject of conversation.

Not long after the date for partition had been set, my mother went to one of Gandhi's prayer meetings. His room was tiny, and he greeted her from the floor where he sat cross-legged. He asked about Princess Elizabeth's engagement to Philip, news of which had traveled like wildfire around the world. After taking time to show her one of his few remaining possessions—a small ivory carving of the three wise monkeys—he walked outside to thousands of people, who fell silent as soon he appeared. He read a verse from the Koran, sang an Arabic hymn, then a Christian one, and called for two minutes of silence. No one moved the whole time. When that was over, Gandhi spoke in Hindi for forty minutes, and still no one moved. My mother felt with absolute certainty that she was part of something extraordinary.

A few days later she also benefited from Gandhi's kindness and compassion. She had been riding sidesaddle on a new horse when out with her parents on the ridge. Her horse shied suddenly when a peacock landed close by, and she was thrown to the ground and knocked unconscious. Carried home bruised and concussed and told by the doctor to stay in bed for a few days, she was left feeling miserable, but her spirits were lifted when she received a get-well message from Gandhiji, as my mother knew him, endearingly addressed to his "naughty friend."

Independence Day arrived and with it, an outpouring of human joy. The noise of the people cheering and celebrating rang through India. During the ceremony in the Durbar Hall, her father read out a message from the king and made his own speech, which resulted in more joyful cheering. Afterward they headed to the flag salutation ceremony at Princess Park and heard cries of "Pandit Mountbatten, ki jai!" and "Lady Mountbatten, jai Hind!" There was even the occasional "Mountbatten Miss Sahib!" and "Miss Pamela!" Celebrations continued throughout the day, and later that night they gave a dinner party at what was now no longer Viceroy House but the Governor-General's House. Fireworks and illuminations lit up the night sky, and my mother went to bed that night aware that she had witnessed the birth of two new nations, and history in the making.

But any hope of that bright future was some way off. Now divided by religion, the Punjab region was in total crisis and a mass hysteria gripped the nation as millions of people, formerly neighbors but now refugees, began moving in opposite directions

... went to the ceremony at the Constit-
...et Assembly and Mummy and Daddy
...drove back in State in open cars with
...the Jinnahs. I drove with Begum
...Liaquat and there were quite thick
crowds and cries of "Quaed-e-Azam
Zindabad" and "Mountbatten Zindabad".
Immediately afterwards we flew
back to Delhi in order to be in time
... for the "Midnight mysteries"! Tomorrow,
... being in itself an inauspicious day
... we have to have part of the
... ceremonies at midnight. Therefore,
... Panditji and Rajendra Prasad came
... after the meeting of the Assembly to
... ask Daddy to accept the Governor-
... Generalship. We toasted the

Mummy and Daddy drove in
Carriage and with the Body-
the ceremony in the Consti-
after the Swearing-In C...
the Durbar Hall where
sworn in by the new
and then himself
of the Cabinet in.
be read the me...
Dominion of Ind...
then addressed
President, Raj...
messages f...
also gave...
could not
some tim...

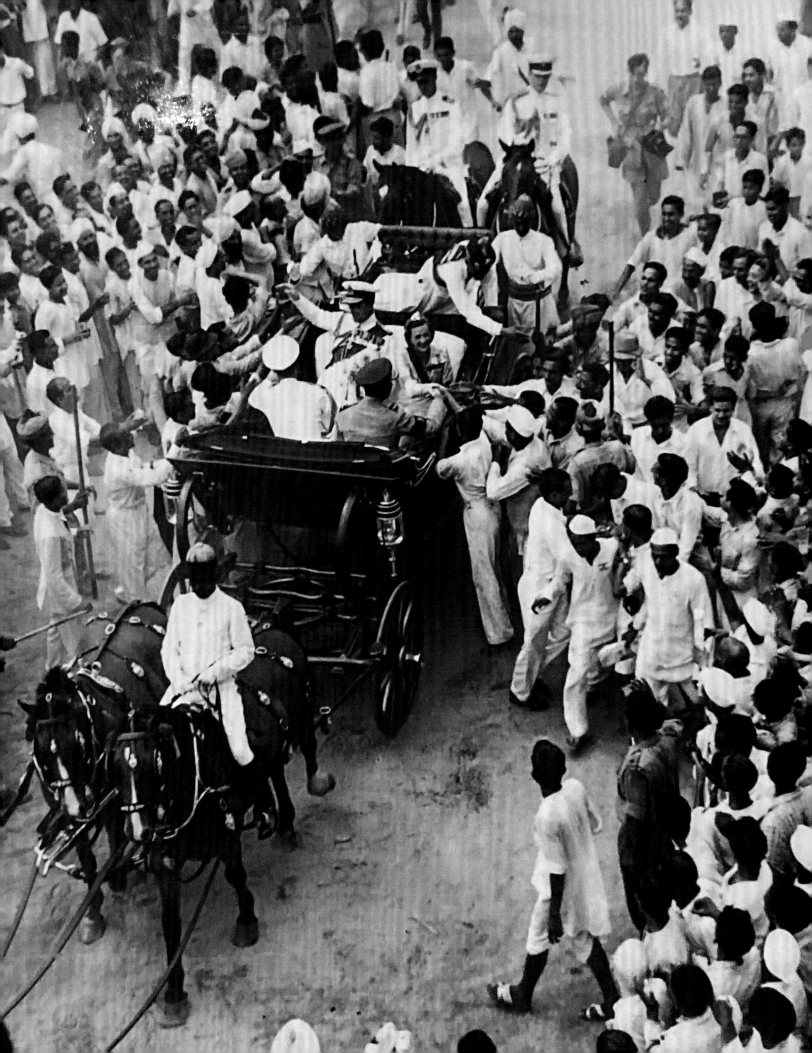

toward their new countries, all using the same roads. This was a mass migration of a great many people. It was unfathomable and heartbreaking to think that for centuries many of these people had lived peacefully alongside one another.

During this time, my mother witnessed my grandmother's capacity for crisis management. After an initial visit to Punjab, where my grandmother found horrific scenes, she decided she would visit other regions and witness the atrocities so that she could report back to my grandfather and Nehru. There were times during that period when her reports were so terrible that they feared for her safety. Her office went into overdrive trying to keep women safe. Stories of massacre and murder were everywhere. It was difficult to comprehend the destruction and loss of life. Delhi was in turmoil, the streets littered with fires and corpses. It was so unsafe that my mother was no longer allowed to go to the clinic or the canteen. But her own mother's bravery and stamina continued to astonish her. During one visit to Punjab, my grandmother's plane landed and was met by an angry mob shouting war cries. Instead of remaining in the safety of her airplane, my grandmother forbade her aides to follow and made the incredible move of walking toward the screaming crowd with her arms open. To everyone's astonishment, they sheathed their weapons and held their arms out, too. It was an extraordinary moment, described by the aide-de-camp who accompanied her as one in which love visibly overcame anger. The leaders and my grandmother hugged and then she moved through the crowd to the refugee camp she had come to visit. She had a job to do and she got on with doing it. In fact, her reputation began to precede her. When cholera broke out in the refugee camps in Amritsar in the middle of that September, my grandparents flew out immediately to survey the movement of refugees in Punjab. A translator who traveled with them later reported how my grandmother was mobbed

PREVIOUS PAGES: My mother's meticulous diary keeping gives us insight into that historic Independence Day, when the king emperor was toasted for the last time, drinking the viceroy out and the governor-general in (my grandfather was invited to stay on and became the governor-general) *(left)*. When they were returning from the flag raising ceremony, enthusiastic crowds rushed forward in excitement to shake hands with the departing viceroy and vicereine. India was now independent *(right)*. OPPOSITE: My mother says it was terribly emotional when the time came for them to return to England. As they got into the carriage and were about to drive away with a mounted bodyguard, one of the horses jibbed and someone called out, "Even the horses won't let you go."

wherever she went—it was well known among the refugees that soon after a visit from Lady Mountbatten, help would be close at hand. "You have brought solace, you have brought hope and encouragement," wrote Nehru in a letter to my grandmother. "Is it surprising, therefore, that the people of India should love you and look up to you as one of themselves?"

In the midst of all the devastation, my mother received a sweet letter from Princess Elizabeth, asking her to be a bridesmaid at her forthcoming wedding. With all the turbulence in India, the wedding seemed incongruous and unreal to her, and she felt sure they would not be able to get away and leave the troubled situation behind them.

But Nehru persuaded my grandparents that they should all go to the wedding, in order not to draw any more of the world's attention to the continuing crisis. And so, on November 9, 1947, in spite of their great anxiety about leaving India, they flew to London for a royal wedding.

OPPOSITE: The family with the staff of Viceroy's House. My mother was horrified when she was told she would have a bearer to help her. Apparently, it was out of the question to refuse. The bearer, Lila Nand, and my mother became the greatest of friends. To begin with he was very disappointed in her but by the end she says he had trained her quite well!

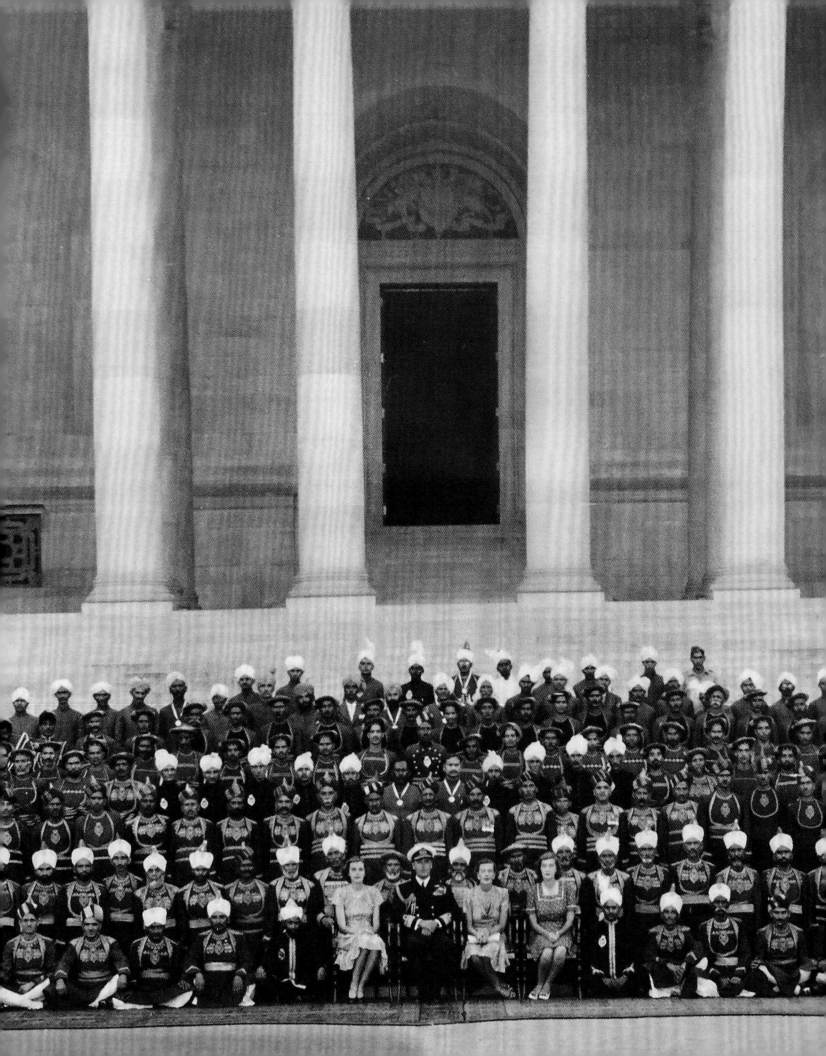

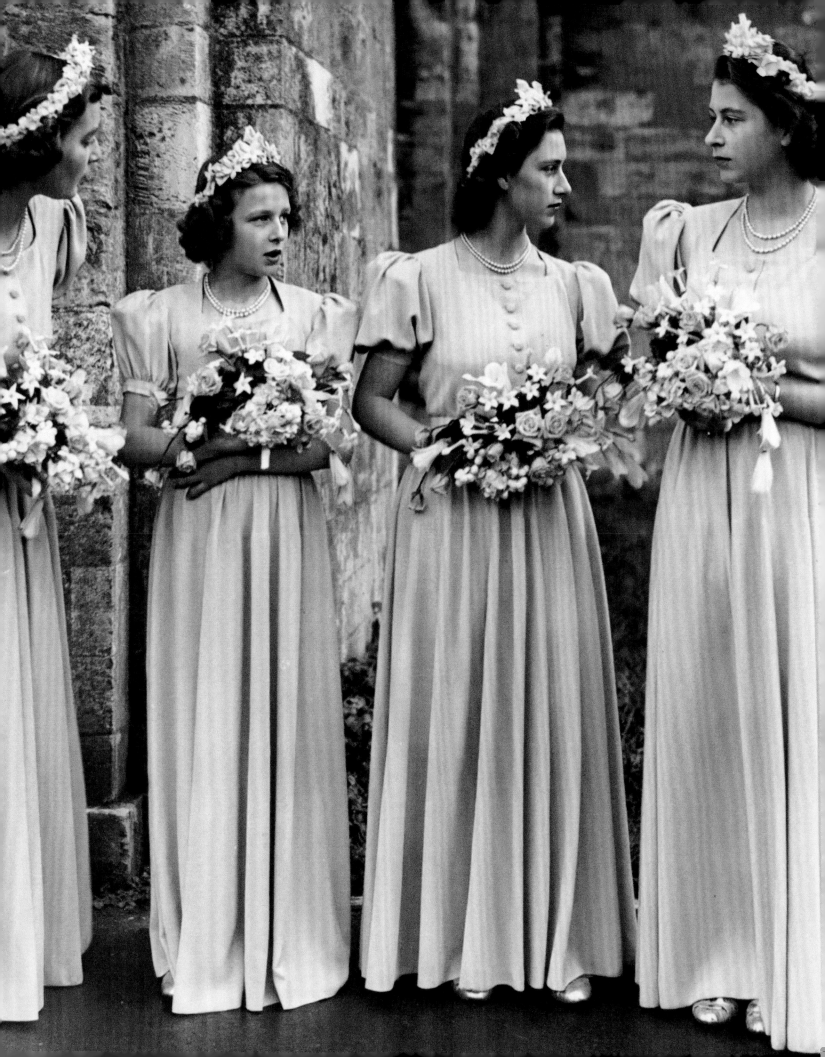

1947

ALL THE NICE GIRLS LOVE A SAILOR

It was in 1946 at Aunt Patricia's wedding to my future uncle, John Brabourne, a year before the royal wedding, that the world first spied the romance blossoming between Princess Elizabeth and Lieutenant Philip Mountbatten. While waiting at the entrance of the church for the bride to arrive, Princess Elizabeth handed Prince Philip her fur coat to hold during the ceremony, and the intimacy of that gesture was captured by the cameras. And that was all it took. Everyone was now in on the secret.

Of course, my mother's family had all known for some time that Princess Elizabeth and Prince Philip were in love. Prince Philip was my mother's first cousin, and my grandfather treated him like a son. Prince Philip's mother, Alice, was absent for much of his childhood, as she suffered from schizophrenia. Having been born at Windsor Castle in the presence of her great-grandmother, Queen Victoria, she was diagnosed with congenital deafness as a child. She nevertheless learned to lip-read in multiple languages and grew up to be very beautiful, known affectionately as "the great beauty of Darmstadt." She married Prince Andrew of Greece and Denmark. After years of being in a sanatorium, she devoted the rest of her life to charity work in Greece, where she

OPPOSITE: *(from left)* My mother, Princess Alexandra, Princess Margaret, and Princess Elizabeth at my aunt Patricia's wedding in 1946. As head bridesmaid, my mother found it somewhat intimidating to be the boss.

founded a Greek Orthodox order of nuns. Sadly, the order folded due to lack of suitable applicants, but Alice continued to wear a long gray and white dress and wimple in the style of a nun's habit for most of her life. She also smoked like a chimney and loved to play card games, especially canasta, habits that always seemed rather comically at odds with her devout religious beliefs, and yet which also personified her defiant spirit.

When my mother was in her twenties, she stayed with Princess Alice in Athens, along with her cousin Mary Anna, from her mother's side. Princess Alice was quite formal, and even though her apartment was very small, the girls felt they should curtsy to her whenever she came into the room. This was mostly fine if they stood one behind the other, but in the tiny bedroom they had to stand on the bed when they weren't asleep, and if Princess Alice came in and they were standing on it, they had to curtsy deep into the mattress, holding on to each other to stop from falling off.

With his Greek father exiled and living in Paris and his mother unwell, Prince Philip had spent a lot of his younger years moving from one place to another, often staying with my grandparents either at Broadlands or in Malta. Having no parents to live with and an expired princedom to a country that didn't want him, and with his sisters all married off to Germans, he was something of a royal problem. His lineage was impeccable, but his lack of fixed abode posed rather a challenge. In fact, he often wrote NO FIXED ABODE next to his name in guest books.

It was touching that Prince Philip found safety and direction in my grandfather's guidance, and the formidable grandmother, Princess Victoria, that he shared with my mother. He was eight years older than my mother and largely uninterested in his younger cousin, but she adored him. He also happened to be extremely dashing, with a great sense of fun and a sharp wit, which made him all the more attractive.

OPPOSITE: The bride, my aunt, radiant in a dress of gold Indian brocade with long medieval sleeves and a veil incorporating tulle her own mother had worn and lace belonging to her husband's family, through which glistened the diamond and pearl tiara her grandmother had worn at the Russian court.

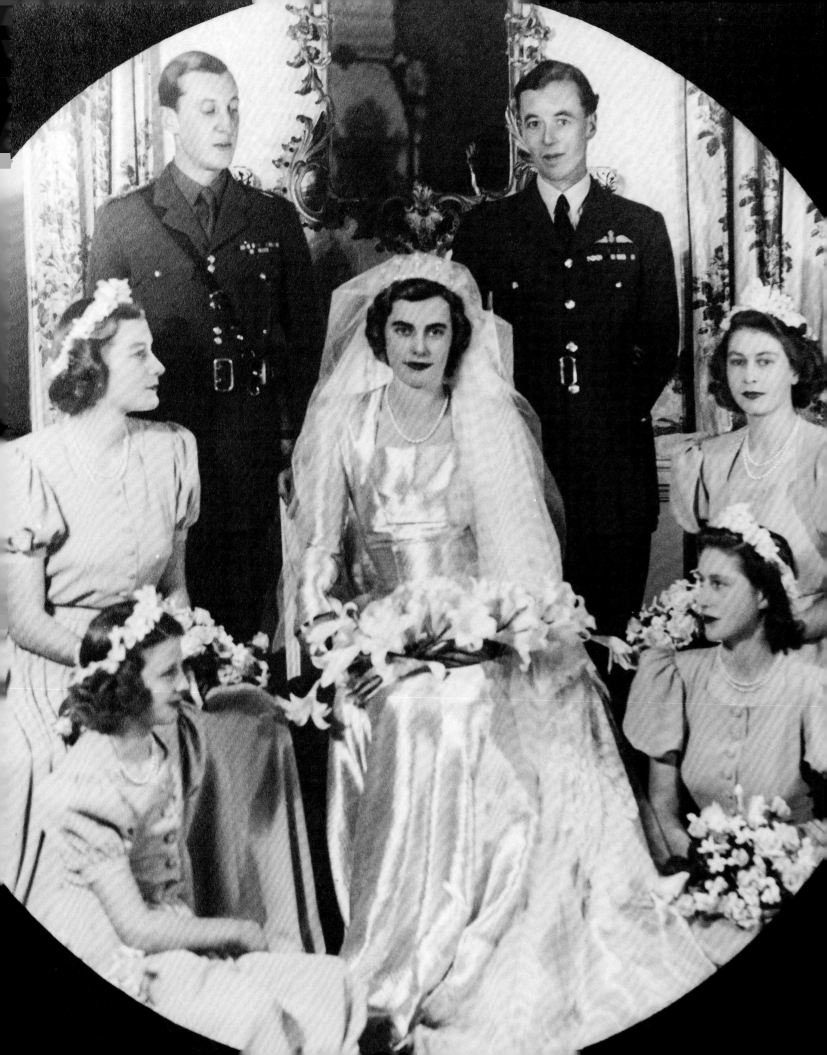

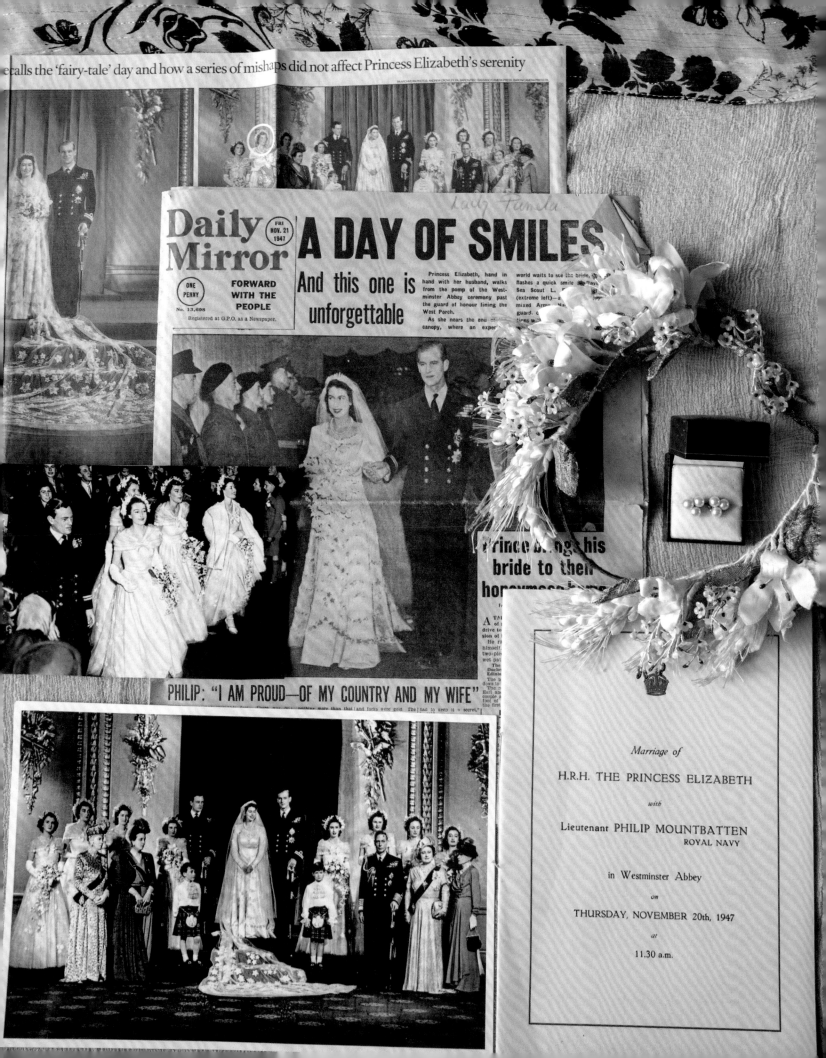

...calls the 'fairy-tale' day and how a series of mishaps did not affect Princess Elizabeth's serenity

Lady Pamela

Daily Mirror

FRI
NOV. 21
1947

ONE
PENNY

FORWARD
WITH THE
PEOPLE

No. 13,698

Registered at G.P.O. as a Newspaper.

A DAY OF SMILES

And this one is unforgettable

Princess Elizabeth, hand in hand with her husband, walks from the pomp of the Westminster Abbey ceremony past the guard of honour lining the West Porch.

As she nears the end of the canopy, where an expectant world waits to see the bride, she flashes a quick smile. Sea Scout L. (extreme left)—a mixed Army/Navy guard, cheers with the crowd.

Prince brings his bride to their honeymoon

PHILIP: "I AM PROUD—OF MY COUNTRY AND MY WIFE"

Marriage of

H.R.H. THE PRINCESS ELIZABETH

with

Lieutenant PHILIP MOUNTBATTEN
ROYAL NAVY

in Westminster Abbey

on

THURSDAY, NOVEMBER 20th, 1947

at

11.30 a.m.

Cam...

20th

The Hon.
Pamela Mountbatten
8. Government House New Delhi

BALMORAL CASTLE

Dear Pamela,
 I was so very
pleased to get your Telegram,
and I am delighted that you
are going to be a bridesmaid.
 I wondered if you would
send me your measurements
so that I could give them to
the dressmaker, as I imagine
won't be arriving in

PREVIOUS PAGES: Clippings and family photographs of Princess Elizabeth's wedding in 1947. Princess Elizabeth's wedding dress was inspired by Botticelli's painting *Primavera*, symbolizing spring, and it did seem to everyone gathered, and the nation watching, that there was a fresh sense of renewal and hope after so many years of war *(left)*. Princess Elizabeth's letter to my mother asking for her measurements, as my mother was not able to attend all the fittings since she was in India with her parents. The princess went on to describe the dresses, "White tulle with slight embroidery on the skirt, which matches the embroidery on my dress. It's very difficult to think of a dress that will be fairly warm on a November day" *(right)*. ABOVE: When Aunt Patricia telephoned my mother at school to let her know that she had accepted the proposal of marriage from John Brabourne, my mother experienced the strange sensation of great excitement coupled with deep despair. She couldn't believe that she was losing her sister just as her family was reunited, but her misery didn't last long. My uncle John could not have been kinder; soon my mother adored him as the brother she never had.

In 1946 he proposed to Princess Elizabeth. Protocol meant that the princess could not get married until she was twenty-one and so, it was only in the late spring of 1947 that their engagement was announced. Earlier that year, Prince Philip renounced his Greek royal title and became a naturalized British subject, taking the surname of his maternal grandmother, Mountbatten. On July 9 an official portrait was issued, and from their expressions, the press declared that this was clearly a marriage of choice, not of arrangement.

My mother's family had been delighted by Aunt Patricia's wedding, especially my grandfather, as Uncle John had been his ADC (aide-de-camp) and he was well accustomed to trusting him with the things that were most important in his life. And while, of course, their wedding day was on a far smaller scale than the anticipated royal wedding, it still seemed to ignite a kind of fever in the public. The thought of seeing Patricia Mountbatten and the royal princesses, and all those brave naval officers—including Prince Philip, who was an usher—at such close proximity seemed to grip the nation.

My grandfather, with his usual good grace and characteristic military precision, organized everything around his daughter's wedding. My grandmother seemed to see things a little differently, writing in her diary just ten days before the wedding, "Everyone's getting very overworked and rather cross," and, "'Operation Wedding' is closing in on us."

My mother was one of four bridesmaids, along with Princess Elizabeth, Princess Margaret, and Princess Alexandra of Kent. Afterward, when three hundred seventy family and friends came back to Broadlands for a wedding breakfast, having removed her glasses for the day my mother found she had difficulty recognizing anyone. At one point she mistook a very large man for her old headmistress, Miss Faunce. She was mortified when the archbishop of Canterbury assured her that the man she had just been talking to as if he were Miss Faunce, whoever he may have been, was a "fine rugger player."

For her own wedding, the following year, Princess Elizabeth chose eight bridesmaids, and by the time my mother arrived back in London from Delhi, the other seven had all attended several fittings. She could only manage two fittings in the ten days before the wedding, but the couturier, Norman Hartnell, and his team had sent for her measurements, and the dress fit her like the proverbial glove.

Princess Elizabeth's dress was nothing short of spectacular, all the more so because wartime rationing was still in full effect and, like everyone else, she had to use coupons to obtain fabric. The government did allow her two hundred extra ration coupons and, rather heartwarmingly, hundreds of women from across the country also sent her their own fabric coupons, as they were excited about the wedding and wanted her to have a beautiful dress. Unfortunately, the transfer of coupons was not permitted, and each one had to be returned to the sender.

As is customary, there were a reception and a ball the night before the wedding, and it was a marvelous opportunity to see so many European royals together after such a long period of separation during the war.

As with any wedding, there were a few hair-raising moments in the morning as the big moment got closer. Princess Elizabeth's tiara, given to her by Queen Mary, snapped and an aide had to be whisked off in a taxi to the jeweler's for a quick repair. And as if that wasn't enough drama, the pearl necklace that the princess wished to wear, which was a gift from her father, had been left on display along with all the other wedding presents at St. James's Palace.

Another aide, Lieutenant-Colonel Martin Charteris, was dispatched to retrieve the pearls. On his return, it was discovered that the princess's bouquet was nowhere to be seen. Once again, there was a lot of rushing around until it was found. Someone put it in a cupboard where they rightly thought it would remain cool—they just hadn't told anyone else. As it was handed to Princess Elizabeth, who remained exceptionally calm throughout, my mother noticed a lovely touch: reaching back through the generations, a sprig of myrtle had been added from the still-thriving bush grown by Queen Victoria's oldest daughter, the Princess Royal, which touchingly was to be laid on the Tomb of the Unknown Warrior after the wedding.

OPPOSITE: The wedding program of Princess Elizabeth and Prince Philip. Famously, Crown Princess Juliana of the Netherlands commented loudly, "Everyone's jewelry is so dirty." Most of the jewelry had only just come out of storage for the occasion; it's remarkable any of it survived the war.

Marriage of

H.R.H. THE PRINCESS ELIZABETH

with

Lieutenant PHILIP MOUNTBATTEN
ROYAL NAVY

in Westminster Abbey

on

THURSDAY, NOVEMBER 20th, 1947

at

11.30 a.m.

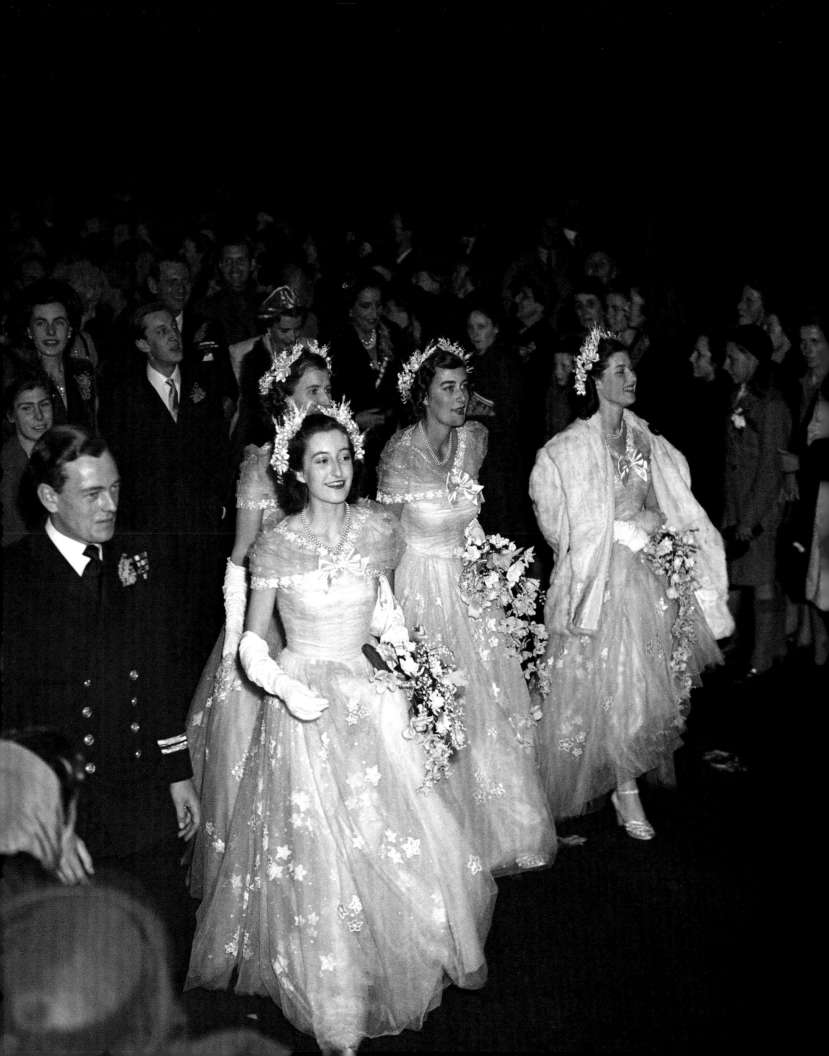

During the rehearsal, they had all been taught to walk slightly right to avoid treading on the Tomb of the Unknown Warrior, but of course as they set off, one of the little pages, Prince Michael of Kent, stepped right on it.

My mother says Prince Philip, standing with his best man and first cousin, David Mountbatten, 3rd Marquess of Milford Haven, looked extremely handsome that day. It was no surprise that nearly every girl and woman in England felt they might also like to marry him. Loudspeakers were set up so that the crowd outside could hear every word of the ceremony, which was very moving. Over two hundred million people across the world listened to the BBC broadcast of the day's events.

Interestingly, Cecil Beaton, who was the usual photographer for royal events, was not chosen; this was a sign of how the new prince and princess were set on moving with the times. Instead, it was Prince Philip's friend Henry Nahum who took the official photographs, and it was all far more relaxed than the usual rigamarole. When the bridesmaids were no longer needed, they sat down to watch all the various relatives and groups of people being brought in and sent away again after their photographs were taken. My great-grandmother was no fan of being photographed and kept positioning herself on the edge of the group in the hope that she might somehow avoid being in the picture at all. She looked particularly smart, wearing her customary colors in a long black coat, beautifully embroidered in white. My grandfather had brought it from Kashmir, as she refused to spend anything on herself but was far too polite to refuse a present.

My mother was particularly interested in watching her aunt Alice, Prince Philip's mother, as she navigated the occasion. Curious as to what she made of her son's marriage, my mother was intrigued that Princess Alice was now the future queen's mother-in-law. She was quite a tricky person in many ways, and the family wondered

OPPOSITE: My mother in the middle of the bridesmaids, with her brother-in-law, John Brabourne, following behind, and the best man and cousin to Prince Philip, David Milford Haven, just to the left. There had been so much interest in the dresses that the windows of Norman Hartnell's central London studios had to be whitewashed so members of the press and public would not catch sight of the team at work.

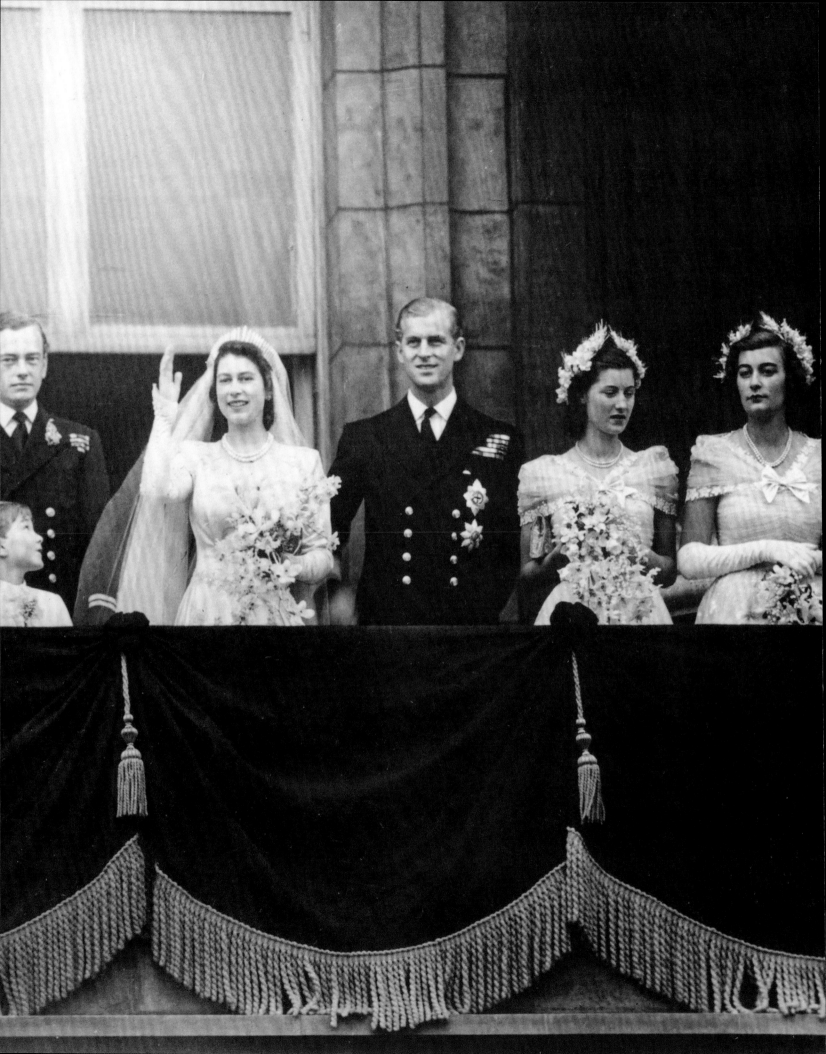

how Princess Elizabeth would cope with her. As it turned out, she did everything she could to make Princess Alice comfortable and welcome throughout the rest of her life.

After the photography was over, the bridesmaids, pages, and best man accompanied the bride and groom, as well as the king and queen and Queen Mary, onto the balcony. They were met by a sight my mother has never forgotten. The police had been holding the public back around the Victoria Memorial, but when they came out onto the balcony, the police let the crowd move closer, and they could see and hear a sea of people surging forward. Every time the newlyweds waved, the volume of the cheering increased. They were later told that while the crowd was waiting, they sang "All the Nice Girls Love a Sailor," which everyone in the wedding party thought was marvelous.

It was a relief to finally sit down to the wedding breakfast, which wasn't really breakfast at all as it was served well into the afternoon. A splendid banquet—filet de sole Mountbatten, perdreau-en-casserole (partridge), and bombe glacée Princess Elizabeth (ice cream cake). Twelve wedding cakes had already been cut up and were later shared among hospitals, schools, and charities with which the princess was involved. The official wedding cake, made with ingredients from around the world, became known affectionately as the "10,000-Mile Cake" due to the sugar that had made its way across the seas from the Girl Guides of Australia. It consisted of four tiers and measured in at a stunning nine feet tall. Particularly impressive, my mother says, were the icing decorations, in the shape of naval badges and the coats of arms of both families. When the time came, Prince Philip used his wedding gift from the king—a naval sword—to slice through it. A cheer went up as the newlyweds made their silent wish.

When the bride and groom had changed out of their wedding attire—Princess Elizabeth into a stylish Norman Hartnell misty-blue dress and coat, with a wonderful matching blue hat—and were ready to leave, the assembled guests hurried through the palace courtyard to shower them with rose petals. Princess Elizabeth was delighted to find that

OPPOSITE: The moment the public waited for: the balcony wave. Even with war rationing of fabric still in effect, Norman Hartnell and his team of seamstresses managed to create a wedding gown fit for a princess, with a train embroidered with over ten thousand crystals and seed pearls. Nothing short of spectacular, especially after all those bleak years of war.

Susan, her very favorite corgi, had been hidden under a rug in their carriage so that she could take her on the honeymoon, which was going to begin at Broadlands and end at Balmoral. Waving them off, my mother could imagine the excitement of the household at Broadlands, with the chef, Mr. Brinz, in his element, preparing for their royal guests. Before they left, Prince Philip gave each of the bridesmaids a silver powder compact; my mother's had two bands of gold with an E and a P, surmounted by coronets, and six dark blue sapphires running down the center.

After the couple left and the reception was over, the bridesmaids went on to a dinner and dance hosted by the best man, David Milford Haven, who was not only very good-looking but also rather more grown up and sophisticated than the rest of the group. His girlfriend at the time was the Swedish model Anita Ekberg, but even though she wasn't there, he kept leaping out of his seat to talk to a rather dazzling young woman at the next table, leaving everyone else feeling somewhat neglected!

OPPOSITE: How lovely to see here the tiny Book of Common Prayer given by Queen Victoria to her granddaughter Victoria, my mother's grandmother, who seventy years later passed it on to my mother. Mixed among diaries, postcards, and photos from the 1940s, there is a telegram sent from father to daughter on the news that my mother had come top of the school in her exams: "JUST BACK FROM SINGAPORE SURRENDER. DELIGHTED BUT NOT SURPRISED AS I ALWAYS THOUGHT YOU WOULD COME OUT TOP."

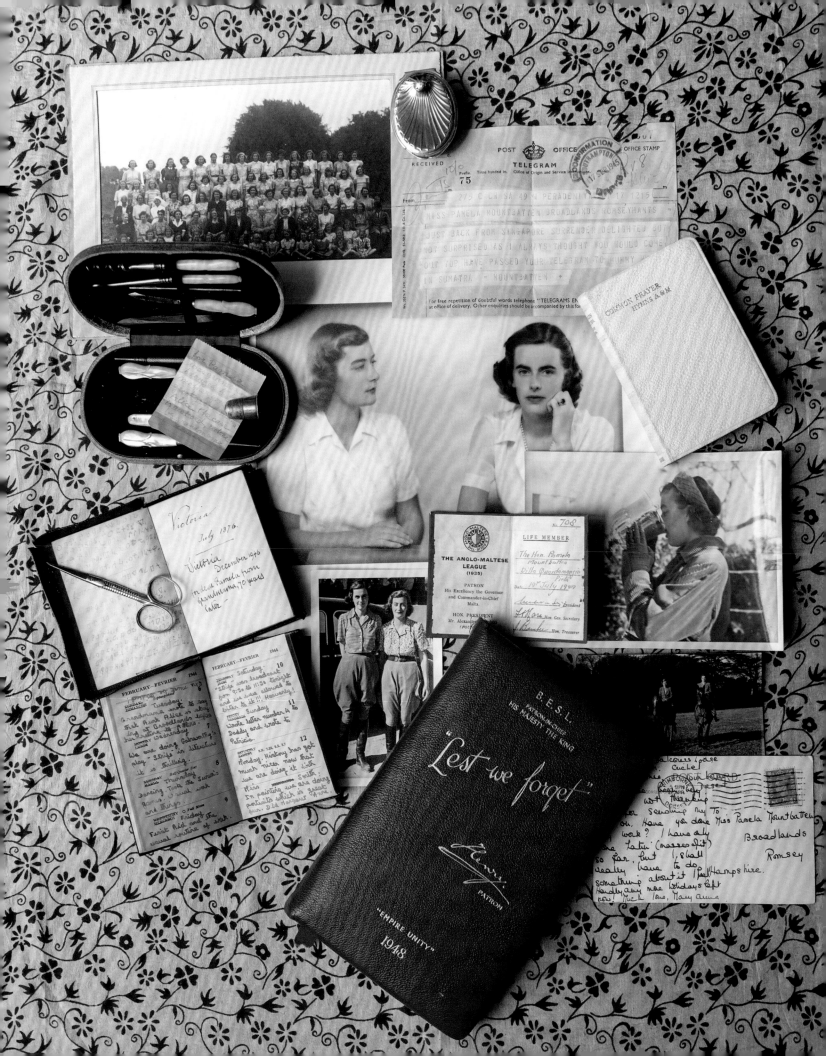

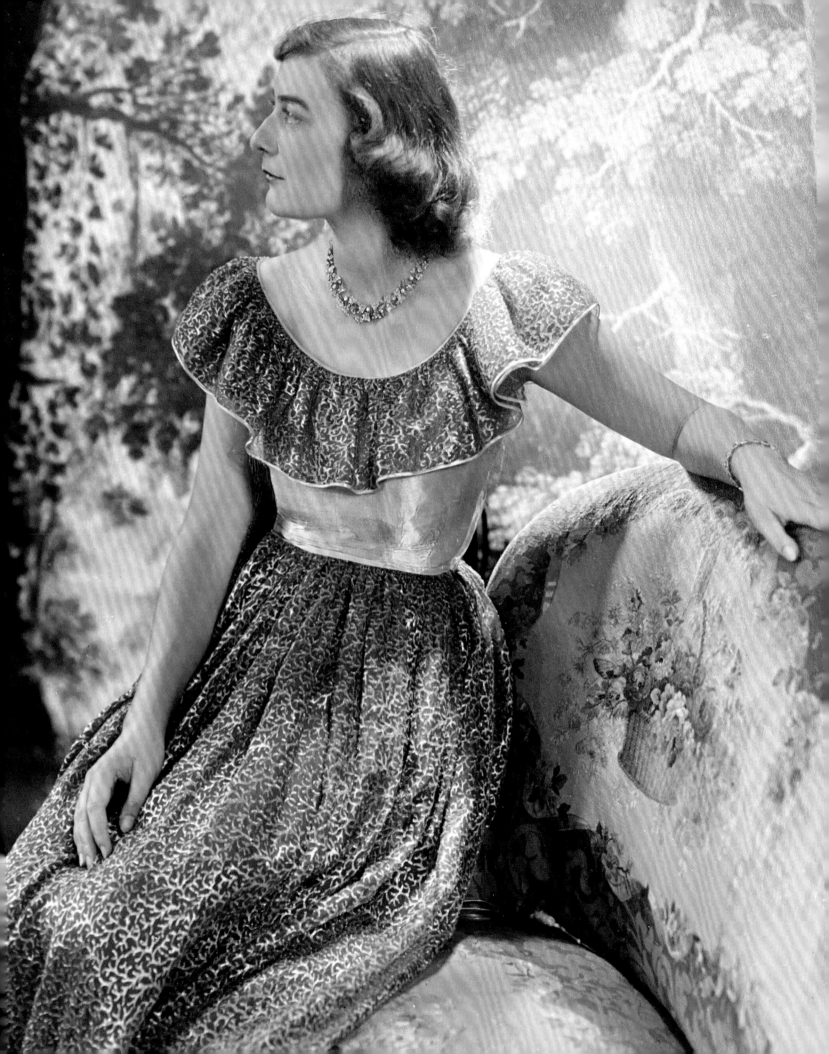

1952

A Deep Curtsy

Shortly after Princess Elizabeth and Prince Philip's wedding, my mother and my grandparents returned to India. In January 1948, only a few months later, Gandhi was assassinated. Gandhiji had become a friend during my mother's time in India, and the news came as a horrific, unfathomable shock. At first, they could not believe it. The whole of India came to a complete standstill, everyone utterly stunned by the murder of the Father of the Nation.

My mother and grandparents left India in June 1948 and returned to Broadlands, each of them struggling in their own ways to adapt to life back home. My mother was nineteen years old and found herself roaming moodily around the house. She had been useful in India, and now she needed something to occupy her time.

Fortunately, they weren't at Broadlands long, as my grandfather was appointed to command the First Cruiser Squadron in the Mediterranean fleet, which meant a return to Malta.

OPPOSITE: A portrait of my mother taken by the famed British photographer Cecil Beaton in his London studio, commemorating the return of my mother and grandparents from India. My mother's dress was made from a sari she found in Delhi.

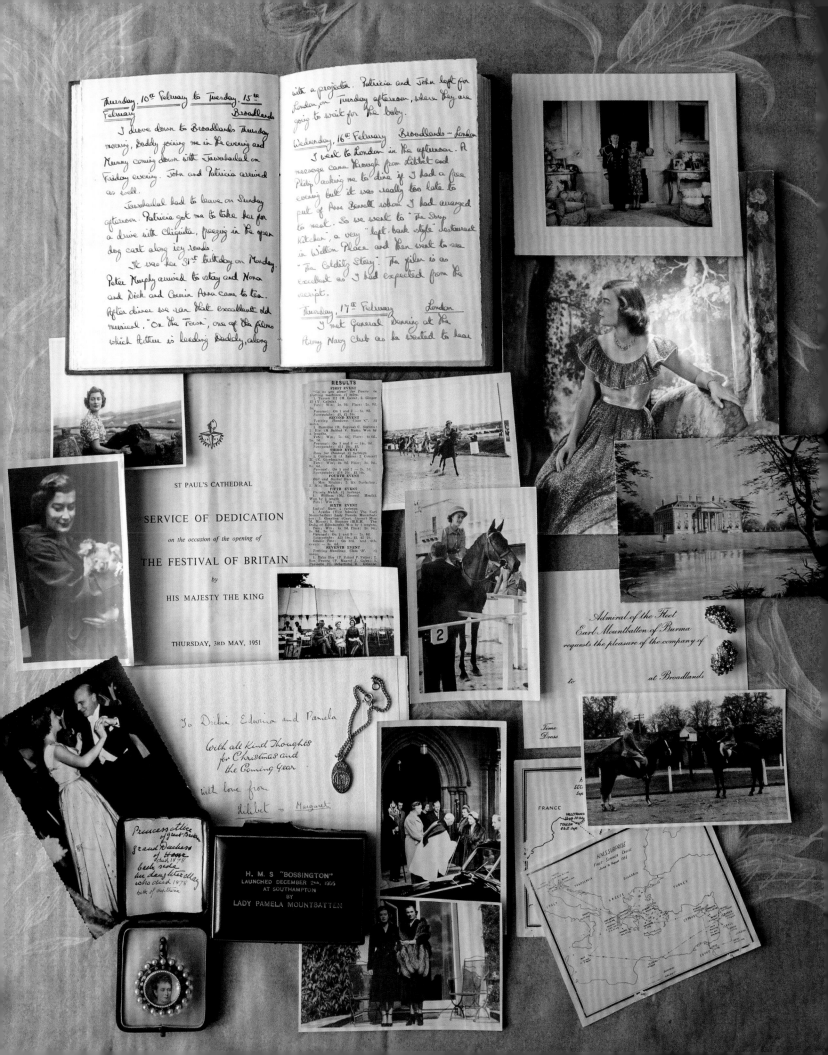

Thursday, 10th February to Tuesday, 15th February — Broadlands

I drove down to Broadlands Thursday morning, Daddy joining me in the evening and Mummy coming down with Jawaharlal on Tuesday evening. John and Patricia arrived as well.

Jawaharlal had to leave on Sunday afternoon. Patricia got me to take her for a drive with Chiquita, freezing in the open dog cart along icy roads.

It was her 31st birthday on Monday. Peter Murphy arrived to stay and Nona and Dick and Cousin Anna came to tea. After dinner we ran that excellent old musical "On the Town", one of the films which Pattine is keeping Daddy, along

with a projector. Patricia and John left for London on Tuesday afternoon, where they are going to wait for the baby.

Wednesday, 16th February — Broadlands – London

I went to London in the afternoon. A message came through from Lilibet and Philip asking me to dine if I had a free evening but it was really too late to put of Anne Bevan whom I had arranged to meet. So we went to "The Soup Kitchen", a very "laid-back style" restaurant in Wilton Place and then went to see "The Colditz Story". The film is as excellent as I had expected from the script.

Thursday, 17th February — London

I met General Denning at the Army Navy Club as he wanted to hear

ST PAUL'S CATHEDRAL

SERVICE OF DEDICATION

on the occasion of the opening of

THE FESTIVAL OF BRITAIN

by

HIS MAJESTY THE KING

THURSDAY, 3RD MAY, 1951

RESULTS

To Dickie Edwina and Pamela

With all Kind Thoughts for Christmas and the Coming Year

with love from

Lilibet & Margaret

H. M. S "BOSSINGTON"
LAUNCHED DECEMBER 2nd, 1955
AT SOUTHAMPTON
BY
LADY PAMELA MOUNTBATTEN

Admiral of the Fleet
Earl Mountbatten of Burma
requests the pleasure of the company of

to at Broadlands

Time
Dress

FRANCE

H.M.S. SURPRISE

There were a great many naval families in Malta and my mother took a job as a case-worker for the Soldiers', Sailors', and Airmen's Families Association (SSAFA), joining the office that concentrated on the domestic welfare of men serving overseas. The work kept her busy, but she was quick to accept her mother's invitation to return with her to India to inspect the Refugee Relief and Rehabilitation Committee that my grand-mother had set up after partition—and to see Nehru. My mother says she had a sense, even then, of the deep mutual respect and affection Nehru and my grandmother had for each other, and which would endure for many years to come.

In 1948 my mother and grandmother returned to Malta, and Princess Elizabeth came to welcome Prince Philip back with the fleet. She had two children, Prince Charles and Princess Anne, by this point and had not seen my mother in a while. It was good to welcome her to their home on the island. While Prince Philip was on land, they came to stay with my grandparents at Villa Guardamangia, the house my grandfather would eventually pass on to the couple. The island was too small for them to live a "normal" naval life, so they found relative anonymity at this home, which had beautiful, secluded gardens and enough space for everyone.

My mother officially came of age in Malta, celebrating her twenty-first birthday with Princess Elizabeth, whose twenty-fourth birthday fell two days later. They went to the Phoenicia, the first luxury hotel to open. The princess danced extremely well and beamed all night. She was so free and at ease with everyone that when the time came for her to return to England, my grandmother remarked it was like putting a little bird back into its gilded cage.

My mother didn't have to wait long to spend time with the princess again. In late 1951, it was decided that Princess Elizabeth and Prince Philip should undertake the long-planned Commonwealth Tour in place of the king and queen, and my mother was asked to accompany her in an official capacity as her lady-in-waiting. The king, a fervent

OPPOSITE: A diary entry talking about freezing-cold rides in the pony trap and an invitation to supper with "Lilibet," among Christmas cards from the royal princesses, newspaper clippings of horse-racing successes, a postcard of Broadlands, and a photograph of my grandparents in front of the drawing room fireplace at Broad-lands. On the far left my mother is dancing with the composer Malcolm Sargent. FOLLOWING PAGES: My mother winning the ladies' race in Malta in the most stylish pith helmet and sunglasses.

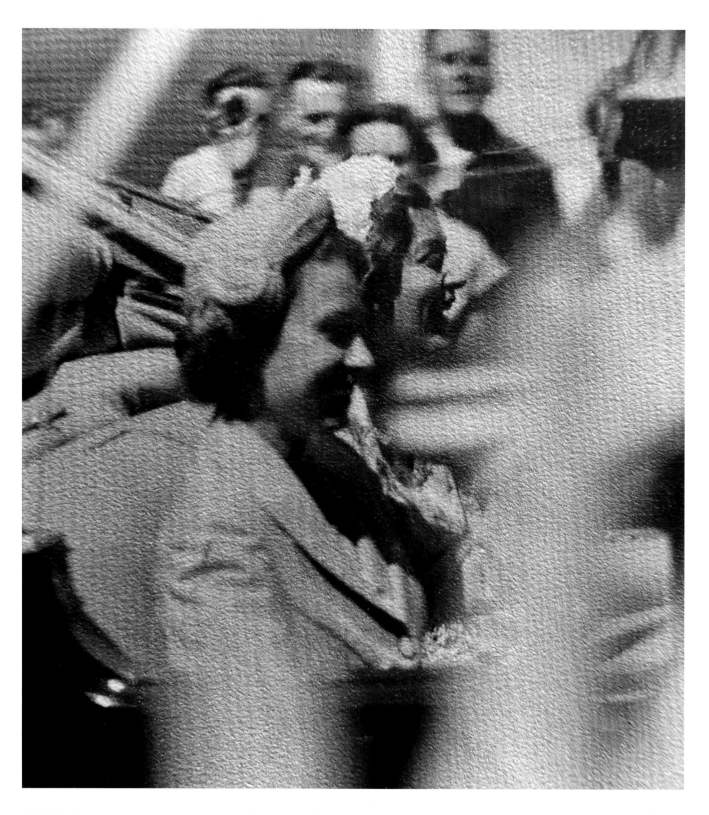

ABOVE: A lovely moment captured on the Commonwealth Tour. My mother laughing beside the future queen in an open car in Western Australia, on their way to a women's lunch. PAGES 116–17: My mother (second from left) cantering through Windsor Park with Princess Margaret, Queen Elizabeth, and Prince Philip, having been invited to stay for the weekend.

smoker, had his left lung removed in September of that year. By the end of 1951, he was still quite unwell. At the state opening of Parliament, the lord chancellor had to read the king's speech for him, and the king's Christmas broadcast had to be recorded in small bursts and then edited together. He was simply not strong enough to do the tour, and so the younger royals were asked to go in his place.

It was a lot to ask of them, Princess Elizabeth in particular, as Prince Charles was still only three years old and Princess Anne just eighteen months. There was never any question that the children would go with them, as it would have been completely impractical to take them on such a long sea journey, with Princess Elizabeth and Prince Philip flying off on whistle-stop tours and going to all sorts of unsuitable places for small children. They would be well cared for by their grandparents and uncles and aunts as well as nannies, and Princess Elizabeth and Prince Philip would send tape recordings to them via the diplomatic bag, allowing their children to hear their voices and some of the stories from their travels.

My mother admits that she was not immediately enamored with the thought of being a lady-in-waiting. After such a busy and fragmented few years in India and Malta, she just wanted to be in one place, at home. But she had no choice, really, as duty called. My great-grandfather had been with King George V on his visit to India, and my grandfather had accompanied the Prince of Wales, later King Edward VIII, on his tour to India, Australia, and Japan. My grandfather was obviously keen to keep the family tradition alive, and with Aunt Patricia married, the privilege fell to my mother.

At a reception one evening before the tour left, my mother realized that her relationship with the princess was about to change and become much more formal. Upon spotting my mother, Queen Mary immediately took her to one side, telling her somewhat firmly, "As you will from now be in waiting, you are to stop calling her Lilibet and only refer to her as Princess Elizabeth or ma'am."

After suffering various unpleasant injections at the Hospital for Tropical Diseases, my mother and the rest of the royal entourage gathered on the last day of January 1952 to say their farewells and set off on the historic tour. The king, the queen, and Princess Margaret all came to wave them off, and it was the first time the king had been seen

in public since his operation. Unusually, he didn't wear a hat, and with his pale face exposed, it was easy to see that he had not recovered at all and how difficult he found the occasion. He was heartbreakingly frail.

Arriving in Kenya, the royal party spent a few days in Nairobi on a frenzied schedule of regimental inspections, hospital and church visits, lunches, and dinners. The streets were lined with cheering children everywhere they went. Then they traveled north to Sagana Lodge, on the slopes of Mount Kenya in the Aberdare Mountains. The lodge had been given to the prince and princess as a wedding present by the people of Kenya, and this was their first visit. They were excited to be away from the crowds and happy just to be together for a short time. My mother was always struck by how deeply in love they were.

Mike Parker (Prince Philip's private secretary) and my mother were the only members of the royal household to accompany them to a tiny hotel built in the treetops. The princess had accepted an invitation to stay there, excited as the location promised spectacular views of the elephants, hippopotamuses, and many other splendid wild animals that went there to drink, usually at night when the temperatures were cooler. The last quarter of a mile of the journey had to be taken by foot, down a slippery, narrow track that was also used by the animals. Their guide, Sherbrooke Walker, warned them not to tread on any twigs or scuff leaves as they walked. He told them to be silent and speak in a whisper only in a dire emergency. The princess looked at my mother in mock alarm as they followed Walker in single file, though they both froze for a moment when they heard some rather unsettling trumpeting and crashing sounds. They all stopped when he stopped and pointed to a white pillowcase that was flying above the roof of the hotel. This, he whispered, was a sign that there was danger at the water hole. He conferred with Prince Philip, and my mother was relieved when she heard Prince Philip reply in what may have been rather too hearty a whisper, "No! Let's go on!"

Walker, a man who didn't seem to be living up to his surname, stopped yet again before indicating that he would go on ahead with the prince and princess and come back for Mike and my mother. Clearly not as concerned for Mike and my mother as he was for the royal couple under his watch, he waved vaguely at the rickety-looking ladders that were nailed to various trees every fifty yards or so and indicated that they should climb

up them if an animal appeared. Mike, ever the joker, leaned over, whispering into my mother's ear, "Pammy, if we find ourselves climbing up one of those things and you notice something overtaking you, don't worry, it'll be me!"

Fairly soon, they were all safely installed at Treetops. Their brush with danger over, they settled smoothly into the modest accommodation, except for the fact that just before their arrival, perhaps sensing the importance of the hotel's guests, some baboons had stolen rolls of toilet paper from the miniscule loo, festooning the branches with swags of it. Princess Elizabeth laughed when she saw it, commenting on this being a different sort of bunting than the usual.

That evening, February 6, 1952, as they sat together in silent wonder watching the magnificent creatures, King George VI died in his sleep, in his bed at Sandringham. He was just fifty-six years old. Princess Elizabeth wouldn't know for some time to come that she had climbed up that ladder as a princess and would descend the next morning as a queen.

After a night of very little sleep at Treetops, their heads and hearts full of the magical array of wild animals they had seen the night before, they set off on the twenty-mile journey back to Sagana Lodge. There they enjoyed a very easy morning, Princess Elizabeth telling my mother how she was looking forward to showing her family some of the footage they had taken of the water hole, totally oblivious to the news that was spreading around the world. When they eventually did learn what had happened, it struck my mother that they must have been some of the last people on the planet to hear about the death of the king.

It was Mike who broke the news to Prince Philip. The prince momentarily crumpled, covering his face with his newspaper. "This will be such a blow," he said, and then without hesitation, he jumped up and went straight into the sitting room to ask his wife to come with him into the garden. Mike and my mother watched from a respectful distance as they walked, Princess Elizabeth stopping in her tracks and leaning into him, her body stiff with shock.

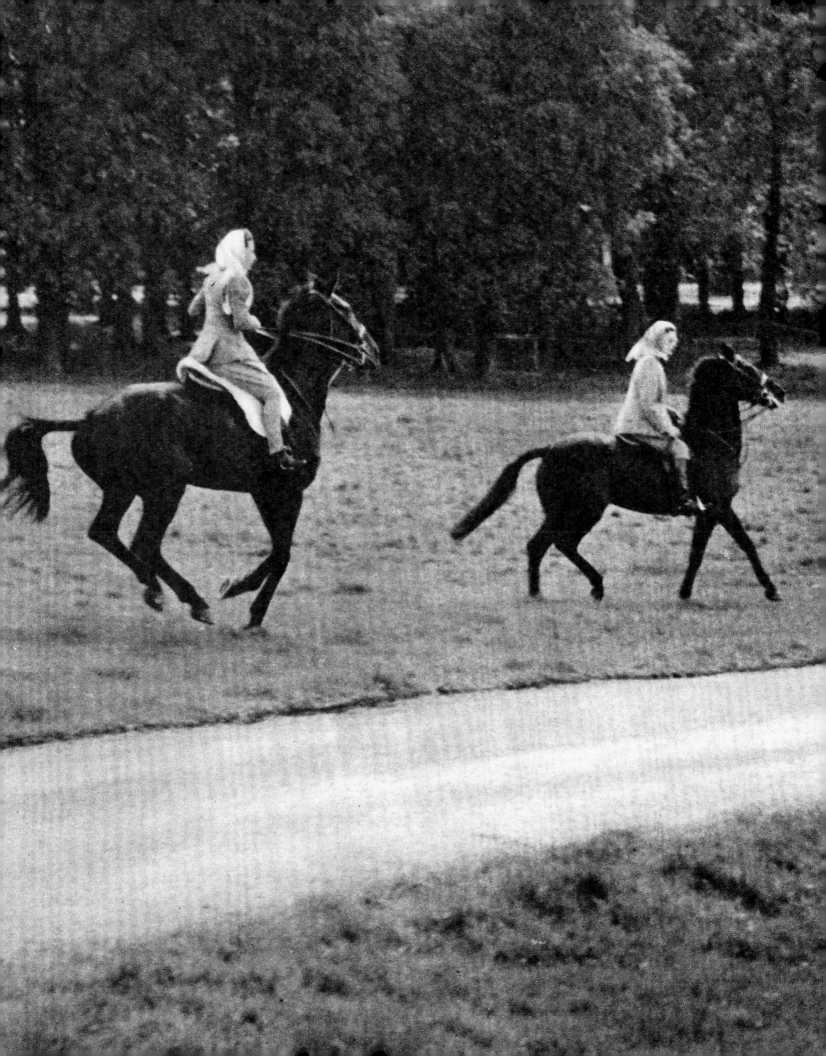

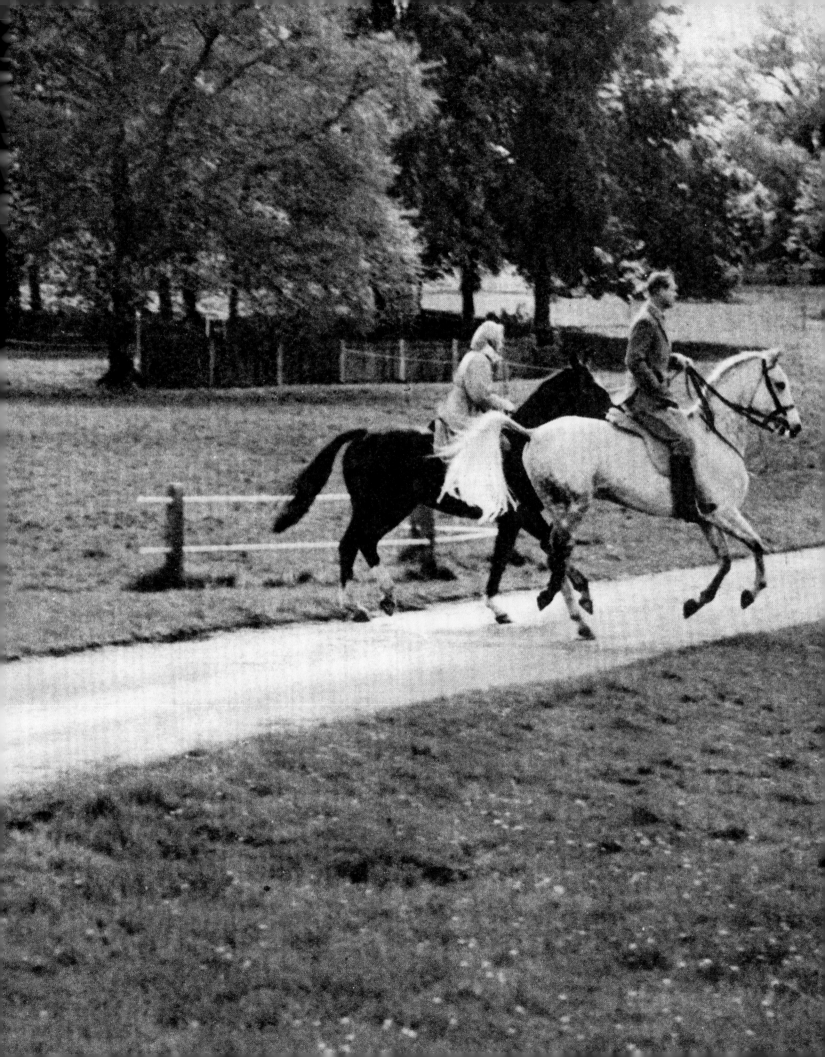

My mother knew how much Princess Elizabeth adored her father and how much he adored her. She had seen firsthand the gentle understanding between the two, the mutual respect they held for each other. As Prince Philip and Princess Elizabeth returned, my mother instinctively reached out to embrace her but remembering in that instant that Elizabeth was now her queen, instead dropped into a deep curtsy. The princess was utterly calm and pragmatic as always, saying simply, "I'm so sorry. This means we all have to go home." Lieutenant-Colonel Martin Charteris, the princess's private secretary, arrived shortly afterward and asked her what she wished to be called now that she was queen. "Elizabeth, of course," she replied, rather surprised. "That's my name." It seemed obvious, but in fact her father, Prince Albert, who had been Bertie to them, had become King George VI on his ascension to the throne, and her uncle, David, had become King Edward VIII. For some reason, it struck my mother that Queen Elizabeth II, as she had now become, was, at twenty-five, exactly the same age that Elizabeth I had been when she became queen, though how and why my mother remembered that detail was quite beyond her, as she too was in shock.

It felt very odd—indeed surreal, even—for all of them to be processing this momentous change in Kenya, while so far away from Great Britain and the throne. Mike made arrangements for the journey back to England, while the queen's dresser, Bobo MacDonald, and my mother busied themselves, hurriedly throwing things into the queen's suitcases and their own. Of course, mourning had not been anticipated and so the queen did not have an appropriate black dress. They selected the plainest item she had with her—a beige dress and a white hat—and within a couple of hours they were ready for their journey to Nanyuki Airport, about forty miles away.

Leaving the lodge was a humbling experience. All the members of staff were lined up to bid the new queen farewell, many of them in tears. My mother watched as she talked to them, comforting them in her hour of need. As they drove along the dry, dusty roads to Nanyuki, it became apparent that the bush telegraph had gone before them and villagers and scores of Kikuyu people lined the roads, many of them calling out, "Shauri mbaya kabisa," that was translated for them as "the very worst has happened." It was a remarkable sight, and my mother could see how moved the queen was at this collective act of support for her.

The first leg of their journey was to Entebbe Airport, in Uganda, where the royal BOAC Argonaut met them for the flight back to London. But a severe electric storm was brewing and the airport officials, already anxious about lighting the flares on the runway because the ground was so dry, told them that the aircraft could not take off. The queen was obviously anxious to return to England as soon as possible, and instead had to spend two hours in the company of a particularly shy Ugandan official. My mother watched in admiration as the queen engaged him in conversation. Eventually they were able to take off, and when the royal Argonaut crew drew the little curtains separating everyone else on the plane from Queen Elizabeth and Prince Philip's cabin at the rear of the aircraft, my mother hoped that at last she would be able to weep in her husband's arms.

Bobo sent a message ahead to her deputy asking for a mourning dress to be delivered, so that the queen could disembark in England in the appropriate attire. Her deputy found a coat, shoes, and handbag but had not been able to source a suitable hat, so a telegram was sent asking for a hat to be delivered when they landed in London.

It was late afternoon the next day when they began their descent over London. The large official reception that had gathered to welcome the new queen home was visible from the air as they landed. Waiting on the tarmac for the black hat to arrive, my mother could see from the window a gathering of England's most important people. To my mother's relief, my grandparents were also there to greet them. The world had changed so much since she'd last seen them.

As the wheels came down, the queen leaned over my mother's shoulder to look out of the window, to see if she could see her private car, but the palace had sent a fleet of huge black limousines. Seeing them draw up in their morbid ranks she sighed, "Oh, I see they have sent the hearses," and in her defeated tone my mother could hear that the reality of what had happened became clear. Duty now meant that any iota of a private life that this twenty-five-year-old mother and her husband—who would now have to abandon his naval career—and their children had was at an end, and from now on they would forever be in the public eye.

The king was buried at St. George's chapel, Windsor Castle, with three generations of queens there to lay him to rest—his mother, Mary, his wife, the Queen Mother, and his daughter, Elizabeth II—standing together, their black veils curtaining their grief.

My mother stayed on at Windsor for a few weeks to help with the many thousands of letters and telegrams that came in expressing condolences. She was struck by the familiar way in which so many people wrote to the queen, as though she were someone they knew, someone who meant a great deal to them. She was not a remote or a haughty sovereign to them, but a real person whose pain they felt and empathized with. There were a great many from women her age, mothers with aging parents of their own, who saw themselves and their own struggles reflected in the young queen. Many of the letters came from service families and contained personal memories and stories relating to their service and the late king. My mother found it moving to work through them, as they painted a picture of a king who had been so revered; she also knew they were enormously comforting to the queen.

My mother had only become a lady-in-waiting for the Commonwealth Tour, which was now postponed. There would be a long period of national mourning, and the new queen would need a coronation—a huge task to organize as so many heads of state from around the world would need to attend. My mother returned to her parents at their home in Malta feeling somehow far older and wiser, and more adventurous, than the young woman she had been the last time she was there. When she received an invitation from George Arida, a dashing young Lebanese man she met in Malta, to go and stay at his family apartment in Beirut and their home in the mountains, she accepted. It was a breathtaking spot, and legend had it that King Solomon built his temple from the trees surrounding the house. George had a glamorous lifestyle, and they spent their days water-skiing and their evenings socializing with the Lebanese elite, all of them wonderfully chic and exciting to be around.

In such heady circumstances it was inevitable that my mother should fall for George. If circumstances had been different, she felt sure they would have made a life together. But she knew her father would worry about her living abroad so far away from England. She consoled herself with the constant stream of love letters that followed their parting, and looked forward, along with the rest of her family, to the most anticipated and public coronation of the century.

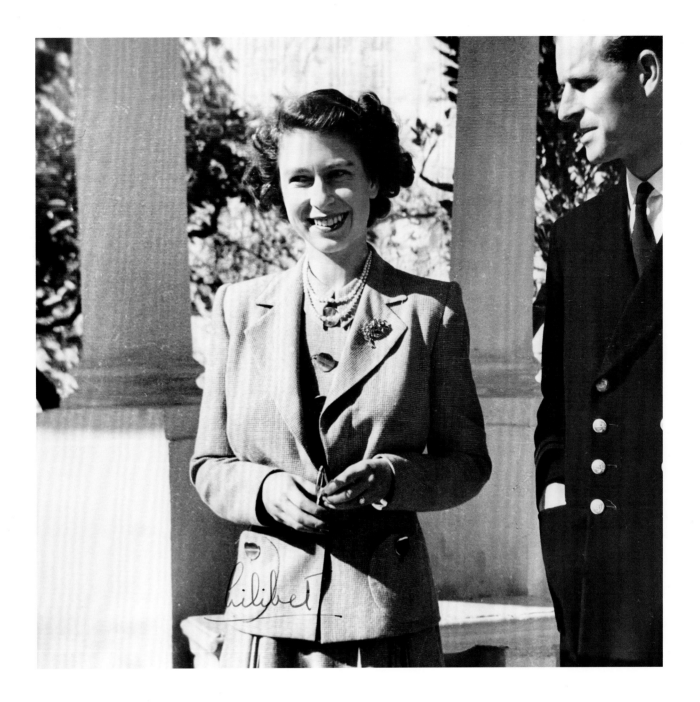

ABOVE: A photograph affectionately signed by the queen, beside Prince Philip in Malta. My grandparents had lent them their house there. It was one of the few times the royal couple ever had some semblance of freedom and privacy. Following pages: In Malta, my mother (left) and the queen dance the eightsome reel at their shared birthday party. My mother's mongoose was in disgrace that day. Having escaped her hotel bedroom, Neola slipped into the room of another guest who thought he was hallucinating when he spotted a small creature standing on its hind legs and inspecting him (left). The queen (left) and my mother (right) chatting with some of the players after a polo match at the Marsa Sports Club in Malta. White gloves: a crucial accessory for watching polo (right). PAGES 124-25: The funeral program for King George VI from 1952, which I found in my mother's archives; we then found the funeral program for Edward VII from 1910. A pair of my mother's evening earrings. We also came across commemorative medals worn by the family, which were not awarded for military service and not worn on uniforms; instead they are awarded for attendance at a particular occasion. A tangible memory.

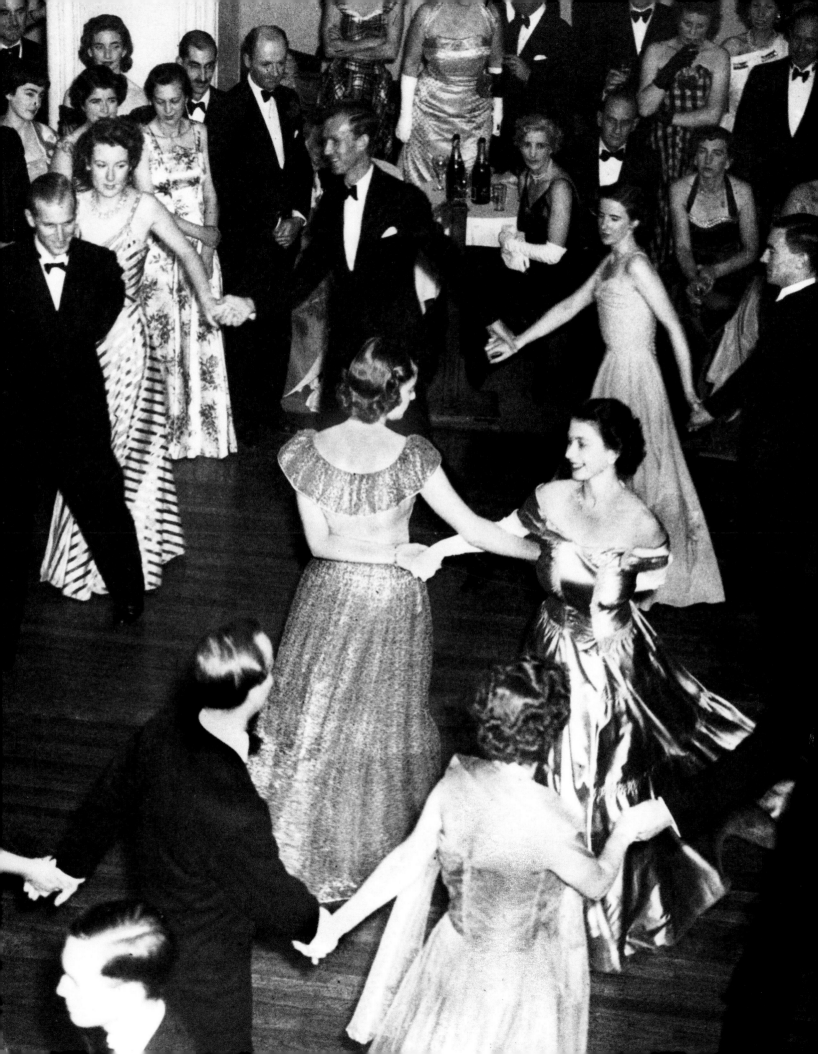

Ceremonial

to be observed at the Funeral of

His Late Majesty
King George the Sixth
of Blessed Memory

February 15th, 1952

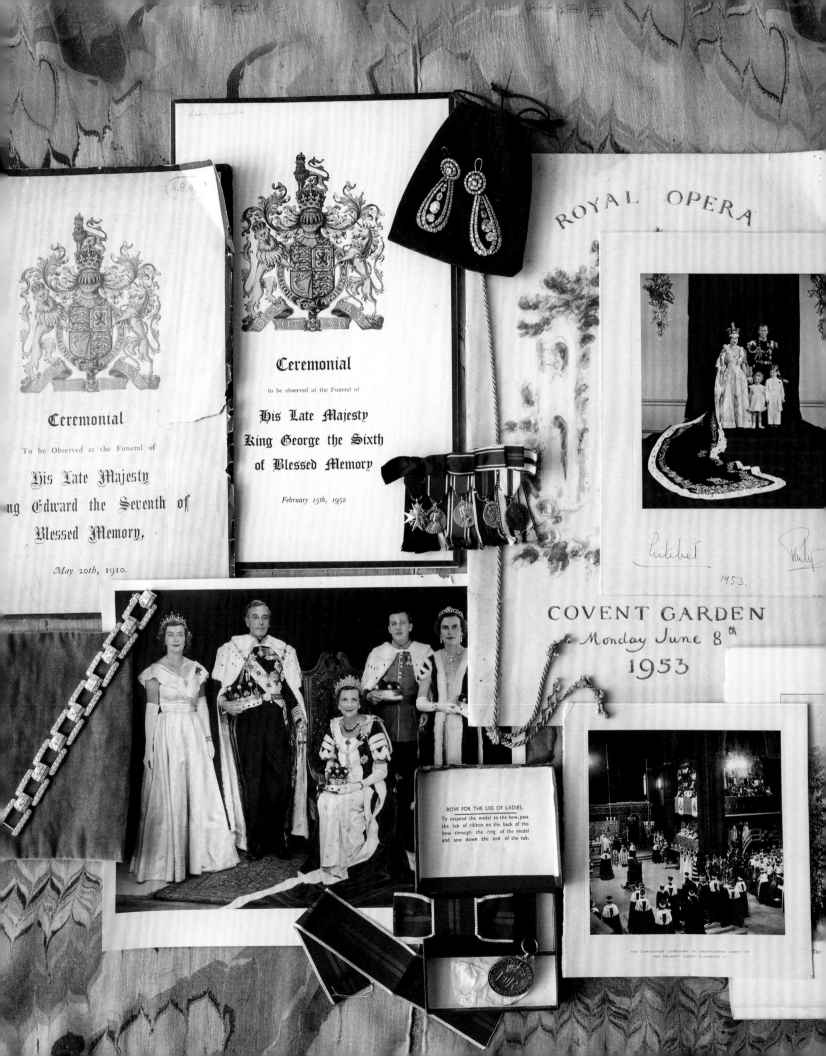

Ceremonial

To be Observed at the Funeral of

His Late Majesty

King Edward the Seventh of

Blessed Memory,

May 20th, 1910.

Ceremonial

to be observed at the Funeral of

His Late Majesty

King George the Sixth

of Blessed Memory

February 15th, 1952

ROYAL OPERA

Lilibet Philip

1953.

COVENT GARDEN
Monday June 8th
1953

BOW FOR THE USE OF LADIES.

To suspend the medal to the bow, pass
the tab of ribbon on the back of the
bow through the ring of the medal
and sew down the end of the tab.

THE CORONATION CEREMONY IN WESTMINSTER ABBEY OF
HER MAJESTY QUEEN ELIZABETH II

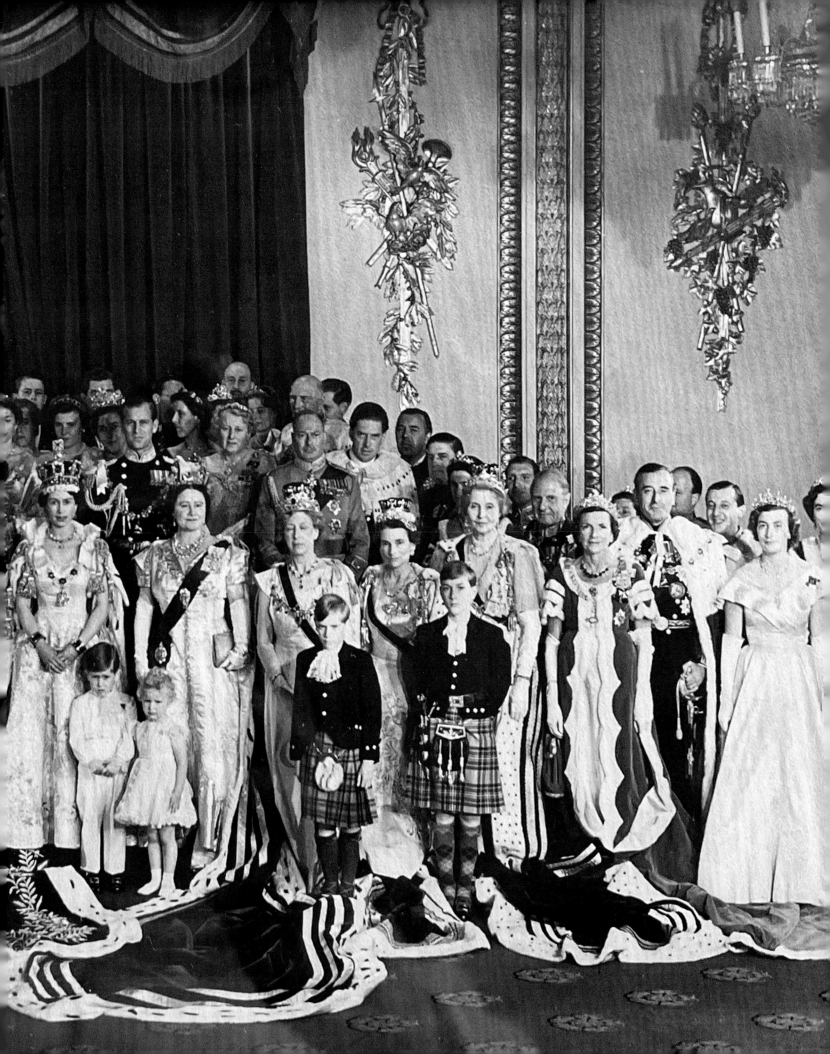

1953-54

GOD SAVE THE QUEEN

While the queen had indeed been declared sovereign the moment her father died on February 6, 1952, it took sixteen months to organize the coronation. Tradition dictates that the monarch has to be crowned in sight of "all of the people," so a great many heads of state from all over the world were invited to attend.

At last, the great day arrived: June 2, 1953.

Every crowned head was given a carriage in which to arrive at the abbey, and as there were so many people to get in, the whole thing took hours, and several peers processed to their seats with sandwiches concealed beneath their coronets. My mother, my grandmother, Aunt Patricia, and Uncle John had been instructed by Lord Chamberlain to arrive only an hour before the ceremony began so they would not have too long to wait. My grandfather had a rather unsettling ride behind the coronation coach, on a horse that was so fresh it pranced around and would not keep to a dignified walk. When

OPPOSITE: The family gathered together after the queen's coronation. Quite a thought that the crown the queen wore had been made in the year 1661. FOLLOWING PAGES: Since the Middle Ages, robes have been worn as a sign of nobility. My uncle, Lord Brabourne (second from the right), seen here beside Aunt Patricia (right), my grandparents (center), and my mother (left), did not have his own set of robes despite being a peer of the realm—so my aunt had the brilliant idea that he should borrow some from the costume department of the film studio he was working with as a producer at the time!

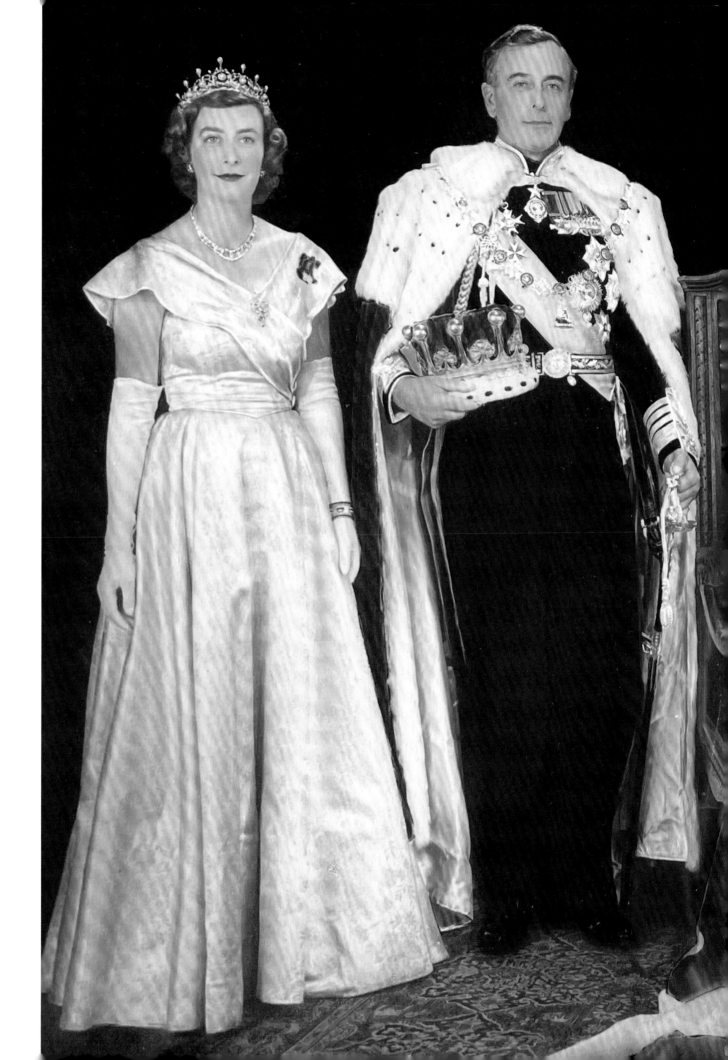

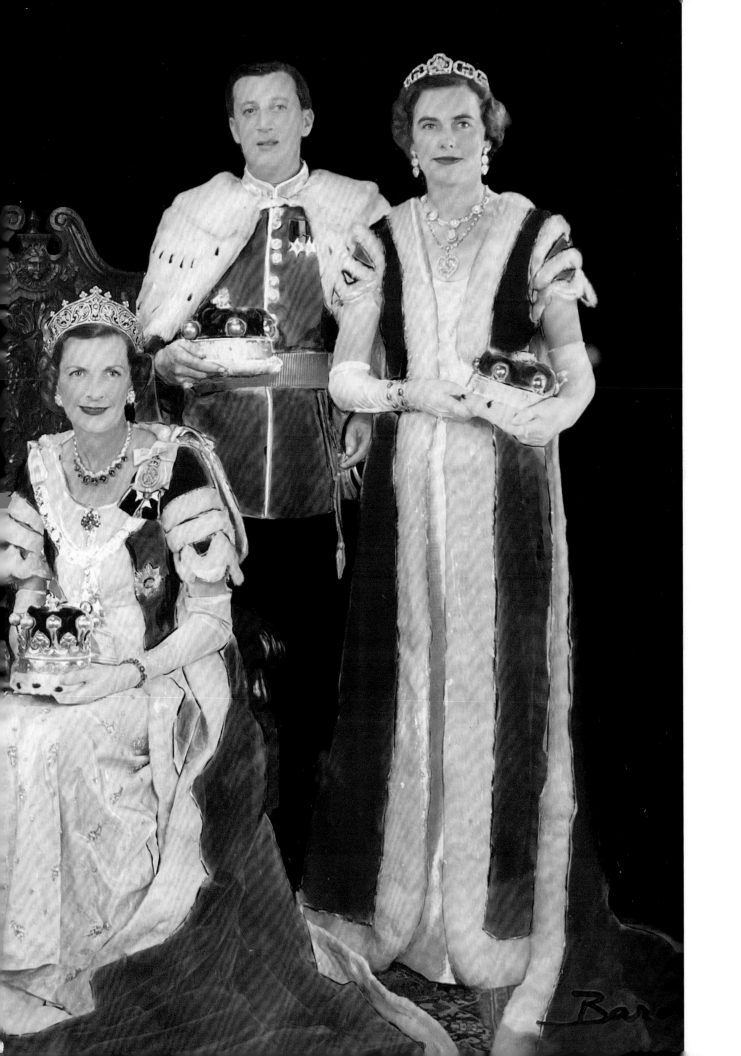

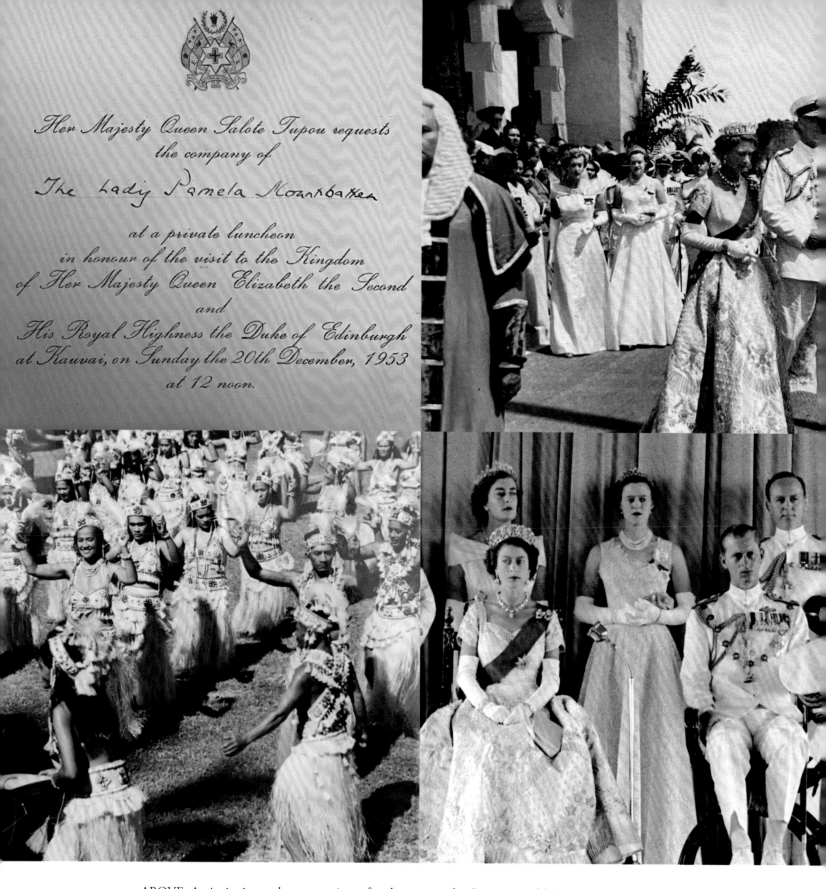

Her Majesty Queen Salote Tupou requests
the company of
The Lady Pamela Mountbatten

at a private luncheon
in honour of the visit to the Kingdom
of Her Majesty Queen Elizabeth the Second
and
His Royal Highness the Duke of Edinburgh
at Kauvai, on Sunday the 20th December, 1953
at 12 noon.

ABOVE: An invitation and state openings of parliament on the Commonwealth Tour, where the queen wore her coronation gown embroidered with beaded emblems of the United Kingdom and all the Commonwealth countries. On one occcasion, a huge marquee was erected on top of a hill so that large crowds could see the ceremony. Unfortunately, when it was very hot, the sequins on the queen's dress nearly roasted her alive.

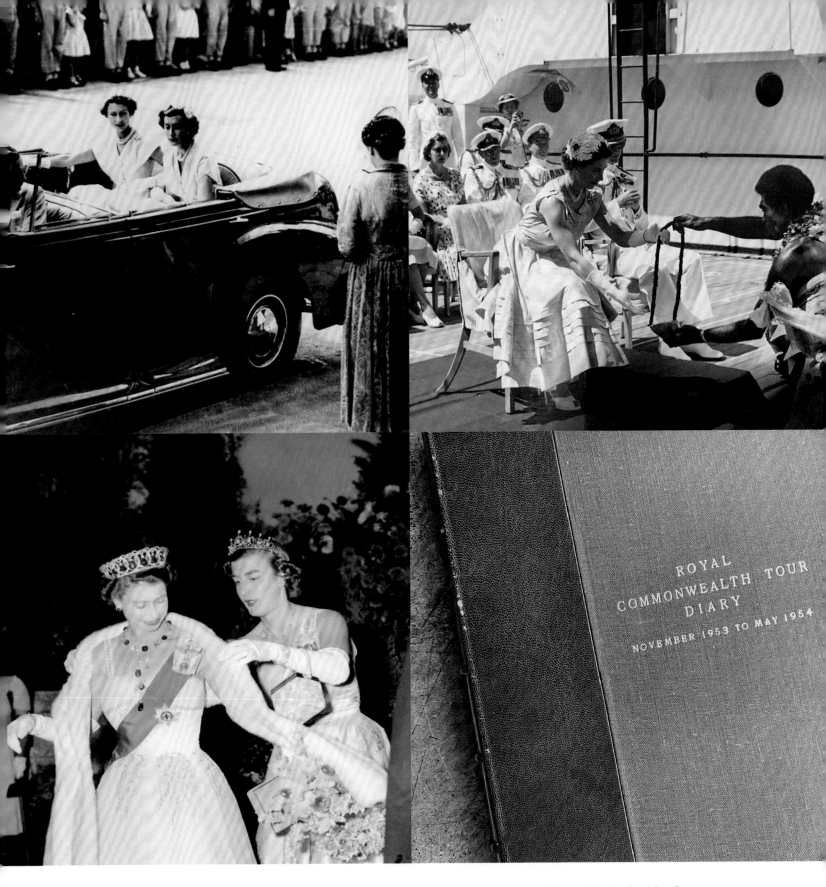

ABOVE: When they reached Fiji, the Fijians came aboard SS *Gothic* and presented Queen Elizabeth with gifts. Every gift presented was preceded by five claps, which took quite a long time. Thank goodness my mother kept these diaries from the tour, which my grandfather had bound for her upon her return.

he dismounted at the abbey and a member of my grandfather's Life Guard regiment approached to take the reins, my grandfather admonished him—somewhat tetchily and unrealistically—to take the horse away and exercise it.

The queen was dressed in a white satin gown designed for her by Norman Hartnell. The full skirt was embroidered with beaded emblems of the United Kingdom and all the Commonwealth countries, including a rose, a thistle, a shamrock, a maple leaf, a fern, and the lotus flower of India picked out in diamante and seed pearls. This dress had taken over three thousand hours of handwork to complete.

My mother knew that the coronation ceremony meant a great deal to the queen, particularly the anointing, for which she requested the cameras be turned off. This was the most moving part of the rite, and when it came, the maids of honor stepped forward to take her velvet robes and jewelry, and to cover her coronation dress with a simple white linen overdress. There was a hushed stillness, a sense of gravity and occasion, as the archbishop of Canterbury anointed the queen's hands, her head, and her heart with the consecrated oil that symbolized her divine right to rule.

As the new queen was crowned, the abbey resounded with the dramatic and thunderous acclamations of "Long live the queen!" and "God save the queen!"

Prince Philip was the first to make his obeisance to her, bowing and kissing her cheek. His mother, Aunt Alice, led the royal family's procession out of the abbey toward the great west door amid the glorious music that echoed round the nave. My mother was so used to seeing her aunt, Princess Alice, dressed in a short nun's veil that it was a surprise to see her looking so dignified and regal in a finely woven floor-length woolen cloak and flowing veil.

The return route to Buckingham Palace was designed so that as many people as possible could see the queen. Queen Salote of Tonga won the hearts of the public by leaving the cover over her carriage open, despite the rain. But what sent the press into romantic speculative overdrive was Princess Margaret's intimate gesture of brushing a piece of lint from the jacket of Captain Peter Townsend, the late king's equerry, and a divorced man.

My mother listened intently that evening as the queen made a speech to her subjects around the world, speaking of her wish to unite her people. My mother knew her words to be genuine and heartfelt when the queen said, "I have in sincerity pledged myself to your service, as so many of you are pledged to mine. Throughout my life and with all my heart I shall strive to be worthy of your trust. In this resolve I have my husband to support me. He shares all my ideals and all my affection for you."

With the coronation over, the Commonwealth Tour was set to resume in early November 1953. Also accompanying them were another lady-in-waiting, Lady Alice Egerton, and the queen's secretaries, Michael Adeane and Martin Charteris.

Once again sailing on SS *Gothic*, it took my mother a while to find her sea legs, but by the third day they had all begun to engage in tremendous bouts of deck tennis, quoits, and deck croquet, which they played with wooden blocks instead of balls, as blocks would not roll off the deck. In the afternoons, there were terrific canasta sessions, at which my mother was rather good, and also liar's dice, at which she was extraordinarily bad.

They arrived in Jamaica twelve days after leaving London. In the light of dawn, Kingston harbor was a remarkable sight: a narrow stretch of sand and grass lay beyond the water and very steep hills, covered in dense vegetation, rose up dramatically behind.

Coming ashore, my mother was a little apprehensive as the governor, Sir Hugh Foot, had signaled to the ship some days earlier to say that as soon as they landed, he wanted to "kidnap" Johnnie Althorp, the queen's equerry, and my mother, and take them to King's House for discussions with him and Lady Foot.

The governor and Lady Foot—mischievously nicknamed "the Feet" by Princess Margaret on a previous visit—had pushed Jamaica into a complete state of panic. Preparations for the tour had been going on for the past nine months, and there had been intensive rehearsals for every single function. Now their arrival had thrown everyone into ecstasies of excitement, and with a heavy sense of doom, Johnnie and my mother realized that they were to be seized and "rehearsed with" throughout their stay.

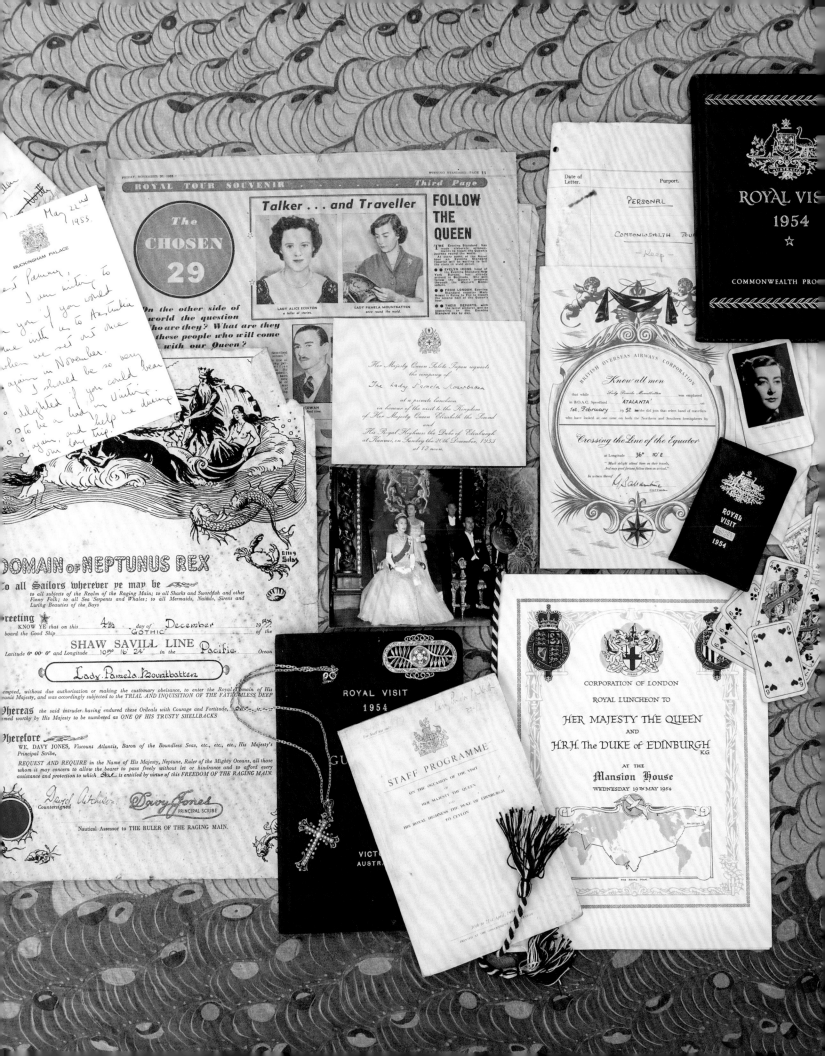

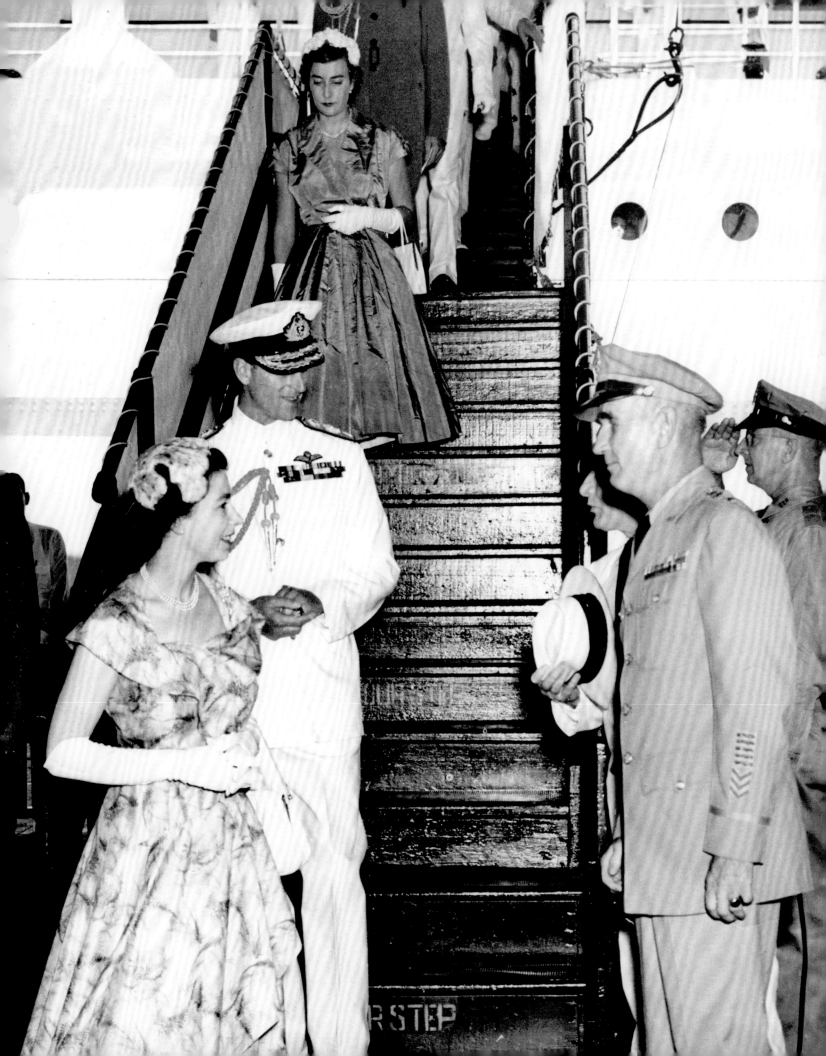

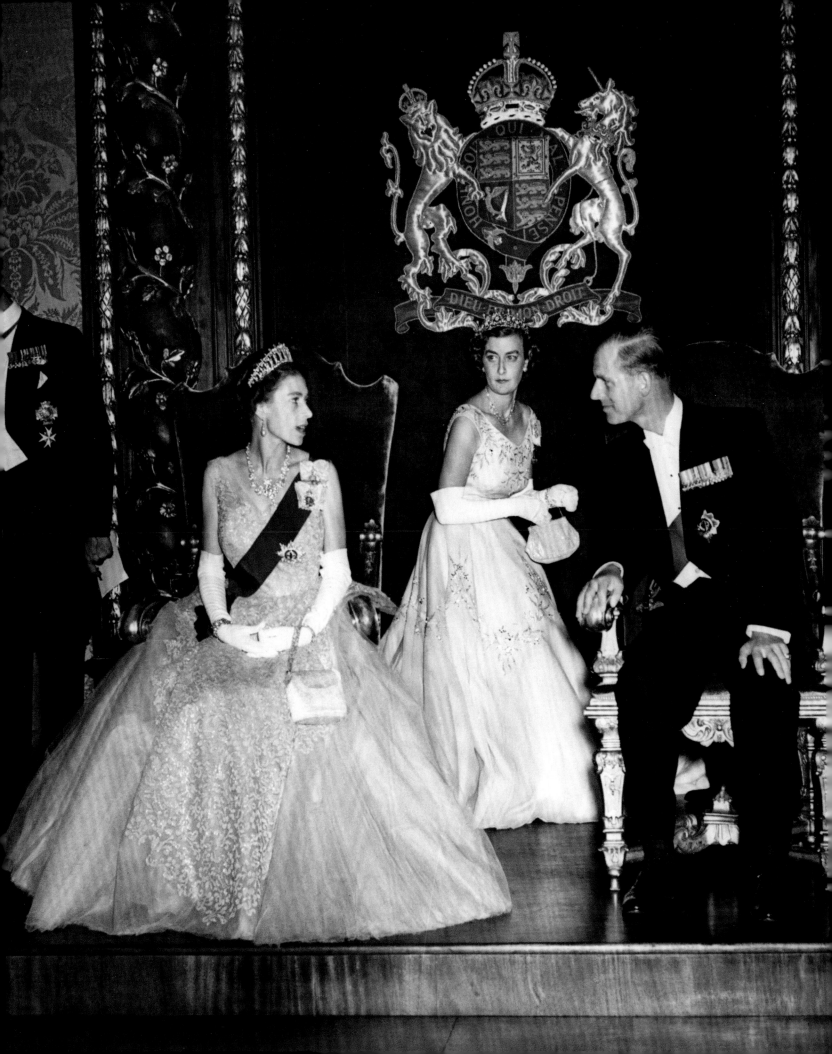

Lady Foot was charming but imperious. As soon as my mother arrived, she took her on a tour of the house, since the queen and Prince Philip would be staying with them. The layout was so simple that even my mother, who always managed to get herself lost, felt confident she had committed it to memory—yet Lady Foot told my mother to retrace her steps to ensure that she knew every corner. Minutes later, she informed my mother how many times a day the queen would be changing her dress. When my mother assured her that the queen would have no intention of changing three times in one morning, she was driven to exclaim, "But we can't have a crumpled queen!" Lady Foot then took my mother to the queen's bedroom and asked whether it was correct for the governor's wife to show the queen into her bedroom or whether she must remain on the threshold, and so presumably shout out directions as to the geography of the room from a distance. My mother tried to indicate that formality should not outweigh practicality, but Lady Foot obviously felt that no detail was too small to discuss. This, then, was my mother's initiation into the strange behavior, or the total loss of common sense, that occurs during a royal tour. She had been warned by the other, more experienced members of the party that often hosts went into complete overdrive.

As they drove through the streets of Kingston, it was as if the whole of Jamaica had turned out to greet Queen Elizabeth and Prince Philip. They were all struck by Jamaica's natural beauty, banana groves, and slender royal palms. "We are unbeatable!" the chief minister exclaimed.

PREVIOUS PAGES: Bits and pieces saved from the Commonwealth Tour. This tour lasted an impressive six months, taking in the West Indies, Australia, New Zealand, Asia, and Africa. It was a significant moment for the new queen as she fully embraced her role and the duty that came with it. "The Commonwealth bears no resemblance to the empires of the past. It is an entirely new conception, built on the highest qualities of the spirit of man: friendship, loyalty, and the desire for freedom and peace," said the queen at the time of her accession (left). My mother disembarking behind the queen in Sydney, Australia, looking very serious on duty as lady-in-waiting. My mother had been a lot less serious earlier, when she was asked to represent the queen during some rehearsals. Unfortunately, these rehearsals took place at sea and on one occasion as my mother took up her position the ship lurched sideways and she couldn't make up her mind whether the queen should stand firmly with her feet wide apart, or stand with her feet together, and risk falling over. My mother was reduced to helpless giggles, and nobody could take the rehearsal seriously (right). OPPOSITE: The queen, my mother, and Prince Philip at a reception in Melbourne, Australia. My mother remembers that the queen had suddenly got a bit cold, so my mother left the reception to go and collect a stole for her. When she came back the crowd was so thick she had to tap people on the shoulder and say, "Excuse me can I come through?" But when she said this to one man, he said, "Certainly not, I've queued a long time for this place. Go and find your own place, young lady."

Panama proved to be quite a trial. They drove back out of Colón to the Canal Zone, where American outriders accompanied them some thirty miles to a lock in the canal. After a long first reception, the royal party was finally able to return to the *Gothic*, hoping for the merest glimpse as she passed through the canal. It turned out, however, that they were not allowed up on deck because it was a Sunday and they hadn't yet been to church. The American bishop, Reginald Heber Gooden, insisted on coming on board and holding a service belowdecks, in the day cabin. But they got their revenge by looking out the window the whole time.

That evening there was an official dinner at the presidential palace, followed by a reception elsewhere. Michael and my mother were nervous, not at all happy if the queen and Prince Philip were out of their sight. When the queen and prince were driven off from the palace after dinner, leaving Michael and my mother behind, Michael pushed my mother into a luxurious limousine, pointed in anguish at the queen's departing car, and commanded the driver, "Follow that car!" The chauffeur protested that the car they had jumped into belonged to the president of the legislative assembly, but Michael was insistent. Later, at the reception, my mother found herself sitting next to the president of the assembly, who said mutinously, "You stole my car." My mother offered profuse apologies and muttered something about not knowing it was his car. But he had not finished, and a twinkle appeared in his eye. "You stole my car, so I stole the foreign minister's car. The foreign minister stole the chancellor's car, and the chancellor had to hail a taxi." The chancellor, it appeared, was not one to bear a grudge lightly and, white with rage, he sat in stony silence for the rest of the evening, refusing to speak to anyone.

Once again, they set sail on the *Gothic*. On December 4, they crossed the equator. Lady Alice and my mother thought they were going to get away without a line-crossing ceremony, but with Prince Philip on board this was unlikely. Wildly enthused, he set about establishing his court, appointing his King Neptune, Queen Ariadne, and other members. The victims were Alice and my mother, two of the Wrens, and a few of the female clerks. The pretend court was held on a platform erected above the swimming pool on the forward deck. The ship's officers and all of the royal party lined the rails overlooking it and the sailors, marines, cooks, and stewards packed the deck surrounding the platform to watch the antics. My mother was accused of numerous charges, from being late for breakfast to being the daughter of an admiral, and was given an enormous wet fish

to hold by Prince Philip. He then unceremoniously tipped the chair she was sitting on, flinging her backward into the pool.

Their arrival in Fiji could not have been livelier. Coming into the Suva harbor, they were surrounded by a number of brightly decorated little yachts. Then, to my mother's huge delight, a dozen outriggers appeared, each sailed by a crew of Fijians in grass skirts. She had never seen canoes such as these before, each one having been cut from a single log with an outrigger secured by lashings of coconut fiber. She was told that most of them had sailed from the Lau group of islands, some two hundred miles away. When they anchored, five chiefs from Bau and Rewa came on board the *Gothic* to perform the Cavuikelekele, an invitation to land.

The welcoming ceremony was spectacular. The queen sat on a small platform in the middle of the deck, the governor and Prince Philip on either side of her. The most senior chiefs came forward and presented a whale's tooth hung with sennit cord. The queen accepted this tabua—the most valuable traditional Fijian object. This was all carried out in silence as the Fijians considered it disrespectful to make any noise during formal ceremonies.

Two days later the group took off in a flying boat bound for Tonga. Upon arrival, they were off to the small town of Nuku'alofa (Tonga's capital), as guests of Queen Salote. She was beloved by her people and held in great respect as a leader, an orator, a poet, and a composer. Her songs were sung on even the most remote islands. She embodied the spirit of Tonga, where song and dance were part of the everyday lives of the people.

Queen Salote was regarded as the ultimate authority on all questions of rank, precedence, and custom, having an outstanding knowledge of Tongan genealogies. It was an extremely stratified society—your status was determined at birth and your achievements could do little to alter it, yet the social position of women was extremely high, sisters always outranking brothers within the family, and the person deciding important questions such as marriage being the father's sister.

It was forbidden to pass in front of a person of higher rank, so they often saw Tongan people rushing about bent double. It was fortunate that Salote was taller than her

sons, remarkably robust young men, each weighing over three hundred pounds—their weight and bearing being a sign of wealth and social position.

It was a noisy arrival. The queen's first engagement was to inspect the Royal Guard drawn up on the wharf. The route was packed, as each group cheered on a single long-drawn-out note, each with a different pitch, with the effect being harmonious. The controlled cheering soon deteriorated into deafening, shrill yelling, which continued without break until they reached the palace.

The palace was a small wooden house with a dark red corrugated-iron roof. A large, sumptuous bathroom was specially installed for the visit. Queen Salote and her entire family moved out so that the queen, Prince Philip, Mike Cowan, and my mother could stay there. My mother's room was tiny, a walled-off passage with a particularly comfortable bed. The fact that two sides of the room were composed entirely of windows made dressing and undressing difficult. Each window had tiny net curtains attached, and she could either shut the windows to have some privacy, and die of heat, or open them and change in view of the whole of Nuku'alofa. Everyone congregated just beneath my mother's room, cheering and waving whenever she went into it, as the small garden and low separating wall offered little privacy. They thought it great fun to watch her while she brushed her hair, so she opted for the heat, changing and sleeping in a hermetically sealed oven. This was a royal visit with a difference, all aspects of their daily routine seemingly on show.

As they said goodbye, Queen Salote had tears running down her cheeks, and while the royal party settled themselves back on the *Gothic*, she and her family sailed five miles out to sea so they could wave to them as they passed.

On December 23, as they docked in Auckland, the more formal part of the royal tour began. This was also when the private secretaries took over the schedule, each moment timed to within a second of its existence. There was a busy schedule ahead of them

OPPOSITE: One of the jobs of a lady-in-waiting is to deal with mountains of correspondence received from women and children around the globe (the private secretaries handle the official correspondence). This page shows all the stationery my mother kept from those years, as well as later souvenirs from stays in royal (and some much-less-royal) residences.

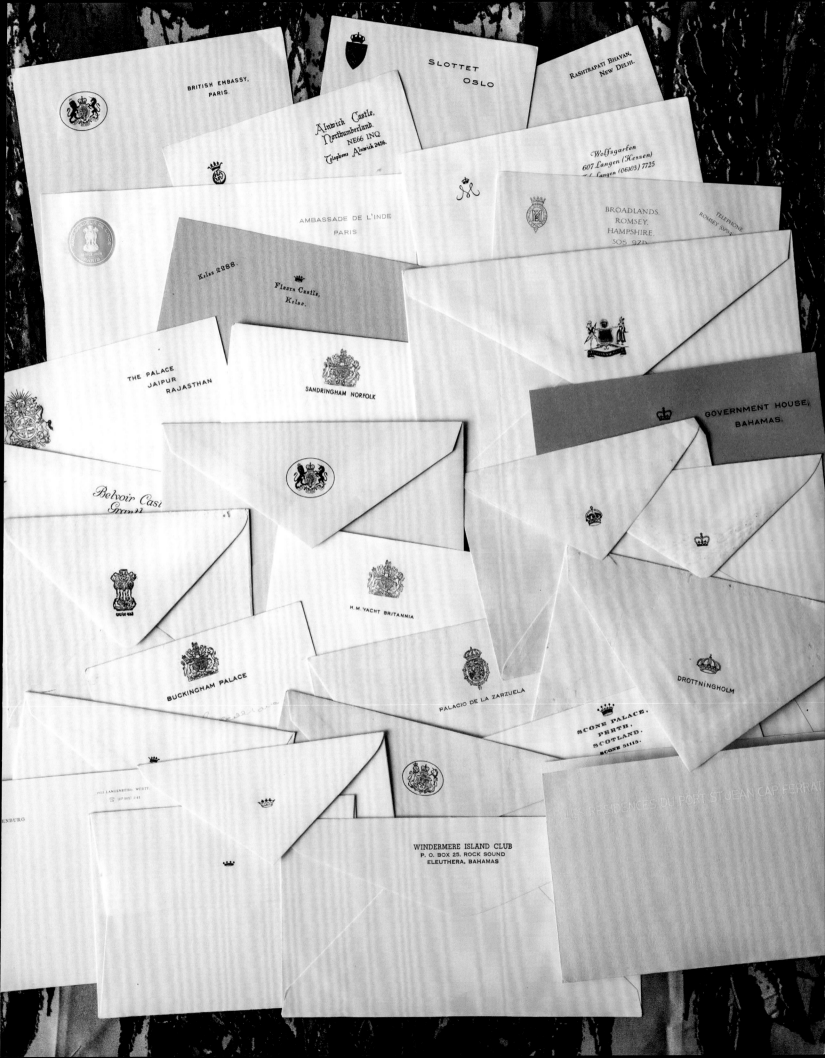

in New Zealand; even Christmas Eve was to be spent on duty, with the morning at Auckland City Hospital. The populace was apparently so healthy, however, that there was a certain amount of difficulty filling it up for the visit.

Then tragically, late on Christmas Eve, there was a terrible rail disaster, the worst in New Zealand's history. The night express from Wellington to Auckland crashed through a weakened bridge spanning a river swollen by floodwater at Tangiwai. Prince Philip accompanied the prime minister to Wellington to attend the funeral of the 151 victims. The mood was subdued as the queen made her Christmas broadcast, and being so far from their families made everyone in the royal party miserable.

By this point in the tour, my mother was resigned to the repetition of ceremonies. The public welcome lasted only fifteen minutes, consisting of the national anthem and the presentation of a bouquet. This was followed by a gift from the town, the presentation of the town council and local dignitaries, the signing of the town hall visitors' book, and, lastly, the hip-hip-hooraying or three cheers.

This leg of the tour was busy, and the New Zealanders were welcoming wherever they went. On their way out to Hamilton, my mother spotted three painted sheep in a field: one red, one white, and one blue, and later one painted red, white, and blue. There were signs that made them laugh, my mother's favorite being, "God Bless the Queen and Keep an Eye on the Duke." They visited the chief of the Waikato tribe, enjoyed flowery and poetic Maori welcomes, and watched in amazement as two great war canoes, each over one hundred feet long, carrying one hundred chanting warriors, paddled down the river.

They were now a month and a half into the tour and all of the staff were getting tired and crotchety. My mother didn't know how Prince Philip and the queen survived, continuing to wave as happily as they had done since their arrival; indeed, the queen had developed tremendous muscles in her arm as a result. They could never relax, though.

Everyone got through the state opening of parliament—my mother felt ludicrous climbing into a long dress and tiara in broad daylight and suffered a fit of nerves at the formality of the event—and then left the dairy farms, weird land formations, and

capital city of North Island for the natural grandeur of the mountains, lakes, glaciers, fords, and sheep farms of South Island.

Here the civic reception was lightened by a little dog that ran out of the crowd, leapt up the steps, and, when Prince Philip and the queen stood during the presentations, jumped up onto one of the vacant chairs and raised its paw to the crowd as though acknowledging their cheers.

The New Zealand tour was a great success, excellently planned and efficiently executed. It was nothing short of a miracle that, thanks to Sergeant Footman Oulton, not a single piece of luggage was lost from the stacks that they were traveling with.

The queen was always impeccable in her behavior and demeanor, performing her duties so perfectly and conscientiously. It was also clear to everyone by now that Prince Philip played an enormous part in the tour's success. My mother loved how he mixed teasing and humor with unexpected kindness and thoughtfulness. It was easy to see why he was so popular wherever they went.

Their entry into Sydney harbor on February 3, 1954, was unforgettable. It was a glorious day, and the sight of this fantastic harbor, with its 150 miles of shoreline, was breathtaking. The whole place was alive with small boats, motorboats, speedboats, sailing boats, and ferries festooned with people, and so top-heavy on the sides nearest the *Gothic* that it seemed preposterous they did not sink. In addition, careering through the tangle, speedboats towed water-skiers in open defiance of the sharks and the more imminent danger of being mown down by other boats, as were the canoeists who ventured out. In addition to the inevitable church bells and cheering, the sound of the ships' horns and sirens was deafening. Indeed, sirens hooting in warning were indistinguishable from the hoots of jubilation, and a number of collisions occurred.

Eventually, they all piled into the procession of cars for the royal progress through the city. After New Zealand it seemed strange to be in an enormous cosmopolitan city with tall buildings and wide streets. There was a tumultuous welcome from the crowds as streamers, rose petals, and confetti were thrown down from the roofs and windows or straight into the cars by those in the crowd who were near enough. The city was won-

derfully decorated, with endless varieties of triumphal arches, including arches made to look like giant crossed boomerangs and even one immense, slowly rotating sham tree trunk.

They plunged headlong into the usual schedule of receptions, inspections, dinners, and drive-throughs. They were all accustomed to people throwing bunches of flowers into the queen's open car, but in Sydney a new danger presented itself when the overexcited crowd started to throw small flags. The sticks came hurtling in at such speed that they hurt the queen and there was concern that she was going to be blinded.

Sydney was abuzz with their visit, and they were amused to see women run out of hairdressers with their hair in pins and nets, the cotton wool that had been protecting their ears from the dryers still in place. They saw men tumbling out of pubs five minutes before closing time as they drove by, and they were told that this was considered by the authorities to be the greatest triumph of the royal tour.

From Sydney they traveled to Tasmania, and from there set sail for Melbourne. At the beginning of March 1954, they took the royal train through Victoria, where some towns were in the grip of an outbreak of polio. As a result, the queen and Prince Philip weren't able to leave the train; instead they stood on the observation deck while the speeches were made. The strain of the tour was showing: Philip mentioned to my mother that several times in the night he had woken up to find himself very cold, with his right arm outside the bedclothes, and realized that he had been waving to the crowds in his sleep.

The queen decided at the beginning of the tour that, even though she loved a good whirl, dancing would be out of the question. She reasoned that if she did dance, she would be devoting a considerable amount of time to one man, whereas if she stuck to talking, she would be able to have a few words with a large number. The good people of Brisbane were distraught, however, that she had made this decision, and wherever they went they were surrounded by people asking why the queen wouldn't dance.

OPPOSITE: On the deck of the HMS *Glasgow* in May 1954. Two women in a man's world.

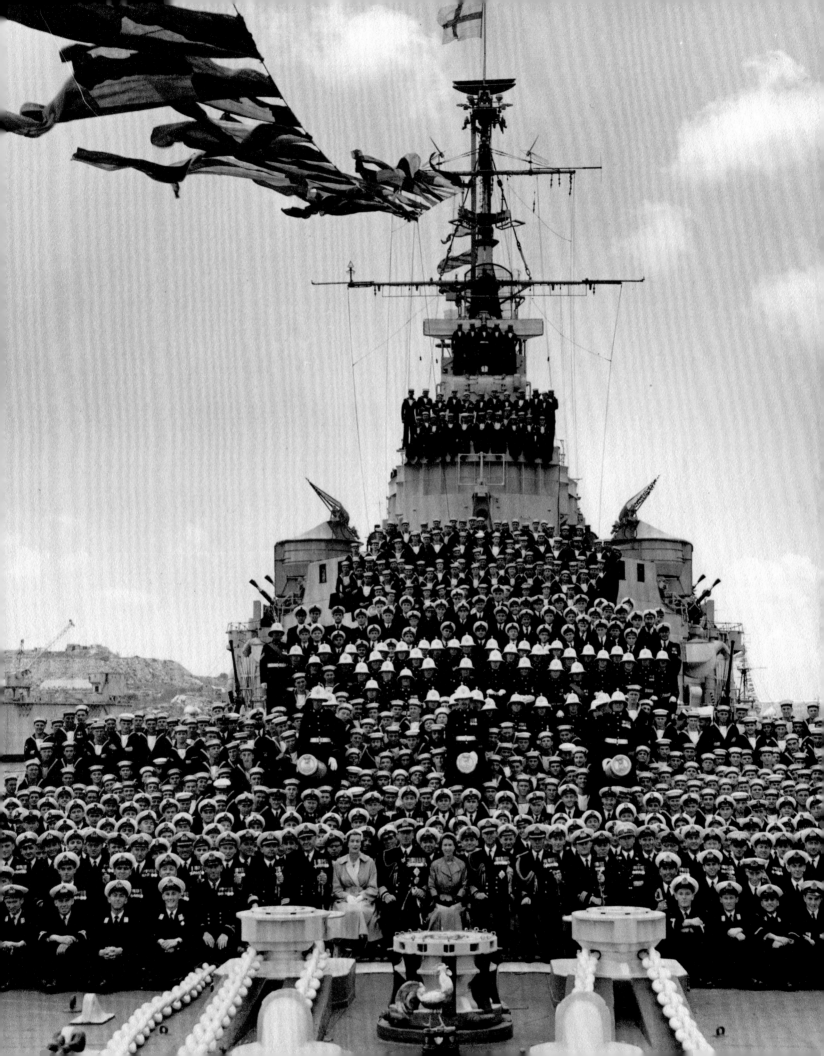

It was vital that the queen and Prince Philip remain healthy. By the time they got to Perth, at the end of March, the outbreak of polio was a major headache for the tour organizers. Cancellation of their visit to Western Australia was even considered, because the premier, Mr. Bert Hawke, did not want the responsibility of the queen contracting polio in his state, quite apart from the very real danger that it might spread through large crowds of people and gatherings of children. It was also obvious that, if at all possible, the tour must take place. All functions were to be held outside, the children's rally was to be canceled, and there was to be no handshaking at any time. The latter proviso was very difficult to adhere to, and the queen soon found herself warmly shaking hands with the Roman Catholic bishop. My mother realized just how much personal contact, that human touch in a handshake, was at the heart of this royal tour.

They left Australia from Fremantle on April 1. Despite the difficulties of the last part of the tour, it had been a great experience, and they had met many interesting people and seen incredible places. But it was definitely the right time to leave, because they were all exhausted, although my mother always remembered how privileged she was to be in this position.

Arriving in Colombo, the capital of Sri Lanka, made my mother instantly homesick for India. The sights, the sounds, and the smells seemed so familiar. She had left Delhi five years earlier, but her time there was still very much a part of her.

The opening of the Sri Lankan parliament, in an open-sided memorial hall, was torture for the queen. The coronation dress was very heavy, and when the sun caught all the diamante and metalwork embroidery, it became so hot that she got burns, even through all her stiff petticoats.

My mother was mesmerized by Sri Lanka—from the quiet kindness of the people to the rice fields, the coconut plantations, the large wild mongooses and monkeys, and the staggering Fortress in the Sky, a gigantic flat-topped rock rising over four hundred feet above the surrounding countryside.

They headed back to England via Aden, Uganda, Malta, and Gibraltar. Aden's towering dark gray volcanic rocks split the horizon with their peaks as they came into the harbor

early one morning. This was the first place where the queen was greeted by groups of black-robed women emitting their trilling cry of welcome.

The newly commissioned royal yacht *Britannia* had now been completed, and having taken Prince Charles and Princess Anne to Malta, it was coming to Tobruk, Libya, so that the queen and Prince Philip could set sail on her. When the party left the *Gothic* at 4 A.M. on April 28, everyone was extremely sad. They had been such a united group for the past five months, and it seemed wrong to be breaking up so near the end of the tour and denying the *Gothic* the triumphant return home. However, upon boarding the *Britannia*, their regrets at leaving the *Gothic* were soon forgotten in the extreme comfort in which they now found themselves.

Several senior members of the Buckingham Palace household had come out on the *Britannia*. They were good company, but inevitably they brought the rather stiff formality of Buckingham Palace with them. The spirit of a family party that had toured the world together was no longer. However, it was a joy for the queen and Prince Philip to be reunited with their children. At their Sunday church service, Sir Conolly Abel Smith, admiral for the royal yacht, read the prayer for the royal family, "We humbly beseech thee to bless our gracious queen, Elizabeth the Queen Mother, Philip, Duke of Edinburgh, Charles, Duke of Cornwall, and all the royal family." When he came to the end, Princess Anne's furious small voice was heard saying, "He hasn't prayed for me, Mummy," nearly bringing the service to an end as they all laughed so much.

It was lovely for my mother to hear of all the children's adventures staying with "Uncle Dickie and Aunt Edwina" in Malta. They brought my mother a letter from my grandmother telling her that poor little Neola the mongoose had died from kidney failure. My mother was very sad because she had expected to be back with him in Malta in two weeks' time. The children wanted to hear about the mischief he had caused, so my mother told them the story of the time their mother had been staying with her family at Broadlands. "Pammy," she said, "I am quite fond of Neola and I don't mind him coming into my bedroom. I don't even mind him opening my box of chocolates. But must he take a bite out of every single one of them?"

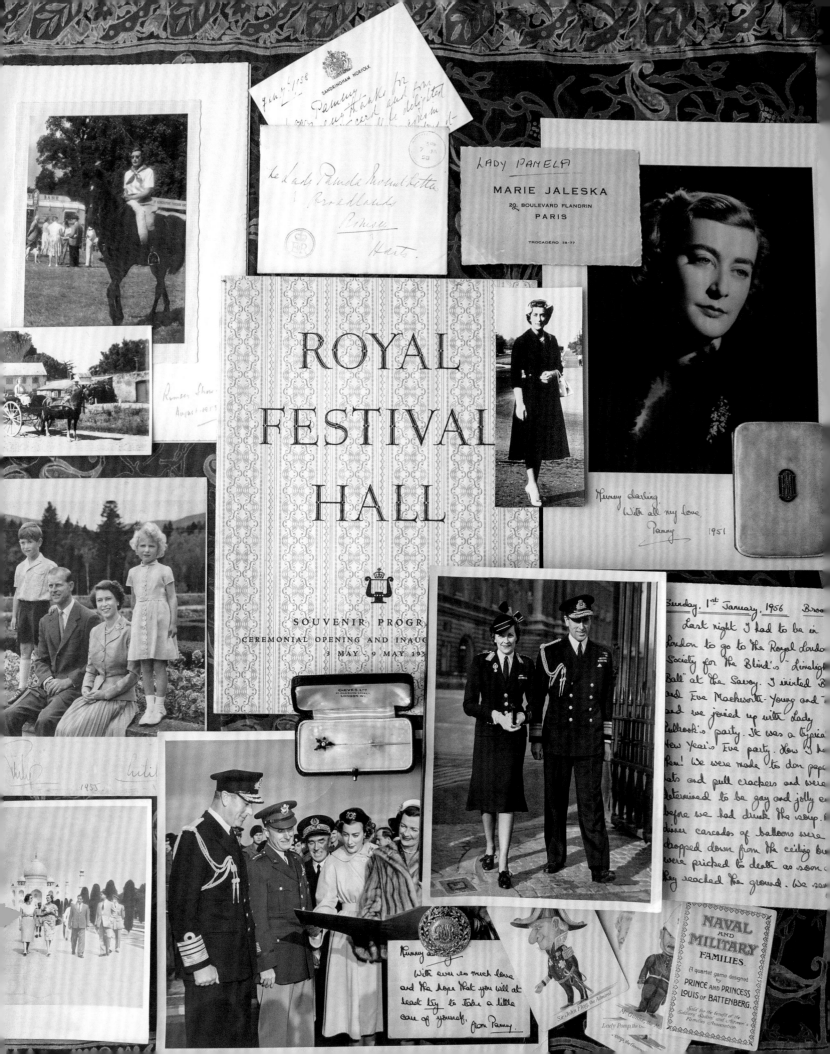

ROYAL FESTIVAL HALL

SOUVENIR PROGR...
CEREMONIAL OPENING AND INAUG...
3 MAY · 9 MAY 195...

LADY PAMELA

MARIE JALESKA
20, BOULEVARD FLANDRIN
PARIS

TROCADÉRO 38-77

SANDRINGHAM NORFOLK

Kenny Darling
With all my love
Pamm. 1951

Sunday, 1st January, 1956 Broo...
Last night I had to be in
London to go to the Royal Londo...
Society for the Blind's "Limeligh...
Ball" at the Savoy. I invited B...
and Eve Mackworth-Young and...
...ed we joined up with Lady
...brook's party. It was a typica...
New Year's Eve party. How I ha...
...hen! We were made to don pape...
...ats and pull crackers and were
...ermined to be gay and jolly e...
...fore we had drunk the soup. ...
...inner cascades of balloons were
...dropped down from the ceiling bu...
...were pricked to death as soon a...
...hey reached the ground. We sa...

NAVAL
AND
MILITARY
FAMILIES.
A quartet game designed
by
PRINCE AND PRINCESS
LOUIS of BATTENBERG.

Kenny ...
With ever so much love
and the hope that you will at
least try to take a little
care of yourself. From Pammy.

GIEVES, LT?
LONDON. W.1

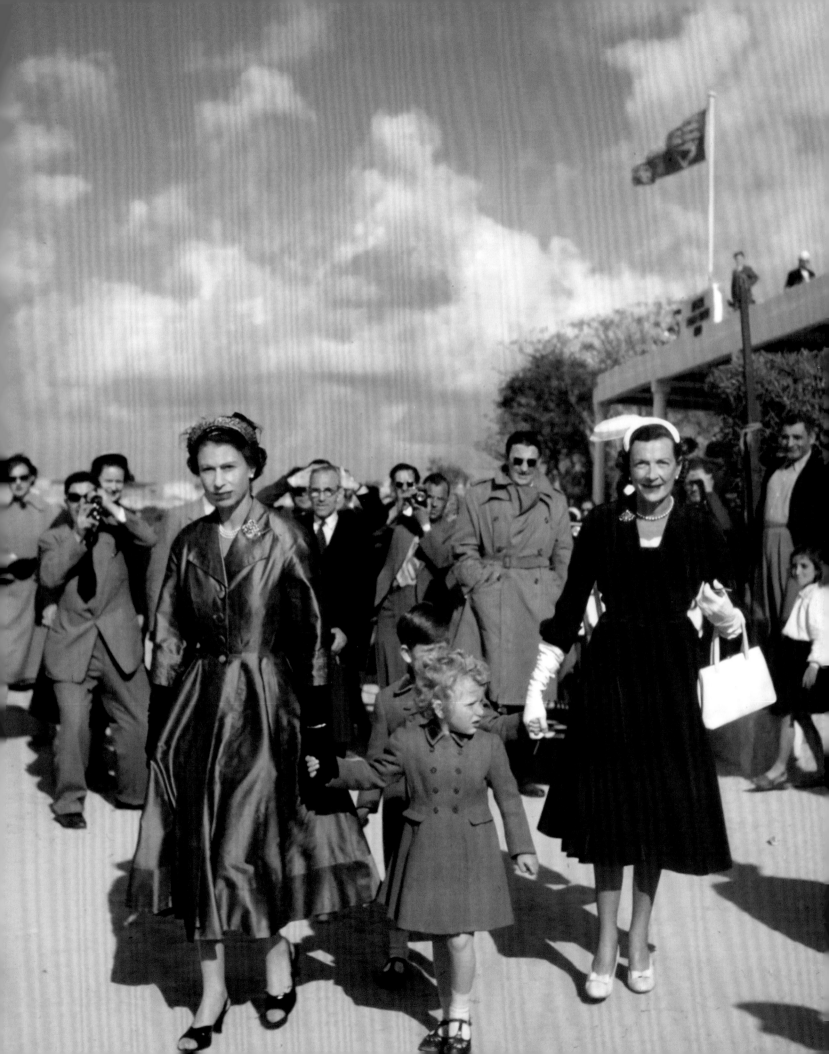

When they reached Malta, *Britannia* steamed up between the lines of her escorting ships, accompanied above by noisy helicopters. It reduced speed and just outside the Grand Harbour breakwater was met by my grandfather's big barge.

As the ship heaved up and down in rough water, my grandmother leapt on board in her usual nimble style. Talking had to wait, as they were instantly caught up in the whirl of a flyby of jets. Then all the ships in the harbor, the naval shore establishments, and the saluting batteries fired a royal salute and, passing the breakwater, *Britannia* was escorted to her berth by landing craft. The noise was deafening: cheering from the packed crowds, the ringing of church bells, the ships' klaxons, all drowned out by the noise of firecrackers, which even by Maltese standards were phenomenal and fearsome.

My mother was very grateful to be back in Malta, to see my grandparents and be surrounded by familiar things at Admiralty House. The queen, Prince Philip, and Aunt Alice dined that night with them before going on to a ball at the Phoenicia. At last, the queen was able to dance. My mother felt even happier for the queen the next day, when she and Prince Philip were able to snatch a small opportunity to act as normal parents and take the children for a drive around the island in their little car.

There were still official engagements to attend in Malta, so my mother remained on board *Britannia*. The Maltese nobility were in their element at the state ball, where they danced their famous il-maltija in powdered wigs and eighteenth-century costumes. It was so windy that the queen and my mother were nearly blown off the flight deck of the aircraft carrier *Eagle*, and the archbishop got so cold during the final brilliant firework display that my grandmother had to wrap her striped silk stole around him. They sailed out of Malta to a terrific send-off from the crowd, people cheering and waving from every possible vantage point.

PREVIOUS PAGES: A sweet note from my mother to my grandmother: "With ever so much love and the hope that you will at least try to take a little care of yourself." Since the war my grandmother had driven herself too hard. In 1960, while my mother was on her honeymoon, my grandmother died in Borneo on an inspection tour for the St. John Ambulance Brigade. She is shown here in her St. John's uniform. Next to this my mother's desperate 1956 New Year's Day diary entry: "It was a typical New Year's Eve party. How I hate them!" The queen, reunited with her children in Malta after several months apart; my grandmother is holding Prince Charles's hand. Duty always came before family. "I declare before you all that my whole life, whether it be long or short, shall be devoted to your service," the queen promised her country *(right)*.

As they entered the English Channel, the Mediterranean Fleet parted company, steaming past at twenty-five knots with the customary flourish and precision. Off Yarmouth, on the Isle of Wight, the prime minister, Winston Churchill, came on board and, rather alarmingly, the queen put my mother on the other side of him during dinner. As he said good night to the queen, she said, "I hope you sleep well." He looked at her and replied, "Now we have got you home, ma'am, I shall sleep very well."

Coming up to Tower Bridge, festooned with a WELCOME HOME sign, all those on board held their breath as they passed underneath, for it seemed impossible that there would be room for *Britannia's* masts. At lunch, with a twinkle in her eyes, the queen resolutely remained in her slacks while she entertained the Queen Mother and Princess Margaret, who were rather splendidly arrayed in silks and diamonds. After lunch, the queen went below to her cabin to change. When she came back up on deck, she looked extra specially smart and appeared rather pleased with herself. She saw my mother looking and said quietly, "I kept these things aside so that I would have something new to wear for our arrival in London." At Westminster Pier, they disembarked to a host of dignitaries, but there was no one more important to my mother in that crowd than her sister, who, touchingly, was there to welcome her home. Rather thrillingly, Lady Alice, Michael, Martin, and my mother had to travel through the cheering crowds to the palace behind the state landau, in a carriage drawn by four bay horses. My mother was bursting with pleasure and excitement—for her that carriage drive made the relentless pace of the past six months worthwhile. They started out in solemn silence but were soon reduced to fits of giggles: as the men were sitting with their backs to the horses, they had to rely on Alice and my mother to warn them whenever they were approaching the regimental flags, so that they could swiftly doff their hats. The Grand Hall of the palace was lined with gentlemen-at-arms and yeomen of the guard and more courtiers than my mother should have thought existed, and seeing tea laid out and watching everyone move about in that stiff Buckingham Palace sort of way, it was difficult to believe she had actually just traveled around the world. My mother took one look at the room buzzing around her and realized that, with immediate effect, she could lead a normal life again. She would not need to attend an opening of parliament every few days or have to climb into a long evening dress and wear a tiara and gloves nearly every night.

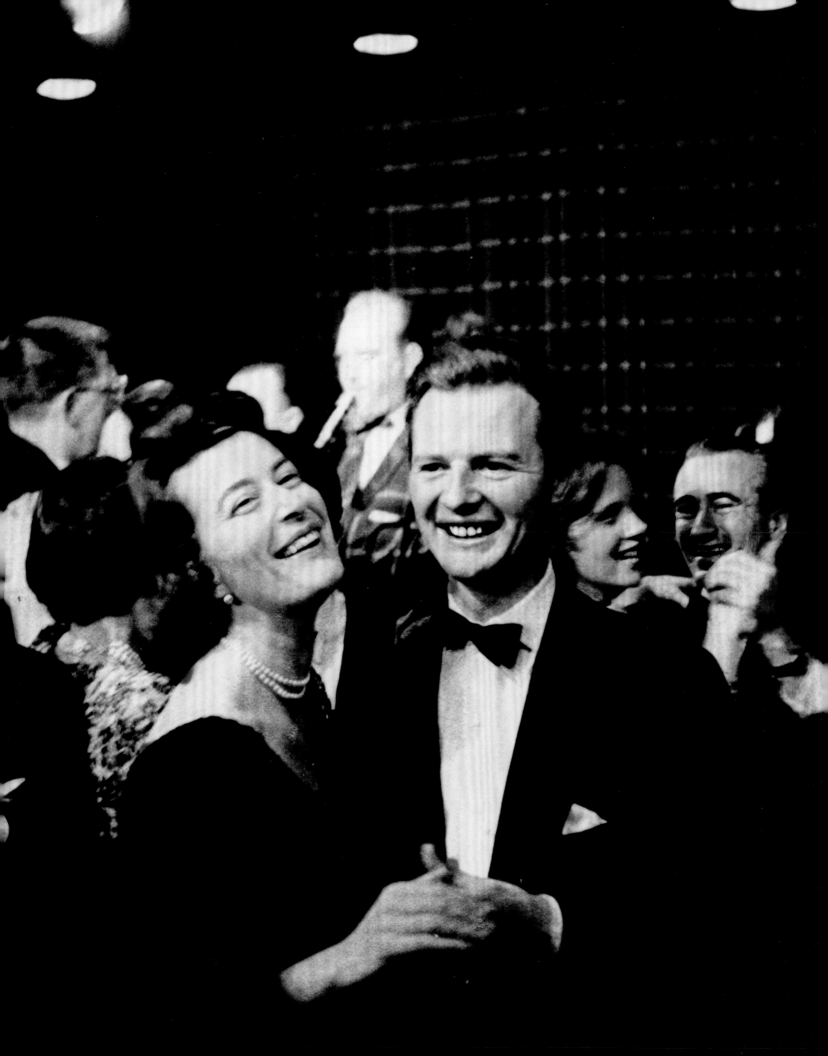

1959-79

An Unorthodox Match

My mother met my father in 1959 at a cocktail party at a house on the historic Cheyne Walk road in London. Later, for one brief moment, they thought about naming my sister, their first child, Cheyne. A narrow escape. Instead, they called her Edwina after our grandmother. My father had gone to the party, arriving early, and found my mother: alone, beautiful, quiet, and rather serious, but hiding a keen sense of humor and fun that perfectly matched his. She had led a quiet life in the years since returning from the Commonwealth Tour, and nothing could have prepared her for meeting and falling in love with the dynamic decorator David Hicks.

My father told my mother his name three times when they met, to be quite sure she remembered it. He also asked her to come for a drink ten days later at South Eaton Place, to see his modern drawings. She had absolutely no interest in modern drawings but was charmed by this handsome, amusing, and confident young man, and so agreed to visit.

When she arrived, according to my father "in the ugliest car I had ever seen: two-tone, with a baby-pink body and light-blue hood," he was again charming, but firmly asked

OPPOSITE: Very early days.

153

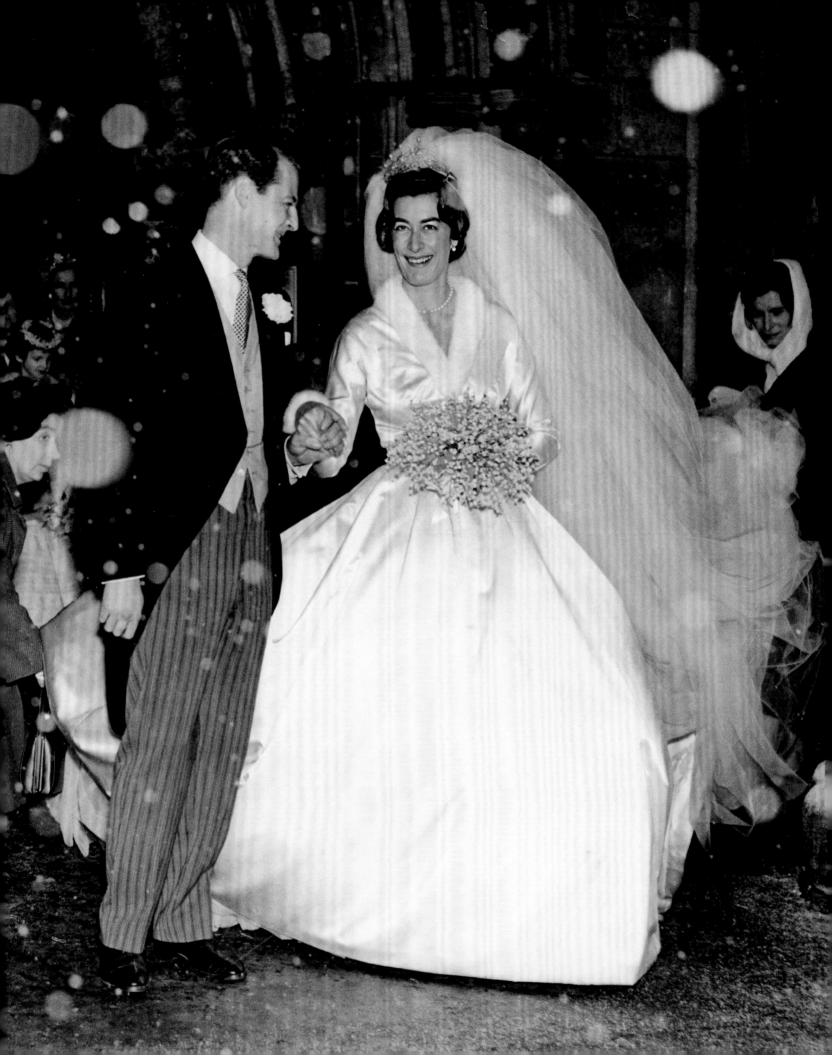

OPPOSITE: A surprise snowstorm made this day an unforgettable white wedding. It also caused huge chaos. ABOVE: My grandmother trying to prevent one of her other grandchildren, Joanna Knatchbull, from leaping out of the car. FOLLOWING PAGES: My parents sailed from Southampton on HMS *Queen Elizabeth* to New York to begin their glamorous honeymoon. The U.S. newspapers had fun when they arrived: "Just a couple of Hicks," read one headline *(left)*. Pumps, pearls, and gloves for running errands *(center)*. My uncle behind my aunt (on the left) and mother and father (on the right) crowded in at a function in July 1965. My father was already beginning to influence my mother's style. That brooch was normally worn on the shoulder of a dress, not on the top of a turban *(right)*.

her to please park her hideous car farther from his house if she ever came again, fearing potential clients would think he had lost his famed color sense.

My mother was well aware that this decorator from Essex was unlike her earlier boyfriends, who had been future dukes and millionaires. She was dreading the day David would meet her famous parents, lest they frighten him away, while he, trying not to seem pushy, never mentioned them.

After weeks of candlelit dinners and dancing, my mother finally mentioned her parents, complaining that she had to go to a military musical parade with them. "I love that sort of thing! The only part of the army that I enjoyed!" he exclaimed to her surprise, and so he was invited. Arriving at the elegant street, Wilton Crescent, they found my grandfather's huge car with his flag on the front and two policemen on motorcycles, ready to escort them. My father, by now a connoisseur of grand lifestyles, noted every detail. My mother nervously introduced him to her beautiful and supremely elegant mother, who was immediately kind to him. Finally, my grandfather "came crashing down the stairs, like a sort of avalanche" in naval evening dress with all his medals jangling on his huge chest, barking orders and hustling them into the car. After the parade, they returned to the house, speeding through the red traffic lights with their police escort. To my father's huge relief, my grandmother drank whiskey and smoked throughout dinner, so that he could do the same.

In the months that followed, their relationship became serious. My parents' engagement was announced in the *Times* on November 2, 1959, to huge press excitement: a "royal" Mountbatten was marrying a "commoner," Hicks.

OPPOSITE: The 1960s were a whirlwind of sadness, excitement, and adjustment. Funerals, balls, memorial services, commemorations, and christenings, and my grandfather's rather long packing list for a Sandringham shooting weekend.

Farewell with flowers and fire

HERALD REPORTER
NEW DELHI, Thursday

An earth tremor centred 150 miles from here

...low, left to right) Dean Rusk, ...d President Radhakrishnan.

GANDHI CENTENARY YEAR 1969 COMMEMORATION

FRIENDS HOUSE. 18 MARCH 7 PM

This meeting has been arranged by Friends Peace and International Relations Committee to commemorate the centenary of Mahatma Gandhi and to pay tribute to his life and work, with its relevance for today.

WESTMINSTER ABB...

ORDER OF SERVICE

in memory of

HER MAJESTY

THE QUEEN OF SWEDEN

Margaretha af Sweden

With ...Lord Chamberlain's

The Lord Chamberlain presents his compliments and has the honour to enclose herewith a Memorandum of Arrangements, together with a Seating Plan, for the Memorial Service for Her Royal Highness The Princess Royal which will take place in Westminster Abbey tomorrow, Thursday 1st April, at 12 noon.

A Red or Green Crown windscreen label should be displayed on the car in order to facilitate arrival at Westminster Abbey. Entrance to Westminster Abbey should be by way of the Great West Door at not later ...1.45 a.m. In case of necessity, a Green Crown ... enclosed.

EIIR

On the Occasion of the 21st Birthday of
The Prince of Wales

YEHUDI MENUHIN

and the

MENUHIN FESTIVAL ORCHESTRA

Leader: Robert Masters

with

MAURICE GENDRON

IN THE BALLROOM
BUCKINGHAM PALACE

FRIDAY, 14th NOVEMBER, 1969

EIIR

On the Occasion of the 21st Birthday of
The Prince of Wales
the Master of the Household
commanded by The Queen and The Duke of Edinburgh
to invite

...Mr David and the Lady Pamela Hicks

to a Concert and Supper Party
to be given at Buckingham Palace
on Friday 14th November 1969

Dress: Dinner Jacket

Guests are invited to arrive from 6.30 p.m.
The reply should be addressed to
The Master of the Household, Buckingham Palace

CW 5/158t.

MEMORIAL

HER LATE MAJESTY

Westmin...

Thursday, ...

ROYAL FAMILY, ...

AND ROYAL ...

THE DUKE OF EDINBURGH

QUEEN ELIZABETH THE QUEEN MOTHER

Princess M...

GPO

POST OFFICE CABLE & WIRELESS SERVICES

RECEIVED PARTICULARS
VIA IMPERIAL
ISSUING OFFICE
London
LT 03869

LVZ513/DS82 NEWDELHI 61 25 1350

COUNTESS MOUNTBATTEN OF BURMA 2 WILTON CRESCENT LONDON-S-W-1

...YOU FOR YOUR TELEGRAM AND LETTER WHICH ...NA GAVE ME LAST NIGHT BOTH YOU AND PAMMY WILL BE VERY WELCOME HERE AND TIME YOU HAVE SUGGESTED WILL BE CONVENIENT TO ALL OF US WE SHALL GIVE YOU REST AND AVOID ALL UNNECESSARY ENGAGEMENTS AFFECTIONATE GREETINGS FOR CHRISTMAS AND NEW YEAR - JAWAHAR

CFM NEWDELHI LT 2- LONDON-S-W-1

Enquiry respecting this telegram should be accompanied by this form. Mark your reply VIA IMPERIAL

Edwina Mountbatten TRUST

...July 17, 1965

The Supremo's last...

AMONG THE CROWD—MRS. WILSON (SECOND FROM RIGHT) AND BESIDE HER MR. DAVID HICKS, LADY PAMELA, LADY BRABOURNE AND LORD BRABOURNE

Picture by L. JOSEPH

This is BRITAIN

They all spent Christmas together at Broadlands, and then, on January 13, 1960, my parents married at nearby Romsey Abbey. They emerged into a whirling snowstorm that seemed a deliberate backdrop to her ravishing Worth dress of white satin edged in white fur. Two thousand guests came back to Broadlands for the reception. Noël Coward, looking at the drifting snow from his car, quipped, "Frankly, I think this is taking decoration a little too far!"

From Broadlands, my parents drove to Southampton to depart on the first leg of their extensive honeymoon. The snow meant the little windshield wipers on my father's fancy sports car could not cope. Neither could my father, who stopped the car, leapt out in a rage, and tore them off! Now that they really were not able to see anything, my mother had to lean out of the window and try to wipe the snow away. Finally, they found a garage where they pulled in and my mother explained to the mechanic that some naughty little boys had vandalized the car. This was the beginning of a complicated marriage between two people who adored each other.

My parents arrived home from their honeymoon to be met at the airplane steps by my uncle John, Lord Brabourne, with the terrible news that my grandmother, Edwina Mountbatten, had died in Borneo during the night of February 21, 1960. My mother was devastated. My grandmother was just fifty-eight years of age. She had worked herself to the bone for the St. John Ambulance Brigade, Save the Children, and other causes. By her bed was a pile of the letters she received from her great love, Indian leader Jawaharlal Nehru, who, for her funeral at sea, sent an Indian navy ship to throw a wreath of marigolds into the waves.

OPPOSITE: Early on in my parents' marriage, at an art exhibition, before my father had time to redesign my mother's hair.

Edwina —— with all good wishes
from a very devoted son-in-law-to-be
Christmas 1959

Quite soon after, my parents bought Britwell, a house built in 1728 among the rolling hills of the Oxfordshire Chilterns. Here my father set about creating the most enchanting, comfortable, and exquisite home for my mother. It would be the place where my father—a restless traveler, but also a devoted countryman, keen shot, and avid horseman—felt most at home.

In 1962 my parents began to travel, first to Israel, for the dedication of the Edwina Mountbatten Forest, in honor of her refugee work. From Israel they went to Iran, where my father was captivated by the beauty of everything he saw. He photographed mosques, palaces, and even the telephone in the shah's palace, which was turquoise with an enormous gold crest on the dial.

The next year they went to Germany, to stay with my mother's cousins in Darmstadt, Langenburg, and Baden, in their historic family houses and castles, all crowded with extraordinary collections of art, furniture, and Fabergé walking sticks.

They went to Kenya in 1964, staying with the remarkable eccentric thoroughbred trainer Pat Cavendish (whom I met right at the end of her life in South Africa, surrounded by dozens upon dozens of cats and her slightly alarming pet chimpanzee). From Kenya they flew on to Addis Ababa to visit the Ethiopian emperor Haile Selassie. They stayed with the British ambassador but drove in the emperor's huge Chevrolet to visit him. They saw Lalibela, with its incredible rock-cut churches, and Axum, legendary home of the queen of Sheba, full of toppled obelisks.

OPPOSITE: Moments captured from the late 1950s into the 1960s. A New Year's Eve party *(bottom center)*, tree planting at Broadlands *(center)*, the steps of Britwell clad in scaffolding, and my grandfather teasing my mother *(right)*, my father with his mother, Iris, a most patient woman *(top right)*. My father, always a keen horseman and dresser *(top center)*. A note penned from my father to my grandmother, and, years later, my grandfather experiments with cleaning his new pool, a seventieth birthday present *(center left)*.

Later that year they were in Tangier, staying at York Castle with Yves Vidal, who had created another of his iconic visions of modern living.

Toward the end of 1964, they were back in Africa, this time joining my grandfather on an official tour of West Africa in his position as chief of the defense staff, the military head of Britain's armed forces. They went to Liberia, Nigeria, and Benin. All very exciting.

In 1966 my father persuaded my mother that they needed a house in the South of France in lovely, unspoiled Roquebrune-sur-Argens. The handsome house, dating from the eighteenth century, was on the main square.

My father began work on the new home of attorney Dan Paul in Miami in January 1970. This was a great project, not only because Dan became a close friend of the family but because his house was civilized and chic, with a beautiful garden by Peter Coats. At the same time that he was working on Dan's house, my father was going out to the Bahamas, to Eleuthera, where he and my mother had honeymooned ten years before. My grandfather knew Sir Harold Christie, a Bahamian politician, realtor, and businessman known as "The Father of Bahamas Real Estate," who played a significant part in developing the islands of Lyford Cay and Windermere. Christie encouraged my mother and aunt to buy plots of land, another project for my father, who set about creating a holiday home that would stand out unlike any other at that time and in that part of the world. Inspired by his visit to Egypt, my father reached back to the dawn of architecture for his inspiration. Ancient and modern, the house, Savannah, initially provoked great alarm and astonishment, though later it garnered much admiration. My mother

OPPOSITE: As the children grew, so did the height of the hair. FOLLOWING PAGES: I tried to persuade my mother to let me use this photograph for the cover of this book. "No, darling, this never quite felt like me" *(left)*. Britwell House was now brimming not only with three young children but an endless succession of guests. My father loved to entertain loudly; my mother preferred to read quietly *(right)*.

164

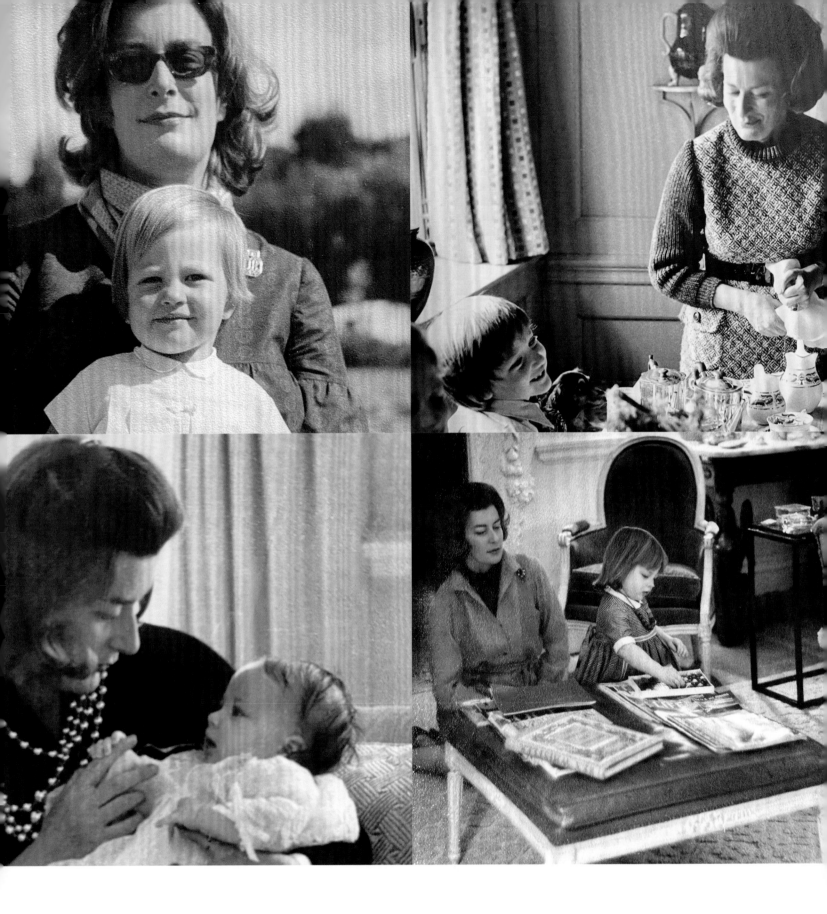

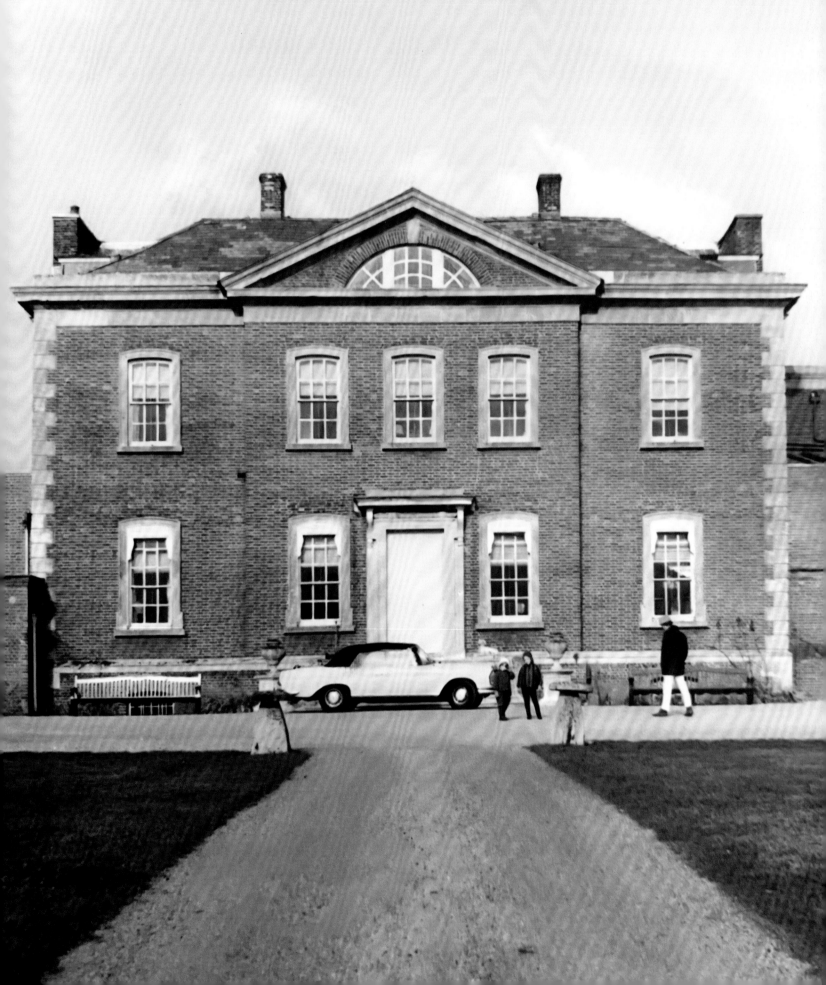

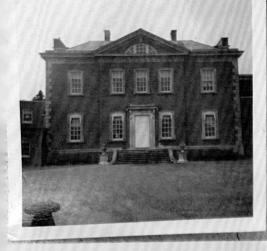

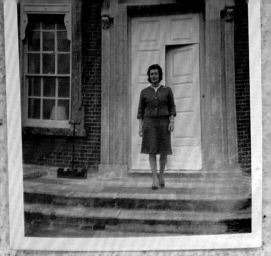

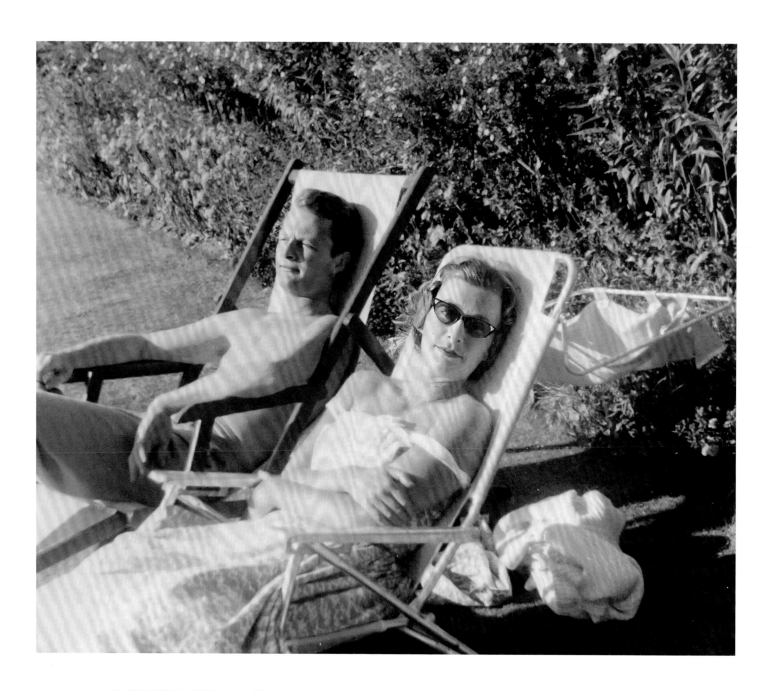

PREVIOUS PAGES: Britwell became my father's design laboratory. Here he created not only a home but a sensational house, photographed by design magazines, whose editors flocked from around the world to see it. My father would take them on a tour from one wing of the house to another, while my mother hid upstairs, happy to be out of the limelight. ABOVE: Sunbathing at Newhouse, the home of my aunt Patricia and uncle John. Even after marrying, my mother would spend as much time as possible with her sister and brother-in-law, whom she adored equally. FOLLOWING PAGES: Between the two sisters, there were a lot of births, babies, and christenings *(left)*. Some serious reflection between my mother and my sister, Edwina *(right)*.

spent many very happy Easters there, surrounded by her children, sister, brother-in-law, and many nephews and nieces—but not her husband, the designer of the home, who decided after creating a house built from cement and sand that he no longer liked the feel of sand between his toes.

In April 1971, my father convinced my mother to leave her quiet English countryside, and her children, horse, and dogs, to join him on a promotional tour of the United States for his Stevens collection of bedding. They had the company plane, which was comfortable, although, as my father irritably noted in his luxurious, leather-bound itinerary, "My window partly frosted over for the entire trip." They visited eighteen cities in three weeks. While my father was busy becoming a brand, my mother was missing home.

Vancouver was not on the Stevens program but craftily added by my father to coincide with the royal family's presence on the royal yacht *Britannia*, so that he could sleep on the yacht and breakfast with the queen.

While my father was opening shops around the world, my mother continued with her charity work: sitting on boards, opening hospitals, touring medical centers, shaking hands, giving speeches, raising money. They were both too busy to notice that all of the splendor of Britwell and the other houses had not come cheap, and my father's work had yet to yield any reward financially. They now shared anxiety over money. The crunch finally came in spring 1977. I can remember being sat down, squeezed between my brother and sister, feet dangling off the sofa, as my parents explained that we had to sell our home; it was simply too expensive to continue living in it. The house required too much work, they explained, and needed too many staff to keep up, especially in the absolute perfection that my father always demanded of his surroundings. The news was confusing, and devastating. But worse was to come.

In addition to Broadlands, my grandmother had inherited an Irish estate in County Sligo from her father. The site was astonishing, high on a promontory jutting into Donegal Bay, with a further finger of rocky land stretching before it into the rough Atlantic waters. Most of the estate was lost when Ireland became a republic, leaving my grandmother to inherit just a little land and a small fairy-tale-like castle, named Classiebawn.

171

MARLBOROUGH TIMES
AND
WILTS, BERKS & HANTS COUNTY PAPER

Established 1859

Price 3d

Friday, April 20, 1962

Registered for transmission

Vol. C. No. 5,460

VAUXHALL CARS
BEDFORD
VANS & TRUCKS
Your main dealers
SKURRAY'S
MARLBOROUGH Tel. 806
Head Office: Swindon 22666

BRISTOL & WEST
BUILDING SOCIE...
Bath Office 3 and 6
Bath. Tel. 222/

and sa... ad
sound in...

QUEEN IS GODMOTHER

Unfortunately, we don't know the answer.

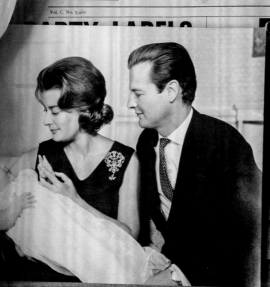

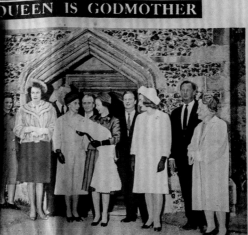

MOTHER WITH DAUGHTER INDIA

India Weekly Thursday 16 November 1967

★ ★ ★ by Lady Pamela Hicks

My First Meeting with Panditji

Lady Pamela Hicks is the younger daughter of Earl Mountbatten. As a girl she was in India with her parents when her father was Viceroy and then Governor-General of India. She tells the rest is her own words ...

WHEN one meets a great and famous man it is usual rather an awe-inspiring moment, particularly if one is seventeen years old, as I was when I first met Panditji. Only too often is the memory of the awe-inspiring moment retains nothing perso... One knew the person in the because that is their reputa... and one is beglamoured by their fame, but in a fleeting introduction it is hard for the great man to convey a personal and lasting impression, particularly when one is expecting instant words of wisdom to fall from his lips, and one is unlikely to be content with anything less than a memorable clap of thunder to mark the occasion. It is clearly a different situation and more often than not it is made impossible by the fact that between the great man and the young person there is little means of communication.

a light and personal touch that he captured one's interest or fired ... enthusiasm and never, never... done. I remember that when... beginner he was talking of his time in jail. I ... and he was ... the nonpoison...

INSTANT COMMUNICATION

But Panditji liked young people so much that there was instant communication. There was no disillusionment. One was left in no doubt about having had a great...

you time to think, and that it would do many people good to be in prison for a while.

It seemed to me that after having spent fourteen years in jail, it was surely able to speak of a

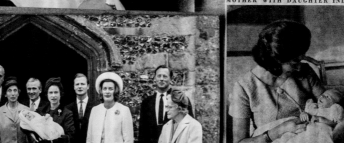

Lady Pamela Hicks with her baby daughter named India
... taken by her husband, Mr David Hicks, ... ly all success.

Duke is godfather at Ewelme christening

The sun shone brightly when Ashley Louis David Hicks was born on July 18, but when he was chris- tened on Thursday it rained ceaselessly, thereby showing no respect at all for his famous relative the Duke of Edinburgh, who flew by helicopter to be a godfather.

Ashley, the second child of the Hon David and Lady Pamela Hicks of Britwell Manor, cried throughout the minute christening service at the 14th century Ewelme Parish Church. The Duke of Edinburgh arrived in a helicopter of the Queen's Flight at R.A.F. Ben... on and drove to the church two miles away.

were the Hon Mrs Mary Max... en and Mrs Beador Drum...
mond.
The Rector of Ewelme, the Rev J. St. Clair Thomas, chris- tened the baby Ashley, the maiden name of Lady Pamela's mother the late Countess Mountbatten Louis after Earl Mountbatten and David after its father.

Following the procession from the church, led by Lady Pamela in a fur hat and gay orange coat, were several tradespeople

from the area round Britwell Manor, who were invited to the christening.

'Thrilled'

One of them, Mr Arthur Scott, a Watlington garage pro- prietor who services Mr Hicks' Jaguar and Lady Pamela's Triumph Herald, said: "My wife and I were thrilled with we of the invitation.
Mr Hicks and Lady Pamela... one other child, Edwina ... who is a few years old... month.

The christening of Ashley Louis David Hicks at Ewelme Parish Church on Thursday last week.

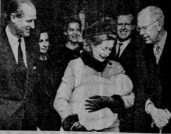

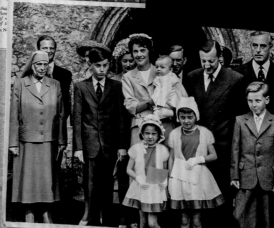

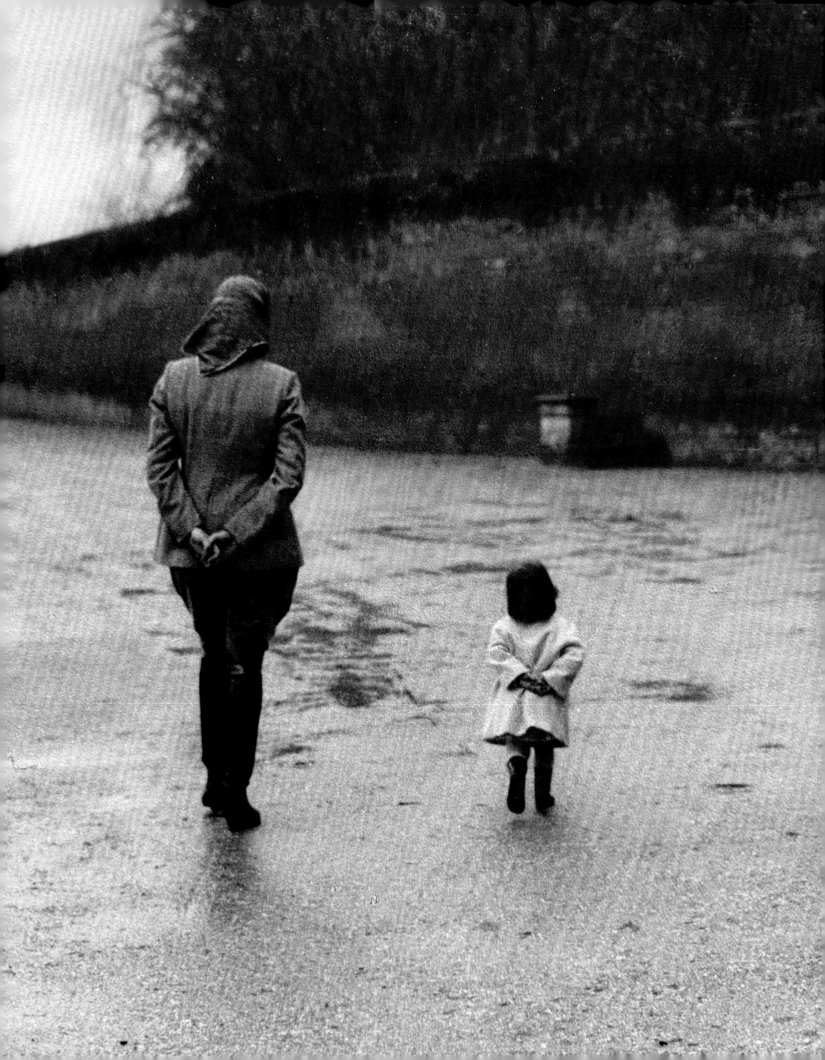

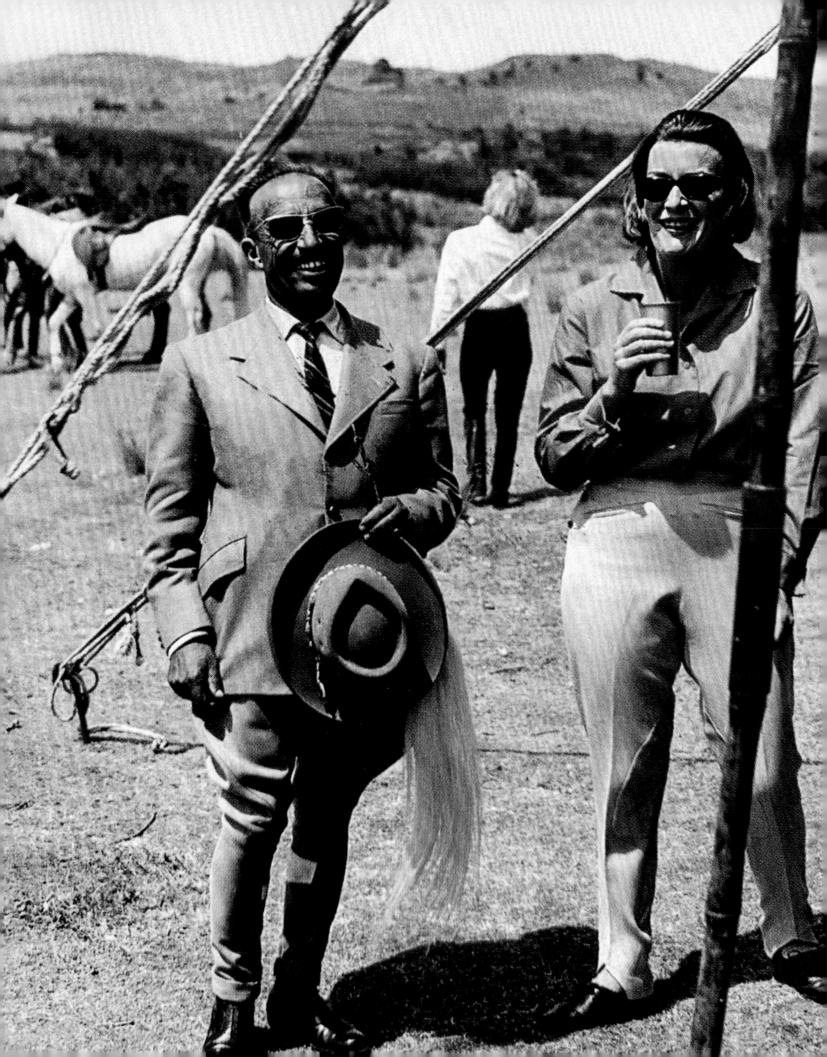

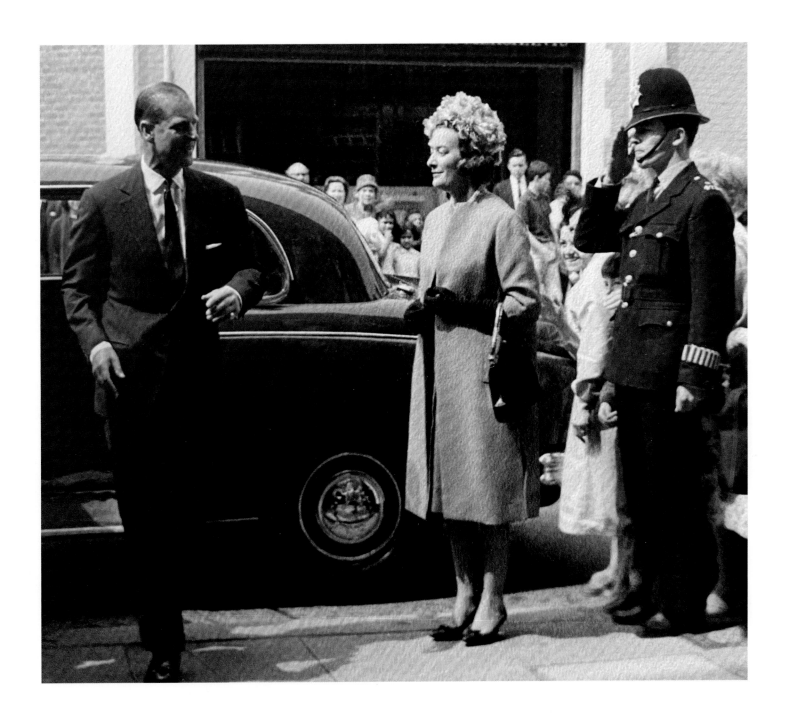

OPPOSITE: My mother with the emperor of Ethiopia's "Master of the Horse." ABOVE: Greeting Prince Philip at a charity event. My mother's life was a blend of travel, charity, and welfare work. "Look up and look out, say less, do more" was Prince Philip's philosophy, and one she took to heart. FOLLOWING PAGES: My mother learned firsthand from her own father, and later from her mother's renaissance, about service and duty, which was also heavily imbued through the example of the queen. My grandfather took these snaps of the queen dismounting in the courtyard of Buckingham Palace after taking the salute at her annual birthday parade, Trooping the Colour *(left)*, and off-duty, about to hack out at Broadlands *(right)*.

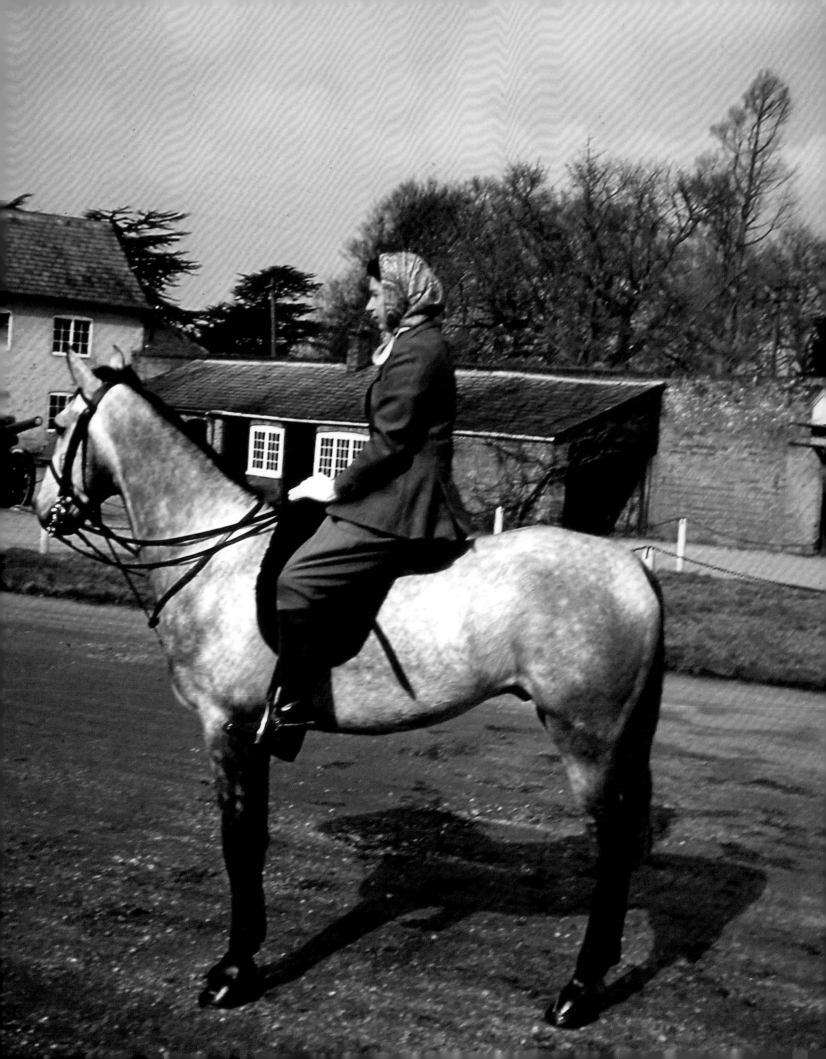

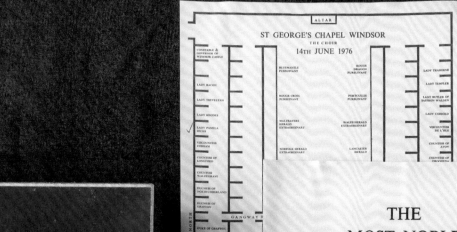

ST GEORGE'S CHAPEL WINDSOR
THE CHOIR
14TH JUNE 1976

THE MOST NOBLE ORDER OF THE GARTER

THE INVESTITURE
14th JUNE 1976

THE MOST NOBLE ORDER OF THE GARTER

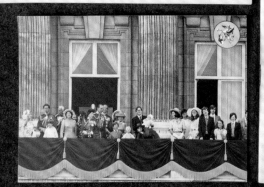

Photo: Fox Photos

THE ORDER OF PROCESSION & INSTALLATION SERVICE

WINDSOR CASTLE

MONDAY, 14th JUNE, 1976

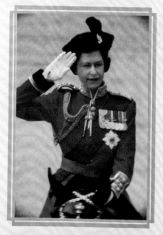

Trooping the Colour

Silver Jubilee Year 1977

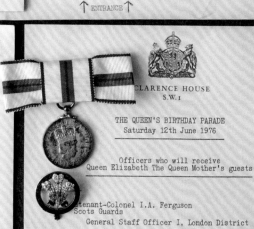

CLARENCE HOUSE
S.W.1

THE QUEEN'S BIRTHDAY PARADE
Saturday 12th June 1976

Officers who will receive
Queen Elizabeth The Queen Mother's guests

Lieutenant-Colonel I.A. Ferguson
Scots Guards
General Staff Officer I, London District

Lieutenant-Colonel M.F. Maxse
Coldstream Guards
Assistant Adjutant General, L

SILVER JUBILEE MEDAL
1952-1977

SILVER JUBILEE MEDAL
1952-1977

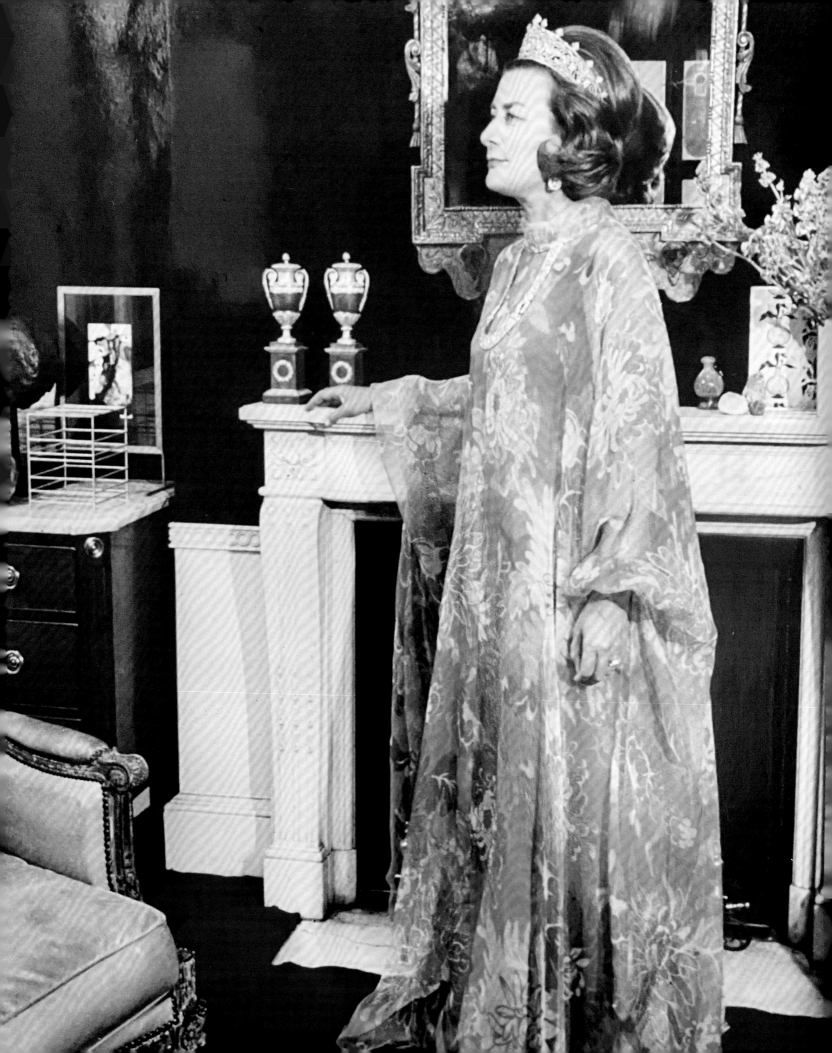

The year 1979 was a terrible one for my family, and I cannot imagine how my mother coped through it. In August of that year, my grandfather was assassinated by members of the IRA, and we lost other family members and a friend in the bombing as well (these events are detailed in the next chapter).

My parents also sold Britwell that year, and were now camping in a very small house at the end of the drive waiting for the new house to be ready. My mother was living among packing cases and cardboard boxes. The glory of Britwell was gone, and the grieving for her family's tragedy began. Was it then that the cancer crept in, feeding on her stress, sensing her vulnerability?

Upon hearing her breast cancer diagnosis, my mother carried on as she always had. Not wanting to be a bore to anyone, she quietly asked the gardener to drive her to the hospital for her operation. She told only a handful of people what was happening, and she chose to recover privately with Aunt Patricia.

My father, meanwhile, was moving his London headquarters to Jermyn Street, so now their small flat in Chelsea made no sense—but Albany, London's most exclusive address, just across Piccadilly, certainly made sense to my father.

Here he painted the walls of his newly acquired set of rooms a deep red, and made a carpet in rich Victorian colors and bulging festoon curtains in scarlet and black. One big room became his bedroom, where he made a truly splendid bed—"a bed to receive one's doctors from, a bed to die in" as he described it—with soaring curtains of scarlet glazed cotton lined with the scarlet silk damask that he had commissioned to be woven in 1962 for the dining room at Britwell.

PREVIOUS PAGES: Every year as children, we had the very great honor of being invited to watch the queen's birthday parade, Trooping the Colour, in which my grandfather rode as colonel-in-chief of the Life Guards. We would drink lemon refresher in the state rooms of Buckingham Palace before standing on the balcony, with the royal family, as the queen waved to the cheering crowds. The little postcard on the bottom shows me as a young girl on best behavior right at the end of the balcony (left). Under great duress, my mother could be persuaded to dress up in her magnificent tiara for some social occasion. Once when traveling to a foreign royal wedding, through one airport to the next, my mother hid her tiara under a large velvet hat in order to satisfy the insurance company that the tiara would be with her at all times (right)!

180

Back in Oxfordshire, my father's brilliance was turning the small dower house into the perfect country home for him and my mother. The Grove lies only a few fields away from Britwell, so my mother's riding was uninterrupted, and my father set about creating a new home and extensive garden.

These days, my mother likes to sit quietly in her pink drawing room reading, just as she did when my father was putting the finishing touches on their home. My mother says she knew there was absolutely no point getting involved in the decorating of the Grove, much to the perplexity of friends and visitors who would ask her what the plans were. "I never knew because I was reading, and really what was the point of spoiling an expert decoration with silly ignorant questions?"

My father was never going to sit still, even after the house was completed, and no one, least of all my mother, would have expected him to settle down next to her on the sofa. In fact, I hardly remember him in the pink drawing room; instead, he would be in the library, directly across the hall of waxed York flagstones. My father created a warm, cozy room around my great-great-grandfather's old desk, upon which stood his grandfather's gilt sphinx clock. Over the small chimney breast my father stretched his grandmother's deep red velvet evening dress, upcycling way before anyone else.

Having to sell Britwell must have been profoundly sad in many ways, even if this fresh rural idyll offered an easier rhythm and spirit, but while the Grove may reflect some of the fancies and foibles of my flamboyant, eccentric father, it remains, to this day, the home of my mother, and an exquisite example of a well-lived life in the English countryside.

While my mother adored England, the other house she spent a great deal of time visiting was Villa Verde in Portugal, the project that probably excited my father the most. Client and friend Nahid Ghani allowed my father's imagination to take full flight in this, the most comprehensive project of his career. He became the architect, interior designer, and landscaper. He commissioned the paintings and drawings and designed the furniture for specific positions.

Villa Verde took three years to build. The villa was magnificently perched on a hill, ensuring that it would have a lasting view of the Atlantic. The friendship between Madame Ghani and my parents was also lasting: my mother spent many summers there and they passed hours at the card table where tremendous games of canasta played out. To this day, Madame Ghani and my mother call each other, each just checking to make sure the other is still alive.

My father turned sixty in 1989. He knew my mother would definitely want to give him a big present and felt that creating a pavilion of his own design in the garden would be just the thing. He started sketching at once. He wanted to build something romantic and Gothic at the corner of his secret garden, where he had hoped my sister, or I, might one day get engaged. We both disappointed him. The design he settled on was for a small castellated tower with a mini design studio below and an outside staircase leading up to a tiny sitting room above. Always thinking ahead, my father explained that the lower room was where he would be laid out after his death, so that we could all come and bid him farewell there.

In 1995 my father decided that he needed to relaunch his interior design career in earnest. For months, builders and painters worked on the rooms at Albany, removing all traces of its previous 1830s, red incarnation. Finally, all was ready. He moved into the newly finished apartment and then, rather formally, he invited my mother to come. It was 1995, but it felt like 1959 all over again, when my father had asked her to come for a drink at South Eaton Place to see his collection of modern drawings. Now he opened the door, and where there had been a narrow little passage beside the galley-like kitchen, she found herself in quite a large hall, painted pale yellow, with white plaster Egyptian gods and pharaohs staring down at her from the walls. The whole mood was modern, clean, and simple, although most of the ingredients were old. My mother saw the new bedroom that he had made for her at the back, which was very pretty, all in pink and orange. She was told that the pictures were of men because "Albany isn't a place for women," which made her laugh. She told him how clever he was to have made it look so good, how big the hall now looked thanks to his genius; then she asked to see the kitchen. There were two tall, narrow cupboards in the corners of the hall, and these he opened with a flourish, showing a tiny sink and miniature fridge in one, and a small kettle, toaster, and microwave in the other. They ate out a lot.

ABOVE: My father learned to be a very good shot. He also smoked for England, as we say.

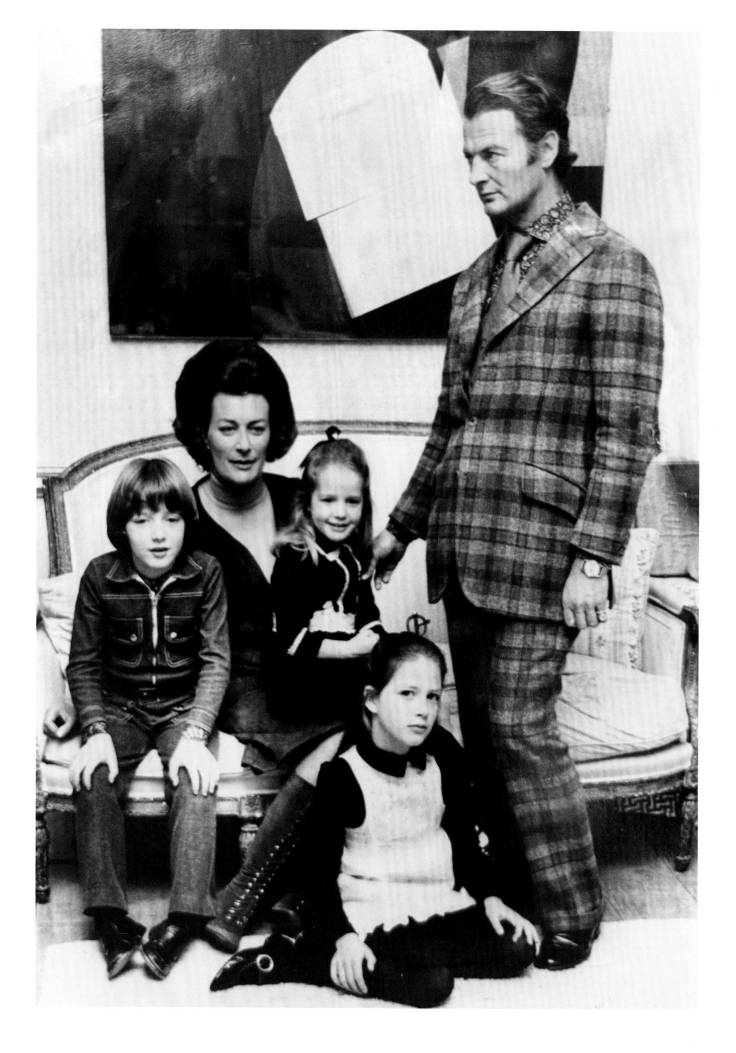

Two years later my father was still traveling the world, his charm and his theatrical talent, his passionate connoisseurship and boundless energy still in demand, lecturing on his work at home and abroad, although a series of cruel blows were to come. My father was handsome and somewhat vain, so dealing with a benign tissue growth that made his neck and arms swell dramatically must have been hard to cope with. His indomitable spirit helped him through the crisis, and he grew a beard to cover his neck and had his tailor remake all his suits and jackets. But during this time, a poisonous business partner led the David Hicks company into bankruptcy. My father could not understand that neither the beauty of his creations nor the power of his name could reverse the situation. After all those years of work he was financially ruined. This must have hurt him deeply, but it also affected my mother, who as always was left to handle the chaos.

In 1997 my father came to see me in the Bahamas, on his way back from an exhausting trip to Cuba. It was the only time I ever really attempted to cook, desperate to impress my very difficult father. He stayed less than an hour. When he left, he was coughing blood. Cancer was raging through him.

We gathered in London for his sixty-ninth birthday. He did not accept our presents, saying he had no time to enjoy them. He had suffered a small heart attack a few days before. My mother found him on the floor and called an ambulance straight away, but when it arrived he refused to get in it, saying it was too hideous and common to ride in. My mother had to drive him in his own car, following the ambulance.

But in true David Hicks style, he returned home to die in his own bed at the Grove, his eyes looking out across the garden he so loved, with my brother and mother beside him.

OPPOSITE: When hunting through old archives to find fresh photographs for this book, I discovered a file neatly labeled by my mother, "Hairdressers Gone Bonkers." This hairdo was one of the least bonkers.

OPPOSITE: The other house my mother spent much of her later life in belonged to dear Persian friends. Nahid Ghani stands here on the terrace of Villa Verde in the Algarve, Portugal, for which my father was architect and interior and garden designer. Plain stone painted cement columns stand out against the roughly rendered walls that have been covered with my father's special concoction of local orange sand, crushed seashells, and bits of stone and terra-cotta. ABOVE: The great room is the full height of the house. At the other end of the room there is a magnificent Georgian chimneypiece, above which is a dramatically scaled plaster mirror frame, almost touching the gigantic cornice. At each end of the room there are circular openings in the manner of a Renaissance palazzo. The carpet was adapted from one of my father's old Persian designs intended to make the owners feel very much at home.

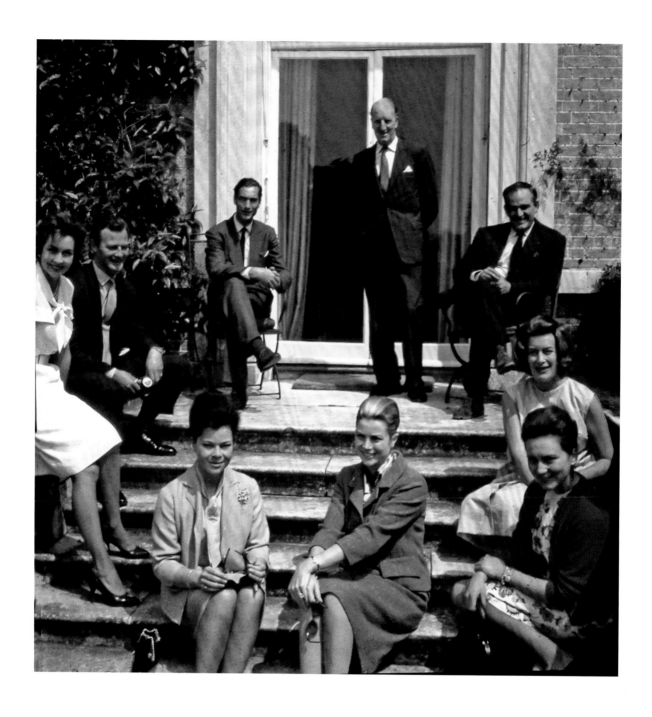

ABOVE: Princess Maria Beatrice of Italy and Princess Grace of Monaco prominently on the steps of Broadlands, among other guests staying for a weekend. My father is on the far left and my mother, pretty in pink, on the far right. OPPOSITE: My mother in her signature pearls, my father in his signature H tie. FOLLOWING PAGES: The passing of years reflected in weddings celebrated, memorial services attended, and concerts enjoyed with not a hair out of place. PAGES 192-93: My parents out riding. My father, never one for conformity.

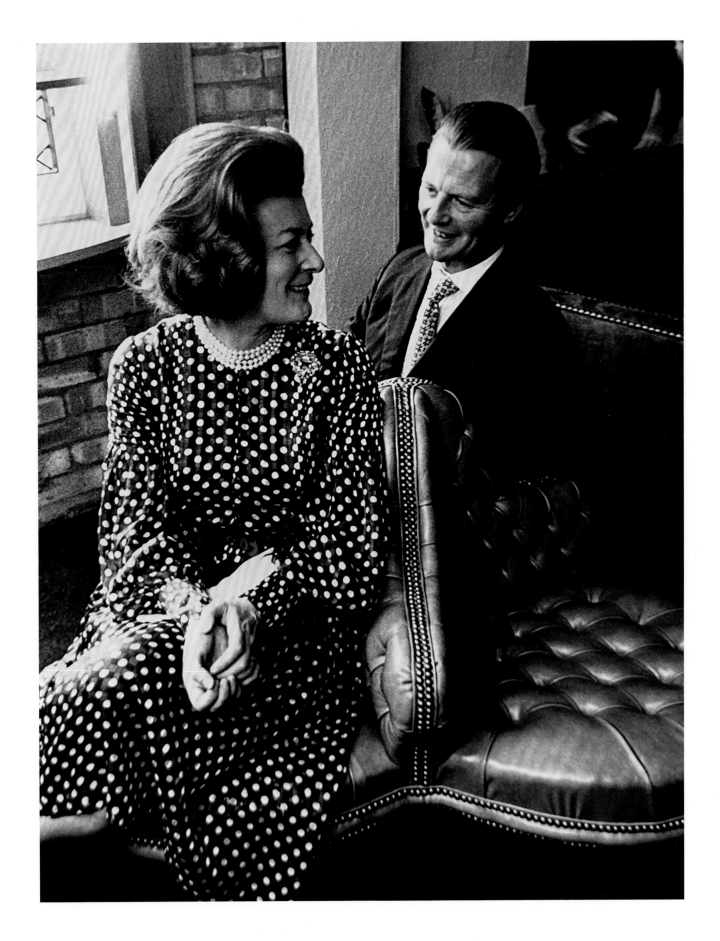

SERVICE OF THANKSGIVING

on the occasion of

The Twenty-fifth Anniversary

of the Marriage

of

HER MAJESTY QUEEN ELIZABETH II

and

HIS ROYAL HIGHNESS

THE PRINCE PHILIP DUKE OF EDINBURGH

in Westminster Abbey

on

Monday 20 November 1972

at

11 a.m.

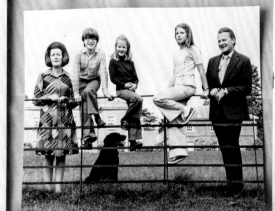

WESTMINSTER ABBEY

ORDER OF SERVICE

in memory of

HIS MAJESTY

THE KING OF SWEDEN

Born - 11 November 1882
Died - 15 September 1973

Friday
5 October 1973
at 12 noon

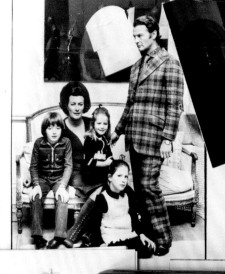

EIIR

WEDDING BREAKFAST

following the Marriage of

THE PRINCESS ANNE

with

CAPTAIN MARK PHILLIPS

BUCKINGHAM PALACE

WEDNESDAY, 14th NOVEMBER, 1973

PRINCE OF WALES INVESTITURE MEDAL

1969

EIIR

The Lord Chamberlain is Commanded by
The Queen and The Duke of Edinburgh to invite

_____ and Lady Pamela Hicks

to the Marriage of
Her Royal Highness The Princess Anne
with
Captain Mark Phillips
1st The Queen's Dragoon Guards
in Westminster Abbey
on Wednesday, November 14th, 1973 at 11.30 a.m.

An answer is requested to the Lord Chamberlain, Dress : Morning Dress for Lounge Suit
St. James's Palace, London, S.W.1, Serving Officers: Ceremonial Day Dress
as this Invitation will not admit. Ladies : Day Dress with Hat

EIIR

MENU

Crème Argenteuil

Suprême de Saumon à l'Anglaise

Poulet Poêlé Derby
Haricots Verts
Chouffleur Glacé
Pommes Nouvelles
Salade

Bombe Glacé Royale
Friandises

WINES

Sherry Fino La Ina
Moselle Scharzhofberger 1967
Claret Château Pontet Canet 1961
Champagne Bollinger 1961
Port Dow 1955

le 10 Juin 1971

BUCKINGHAM PALACE

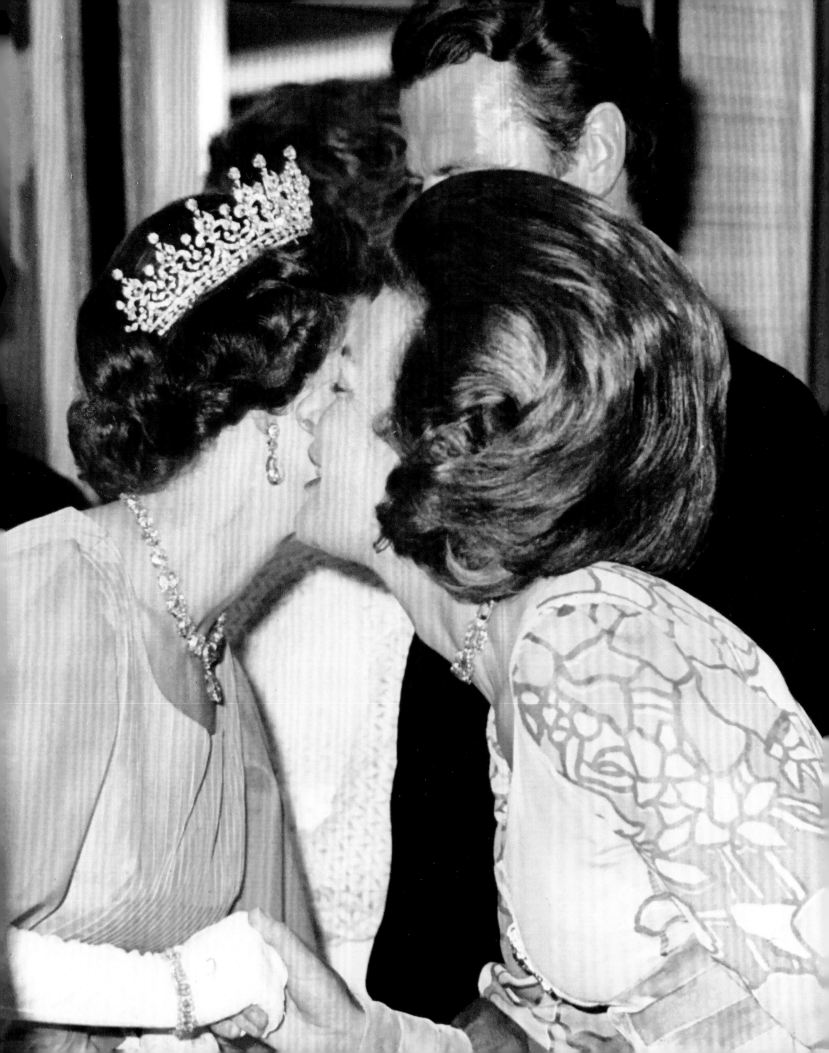

1979

VIOLENCE, TROUBLE, HEALING, AND FORGIVENESS

My grandfather's death came cruelly and unexpectedly. One can never be prepared for death, but the way in which he was taken from us still shocks me to this day. It was August 1979, and we were coming to the end of our annual family gathering at Classiebawn, our family home in County Sligo, on the west coast of Ireland.

Classiebawn—nominally a castle but more of a big house with a fairy-tale look—had been in my grandmother's family for some generations, and she had gone there as a little girl. It had been used as a shooting lodge. But after the Easter Rising in 1916, the family never returned. Later it was restored and reinvigorated and became the focal point of our family holidays, a place where my mother and aunt brought their families each summer to spend time together and with my grandfather.

OPPOSITE: Another happy summer at Classiebawn, our family home in County Sligo, Ireland. At the top of the steps, my grandfather is sandwiched between my aunt Patricia and my uncle John *(left)* and my mother and father *(right)*, with an assortment of cousins and my brother and sister below. My mother gave us all T-shirts with our names on them. I don't think it was entirely done to distinguish Nick and Tim, who, being identical twins, were fairly indistinguishable. We could not possibly imagine the shocking events that were to come. FOLLOWING PAGES: I recently returned with my own children to Classiebawn and took this photograph of the castle from the end of the drive, with the sheep gently grazing and the clouds moving slowly. I was standing there on the anniversary of the IRA bombing on August 27, thinking back to 1979 *(left)*. My mother has never returned to Classiebawn. I imagine she prefers to remember much happier times there, like this quiet moment *(right)*. Despite the ruthless display of the IRA's capacity for violence, my mother and the rest of the family followed my aunt Patricia's example of forgiveness.

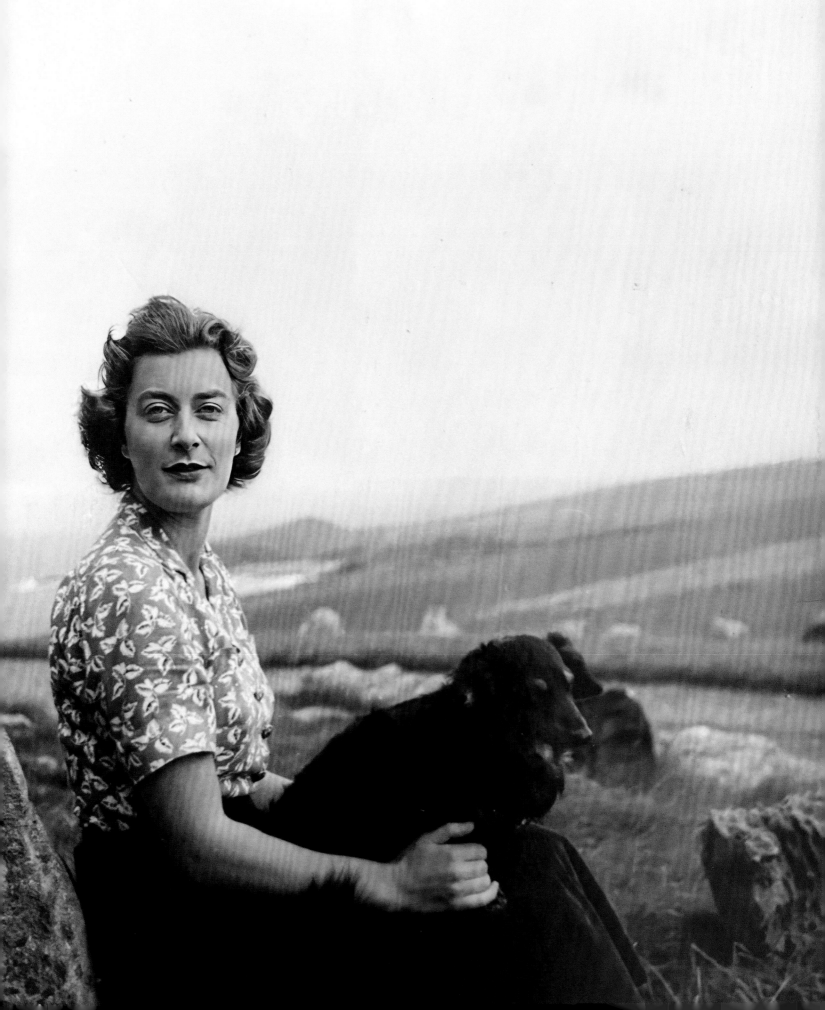

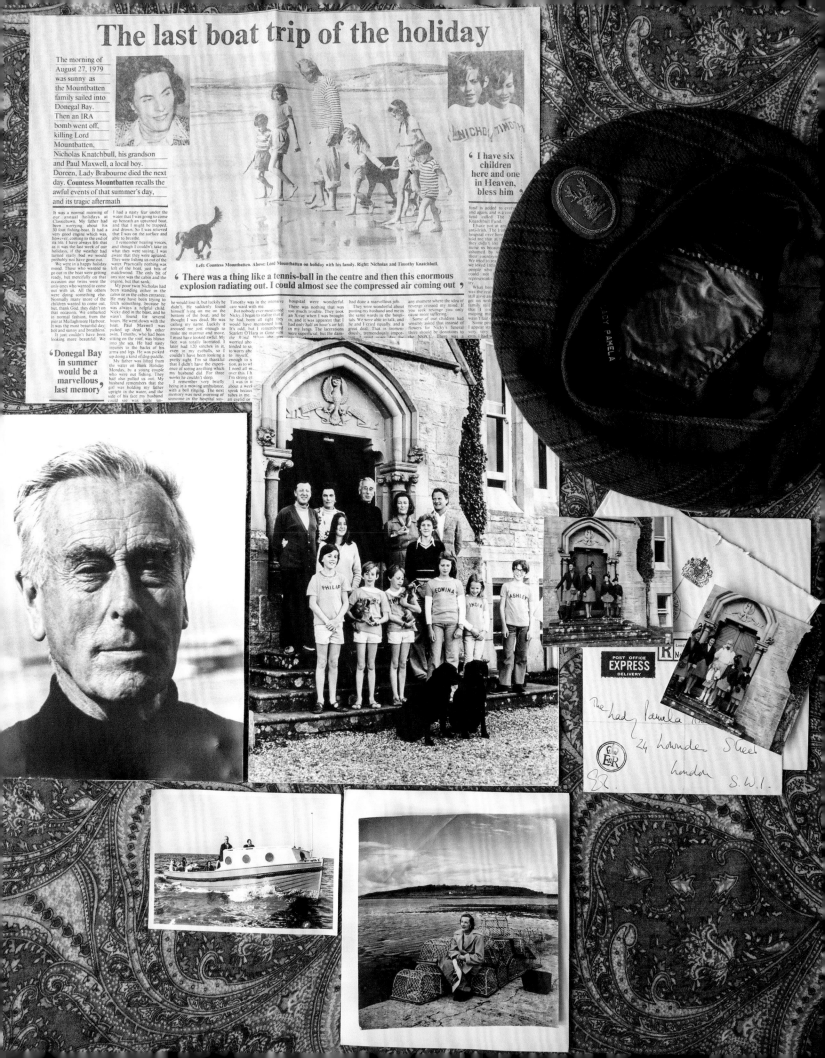

The last boat trip of the holiday

The morning of August 27, 1979 was sunny as the Mountbatten family sailed into Donegal Bay. Then an IRA bomb went off, killing Lord Mountbatten, Nicholas Knatchbull, his grandson and Paul Maxwell, a local boy. Doreen, Lady Brabourne died the next day. **Countess Mountbatten** recalls the awful events of that summer's day, and its tragic aftermath

'I have six children here and one in Heaven, bless him'

Left: Countess Mountbatten. Above: Lord Mountbatten on holiday with his family. Right: Nicholas and Timothy Knatchbull.

' There was a thing like a tennis-ball in the centre and then this enormous explosion radiating out. I could almost see the compressed air coming out '

'Donegal Bay in summer would be a marvellous last memory'

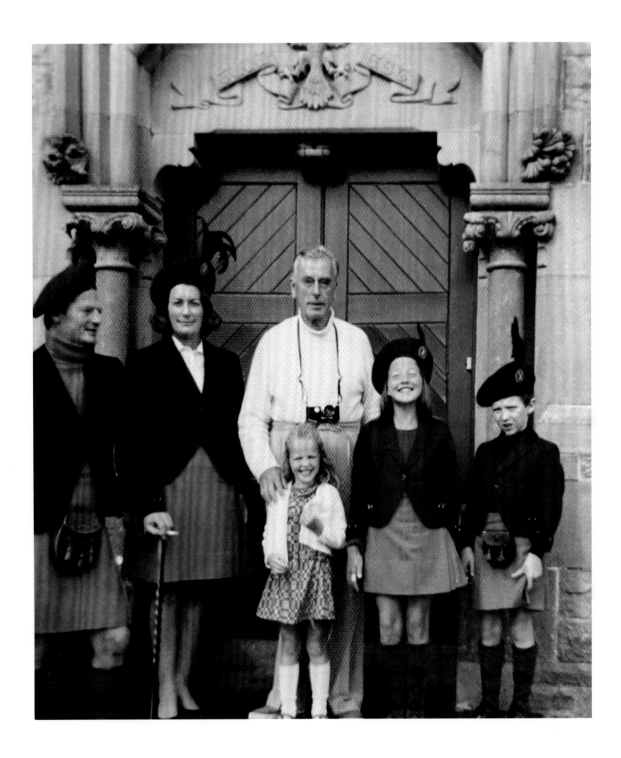

OPPOSITE: The IRA planned the assassination of my grandfather for months. Under cover of darkness, they slipped aboard my grandfather's small wooden fishing boat and planted an estimated fifty pounds of gelignite belowdecks. But there was more death to come. That same day, the IRA surprised a British army convoy on the other side of the island with two roadside bombs, killing eighteen British soldiers. The slaughter of our family and the soldiers at Warrenpoint created an unprecedented crisis for the British government. ABOVE: Up until that point we had enjoyed many blissful holidays in beloved Ireland. My father had fun designing feathered hats, kilts, and tartan jackets, apparently not for the oldest or youngest members of the family.

My grandfather had fallen in love with Classiebawn way back in 1941, writing to my grandmother when he first set eyes on it, "You never told me how stupendously magnificent the surrounding scenery was. No place has ever thrilled me more and I can't wait to move in." Every year he looked forward to us all being there together and made the time huge fun for all the children. We adored our grandfather.

When we were at Classiebawn, much of the time he spent with us centered around his beloved *Shadow V*, the last in a series of small fishing boats commissioned from local boatbuilders, using Classiebawn timber and a great deal of homegrown skill and craftsmanship. The family enjoyed many years of fishing trips on *Shadows I* through *V*, with any combination of the children and adults and dogs. Typically, we would go first to the lobster pots to see if there had been a catch, then try our hand at mackerel fishing; to round the trip off, our grandfather would give us a thrill by taking the boat at full throttle out into the open sea.

This was during the time of the Troubles in Northern Ireland, and when we were at Classiebawn, security was tight. While my grandfather felt safe in Sligo, and was sympathetic to the idea of Irish unity, even offering to mediate between the republicans and the British, he was still a compelling target and had been on the receiving end of thwarted threats before. After all, to the IRA he was a symbol of the British Empire, a member of the royal family, and a prominent naval leader. And while he always eschewed security at the castle—"Who the hell would want to kill an old man, anyway?" he was fond of saying—he accepted that he needed security in place, especially when we were all visiting. Twenty-eight men guarded us twenty-four hours a day, which was deemed adequate by the relevant authorities. We largely took their presence for granted—though we were entirely grateful for it—and it wasn't something that interfered with our time together. The security men spent their days and nights in cars outside the castle or at a subtle distance from us when we went out. My grandfather made sure they ate well and were looked after.

FOLLOWING PAGES: What unbelievable joy we had riding those empty beaches (*left to right*: my cousin Joanna, my mother, my grandfather, and my aunt). We would begin with a slow walk and then a little trot, followed by a calm canter before everyone let loose, ending with a wild gallop.

On the morning of August 27, a glorious summer day, the sea calm and inviting, my grandfather assembled those keen to go out in the boat—Nick and Tim, Aunt Patricia, Uncle John, Doreen, and Paul Maxwell, the local lad who helped us out as a deckhand—on a trip to the lobster pots.

It was calm and peaceful in the castle as my mother worked in the study, going through household inventory lists. I stayed behind with the promise of a visit to the local sweetshop and was charged by my grandfather to look after Juno, his Labrador. Ashley and Edwina were doing their own thing, and my father was working in London.

All of a sudden, my cousins Philip and Amanda burst into the study, where my mother was. Amanda was crying and Philip was highly distressed. When he was able to take a breath, my mother heard him say, "*Shadow V* has been blown up." Without truly registering what he said, she walked out into the hall, and they followed, telling her that from what they gathered a bomb had been detonated by remote control, blowing *Shadow V* to smithereens and scattering the family across the sea. My grandfather and Paul had been killed. My aunt, uncle, Tim, and Doreen were brought to shore. Nick was missing.

Later, as reported by Detective Kevin Henry, one of the security men who was assigned to watch the expedition at the moment of the explosion saw a "huge mushroom cloud of smoke and multicolored flashes. The cloud rose high above me, and then started to disappear. There was debris in the sky and on the sea and I was hit with a huge shower of sea spray. I could hear screams of panic and pain." He tried to alert the lifeguard from his car but didn't get a signal, so he ran to the phone box at the harbor, pulled a woman out mid-conversation, and dialed the Sligo garda.

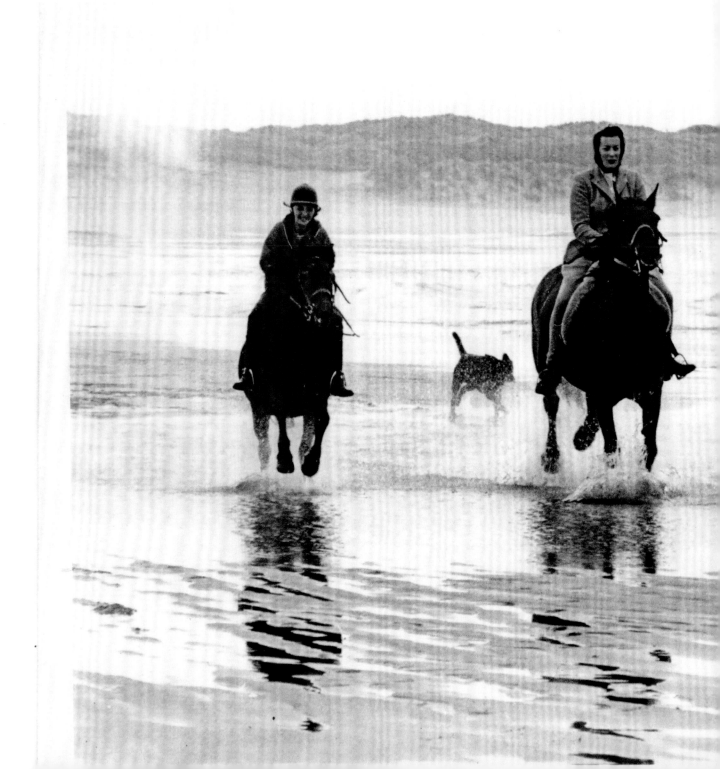

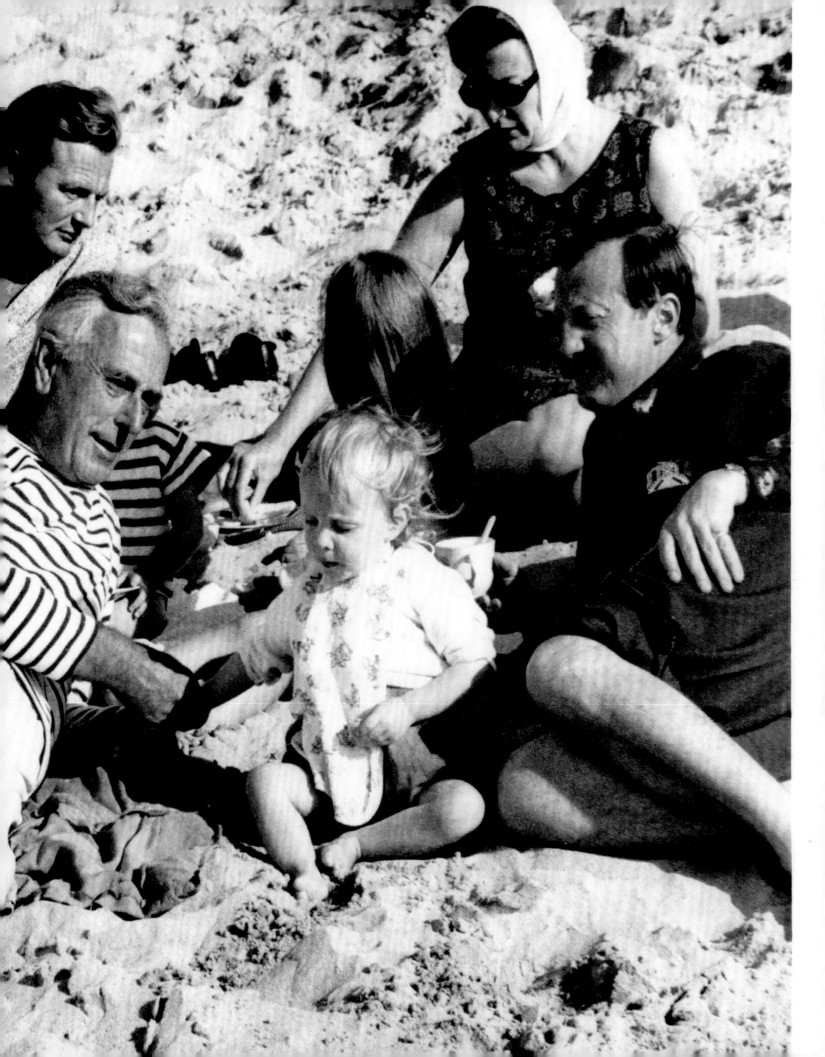

As it was a bank holiday and the water so still and calm, the harbor was busy with tourists both on shore and on the sea. As soon as the boat went up, as shocked and terrified as people were, they scrambled to help. My grandfather was found face-down in the sea, his legs shredded to pieces. He was dragged onto a boat, where some kind and bewildered visitors to the area placed his head on a towel and headed for the shore. My aunt was half-conscious as she was pulled from the water; Uncle John, with his bones broken, was shouting out for his wife and mother, and when people on another boat spotted Tim, his face bloodied from splinters, they rushed to pull him out. Paul was found, dead. Nick had not yet been found.

As the makeshift rescue boats reached the harbor, staff, guests, and day-trippers were on hand from the Pier Head Hotel with torn sheets to use as tourniquets and bandages and pulled-off doors to use as stretchers. My aunt, slipping in and out of consciousness, was heard telling people not to worry about her but to see to her twin boys. When I think about this day now, what haunts me is how desperate she would have been to know if her sons had been injured, or worse.

My mother could barely take this all in but somehow managed to maneuver herself to the hall, where she was wanted on the phone. It was the estate manager at Broadlands, who had somehow already heard from the press association that my grandfather had been murdered.

My sister, Edwina, was upstairs in the tower. Ashley and I were watching a Laurel and Hardy movie in the library with Juno, the Labrador, snoring on the floor in front of the television. We heard the bomb, of course, but didn't know what it was. We saw Amanda running into the house in tears and came out to see what was going on. My mother sat us down and told us that we needed to be brave and strong, that *Shadow V* had been blown up, that our grandfather had died, and that we didn't yet know the full extent of who had been injured and who had survived.

PAGES 204–05: Blissful summers packed full with picnics, riding, and fishing. PREVIOUS PAGES: My grandfather, happiest when surrounded by his family. OPPOSITE: Benbulbin, seen in the background, where leprechauns get up to mischief and fairies dance.

By this point, mayhem had erupted outside, with doors slamming, the sound of alarm and panic, voices trembling as instructions were given and information exchanged. Meanwhile, there was so much confusion about what was happening that Amanda was convinced everyone else on the boat was dead, too. My mother tried to keep Amanda and Philip calm, even though inside she was filled with utter dread.

It was then that Elizabeth Duffy, the owner of a local restaurant, who was one of the first on the scene at the harbor and had accompanied the survivors to the hospital, ran in. She told my mother all that she had seen and all that she knew, and my mother felt some comfort and relief at hearing from someone who had been down there. My grandfather must have died almost immediately. Paul Maxwell had also been killed instantly. My aunt had been rushed to intensive care, surgery pending; my uncle was severely injured, a number of his bones broken; and his mother, Doreen, was already undergoing surgery. All of them were now at the nearest hospital. She told my mother that Tim was in a critical state. She did not know if Nick was alive or if he was dead, as he was still missing. My mother thanked her for all her care and concern but could see she was in great shock, so didn't keep her any longer than she needed to be there.

All my mother could think of was her father face-down in the water, incapable of recovery or going to the rescue of his family, and her sister, knowing that her children were in the gravest of danger, not to mention her husband and mother-in-law. Aunt Patricia's family was her world. Aunt Patricia was my mother's world.

As conflicted as my mother was between leaving at that moment to see her sister and waiting to know what happened to Nick, she knew she must stay until his body was found. It was a couple of hours later when we got the dreaded news that his body had been recovered in the sea and that he, too, was dead. While being driven alone to the hospital by one of the police, my mother couldn't bear it any longer and finally broke down in tears. The policeman recalled driving her "in sadness and disbelief" until she bowed her head "and cried her eyes out, really cried her eyes out." The shock was overwhelming, and even if it was too difficult to fully comprehend the loss of her father, thinking about her sister and the unbearable news she was going to wake up to was too much to carry in that moment. In the silence of the car, she took out a tissue, dried her eyes, adjusted her glasses, and fortified herself for what was to come. She needed to be as strong as she ever had been. Her father would have expected it.

My aunt suffered two broken legs, her body and ears were lacerated by splinters of wood and metal, her eardrums ruptured, and she was unable to see or speak or move any part of her body. Later, she told my mother that while her body was shattered and immobile and she was drifting in and out of consciousness, her mind was alert, and she was terrified someone would switch off the life-support machine. She desperately tried to indicate to the doctors that she was alive. They knew she was alive, of course, but she didn't know that they knew. She had 120 stitches in her face and eyes. She would later refer to this as her "IRA facelift."

My mother found it impossible to believe that the person buried under a myriad of tubes and wires was her sister, who only a few hours earlier had left the castle with her usual energy, anticipating a bright day with her twins, husband, father, and mother-in-law. The only way my mother now knew it was her sister was from her hands, the only part of her that was visible. She had lovely long hands and my mother reached out to touch them. Her face was so bandaged that she was unrecognizable. The doctors said she had a fifty-fifty chance of pulling through and that even if she did, she would be blind. Though she was not conscious, my mother held those beautiful hands and spoke to her anyway. What she said, she could never recall, such was her shock; and then she was led away to see Uncle John.

Uncle John was badly injured but he was conscious, and he immediately asked, "Where is Nicky, is Nicky all right?" My mother was completely at a loss as to what to tell him, worried that his heart, which was already weak, would not be able to take knowing his darling fourteen-year-old son was dead. She asked the doctor what she should do, and he advised her to tell him the truth. It was beyond painful to hear him cry out, "I survived the war, but I can't survive this." My mother took a deep breath and said as gently as she could, "Well, I'm afraid you've got to, because if you don't survive Patricia won't survive."

For days afterward my uncle kept asking for news of Nicky. He knew Timmy had been saved but his brain would not accept the fact that Nicky had not survived. It was enormously painful. Every time my mother went to see him in the hospital, he asked her for news of Nicky. Every time my mother would gently tell him all over again that Nicky was dead.

When my mother returned to Classiebawn from the hospital that first evening after the explosion, the television was full of obituaries of my grandfather, and this both did and did not make his death feel real. One of the programs played a clip of my grandfather saying, "The happiest times of my life have been spent with the family together, and the thought about death that saddens me is that I shall miss them very much."

That night my mother did something unusual, bringing me from my bed and laying me in hers. Earlier and unthinkingly, I ran off to the cliffs distraught and my mother was now concerned about my being on my own in case I did something silly again. I did not understand that at the time and always thought she was keeping me close because there might be more bombs. Neither of us slept that night. My mother lay awake wondering how things had changed so catastrophically, so quickly. I lay awake waiting for another bomb.

Obviously wanting to keep me with her the next day, my mother took me to the hospital. I can't remember how we got there or who took us, but when we arrived the world's press was lying in wait. A throbbing crowd of flashbulbs exploded in our faces as we were pushed toward the hospital entrance, people screaming and waving, angry people shouting, police holding them back. I was eleven years old and I had never heard of a political assassination before. I was taken from my mother and left in a room while she went upstairs. I sat alone in the room, scribbling on the bottom of my Kickers shoes; they had a green spot on one sole and a red one on the other. Green for go, red for stop. "Stop, stop, stop" was all I could think. I later found out I wasn't left alone at all; I just felt alone in that strange small hospital office, waiting for my mum to come back to get me.

OPPOSITE: My cousin Philip driving the pony trap along the harbor, to take (*left to right*) my sister, me, the twins, and my brother to buy ice cream cones with chocolate flakes wobbling on the top. PAGES 214–15: Classiebawn and the harbor photographed by my father in the 1960s. Little has changed over the years. Cows still wander along the water's edge as small fishing boats putter slowly out to sea to check on lobster pots and fishing nets.

When I left Classiebawn with Edwina and Ashley a few days later, on a special RAF helicopter the queen had kindly arranged, I brought my grandfather's dog, Juno, with me, taking the weighty responsibility of looking after him seriously, even covering his ears with the headphones I had been given to wear by an airman on our flight, until he gently took them from the dog's ears and placed them back on my own.

On the morning we left, my mother received news that the last body from the expedition had been recovered. My aunt had taken her little long-haired miniature dachshund on *Shadow V* and the dog had not survived. My mother was informed that Twiga's body had been found in the sea and had been taken to the local police station, where the tiny corpse lay beside other evidence from the explosion. When my mother heard this, she insisted Twiga be brought back to the house. There was some comfort in being able to bury the dog in a homemade coffin at Classiebawn, in the shadow of the castle, among the wildflowers from the grounds.

Four days after the explosion, the bodies of my grandfather, Doreen (who had died the day after the explosion), and Nick left the hospital in Ireland for the journey back to England. Downstairs, government ministers and the mayor joined clergy and hospital staff to see the coffins leave. Upstairs, Tim and my aunt were not even aware of the deaths.

That evening Tim's older sister Joanna who had arrived after the explosion, and my mother went to see Tim. Speaking quietly and clearly, Joanna explained that the explosion had not been an accident; it had been a bomb. "When you were brought to the hospital, some of you were conscious, some of you were not. You woke up; Nick never did." Tim had had no inkling of the truth. He had no idea his identical twin brother had been murdered. Now, held between the arms of his sister and my mother, he broke down. But despite their presence, he felt utterly alone for the first time in his life.

The following day my aunt was taken off the ventilator that had been breathing for her. My mother was there at her bedside. Still unable to speak, she gestured for paper and pen and somehow managed to write, "I think Daddy dead and Dodo and Nick." Shocked, my mother decided to play for time, using her shortsightedness as an excuse, and went over to the window to read the note again. The medical staff's advice was to

tell her the truth when she asked. My mother walked back over to the bed and told her she was right, Nicky was dead. "The worst moment in my life," my mother wrote in her diary. My devastated aunt later wrote in her diary, "Cannot even cry for my poor father, who I adored, as misery over Nick too great and all-consuming." In later years we all recognized in my aunt the strength of a parent who had seen her child killed and whose response had been to redouble her work for others, and to share her ongoing love for the Irish and her complete lack of bitterness.

In the hours and days that followed, the time my mother found most haunting was when she was asked to identify my grandfather's body at the hospital. She thought, I am honestly not going to be able to do this, largely because she knew how badly damaged he was, "which is ridiculous because in fact every next of kin has to identify a murdered family member. But I found that a horrific idea." Luckily, the Duke of Abercorn, a close dear friend, arrived as she was being asked to make the identification, and she said, "James, I can't do this. Will you identify him?" To which he said, very gently and kindly, that he would. She is forever indebted to him.

The bomb was planted and detonated by Thomas McMahon, an Irish republican and volunteer for the IRA. That same day, eighteen British soldiers were murdered in an ambush in Warrenpoint, County Down. Margaret Thatcher said, "By their actions today, the terrorists have added yet another infamous page to their catalog of atrocity and cowardice."

Later, her forgiveness of the IRA was inspirational. As was that of my aunt and my mother, who moved on from this appalling horror with inspiring strength.

215

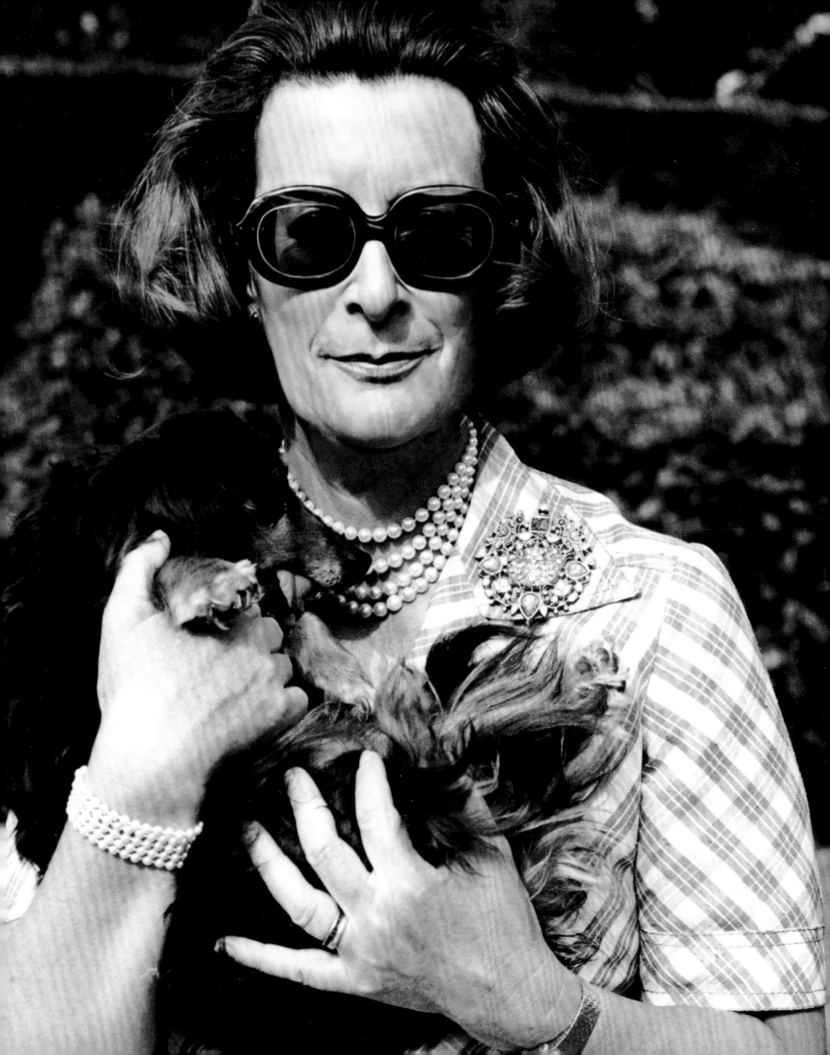

1980-2024

Farewells, Funerals, and the Future

My grandfather, in his characteristic way, had planned his own funeral in meticulous detail, updating the order of events every so often. The last iteration specified a service at Westminster Abbey and burial at Romsey Abbey. His body was to be delivered there by train from Waterloo, accompanied by family and close friends.

So, following his death, his body was taken to Romsey Abbey, where staff from Broadlands held a two-day and two-night vigil. Given the honor of a royal ceremonial funeral, he was then brought to the Queen's Chapel at St. James's Palace, London, where people went to pay their respects.

The funeral took place on the morning of September 5, 1979. Before the service, on the steps of Westminster Abbey, Princess Grace of Monaco approached my mother. Seeing me, she caught sight of a gold cross I was wearing and, bending down to hold it in her hand, commented on how lovely it was. "Thank you," I replied. "It is brand-new from my godmother [the Duchess of Kent], who is here. You see, it's my birthday today."

OPPOSITE: I had wanted the title of this book to be *In the Shade*, because I felt my mother had lived so much of her life in the shade of others: her parents, her older sister, the queen, her husband. Of course, she was always content to be there, out of the spotlight, in the shadows.

My mother said that my grandfather would have enjoyed his funeral, which was every bit as splendid as he had hoped for, televised around the world, and attended by Queen Elizabeth, Prince Philip, and their children; six kings and three queens from European royal families; old comrades; thousands of servicemen and servicewomen of all nations; Nepalese Gurkhas in black pillbox hats; Sikhs in white turbans; survivors of HMS *Kelly*; and diplomats, statesmen, and politicians.

The service was traditional, led by the archbishop of Canterbury, with the lesson read by Prince Charles. The strain in his voice could be heard; he had been so devoted to my grandfather. Every detail was poignant, especially when my grandfather's faithful horse, Dolly, who had carried her master as recently as June at the queen's birthday parade, known as Trooping the Colour, was led in the procession, my grandfather's boots reversed in the stirrups. This tradition dates back to Genghis Khan, as an honor bestowed on fallen warriors. Today the boots facing backward symbolize that the fallen won't ride again; the rider is looking back on his family one last time. This haunting image of the riderless horse has stayed with me all my life.

After the service, we traveled on that specially organized train to Romsey for the private burial. The queen sent a message to ask if my mother would come up and sit with her. She wanted to hear everything, to understand everything, about the day of the bombing. She listened carefully, never interrupting, until my mother finished, then she put her hand over my mother's and looked out of the train window.

OPPOSITE: My mother was the queen's childhood playmate, one of her bridesmaids, a confidante, and a lady-in-waiting. She was with the young Princess Elizabeth in Kenya when she learned of her father's death; at my grandfather's funeral, the role of bereaved and comforter was reversed. Despite the formality surrounding court life, their years together—particularly in the early days of the queen's reign—were full of fun. My mother always laughs telling the story of how, on one royal tour, she witnessed a crowd of tourists arriving on a near-deserted beach, excitedly asking their picnicking party if they had seen the queen of England, because they had heard she was in the vicinity. "Oh yes," said the queen, standing up and pointing. "She went that way."

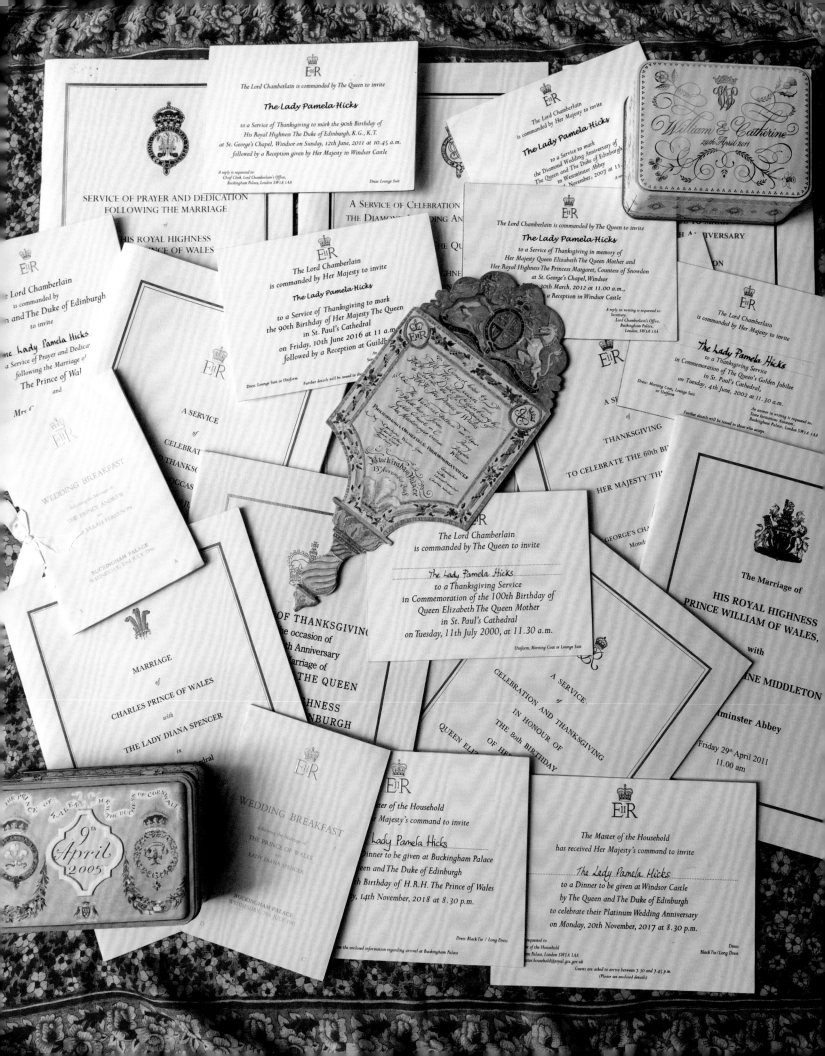

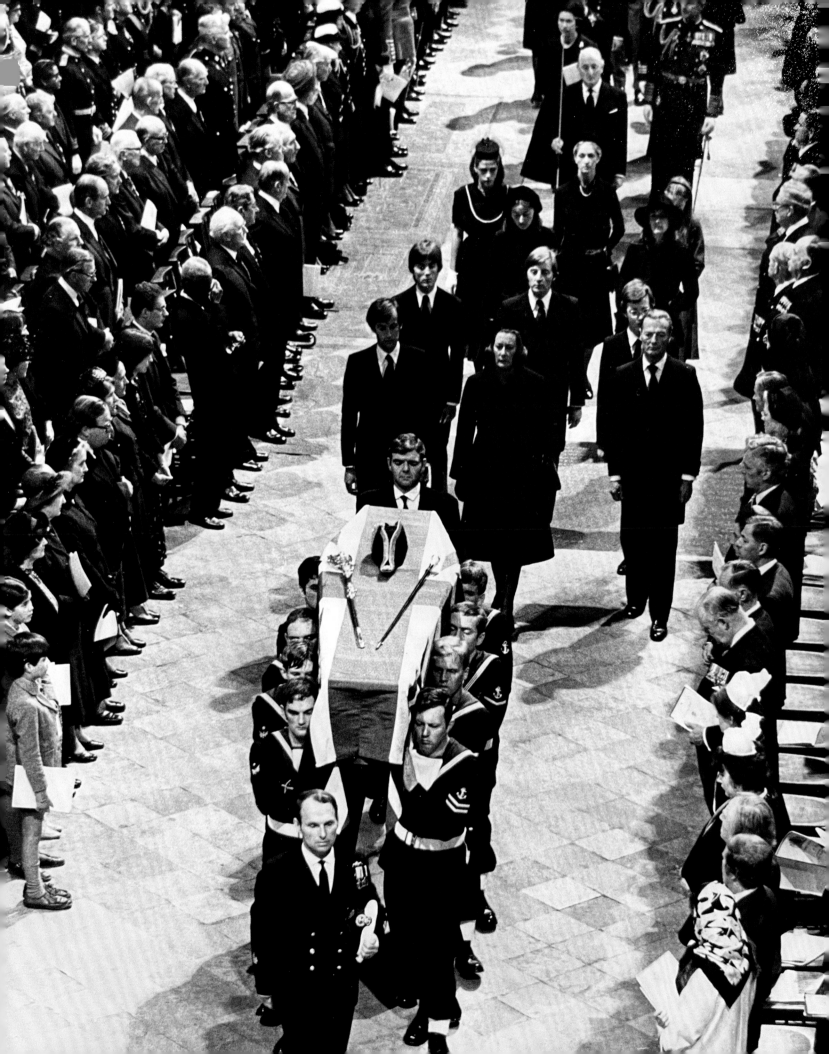

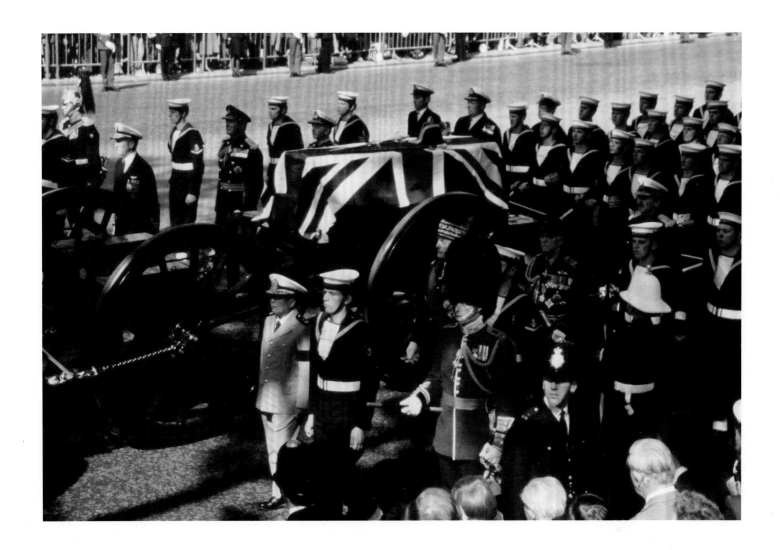

OPPOSITE AND ABOVE: My grandfather was buried with all the pomp and ceremony he could have desired. His instructions, which he had spent many years preparing, were faithfully observed: the proper dignitaries were present; the right regiments and institutions played their part. It could not have been better managed if he had been alive to direct it himself. When the queen visited Ireland in 2011, paying tribute to the Irish rebels, it was an exemplary message of leadership, symbolic of forgiveness and reconciliation. She guided us all—family, nation, and commonwealth. FOLLOWING PAGES: A posy of violets was sent by close friends all the way from Australia in time for me to hold them during the funeral.

When we reached Romsey, hundreds of people were lining the streets, some of whom had already been standing for hours to pay their last respects. As my mother stood there saying her own final goodbyes, she was acutely aware of the absence of my aunt, uncle, and cousin Tim, who were still in critical condition in Ireland. It was dreadful to think of them not being able to say their own goodbyes, lost in a sea of pain and hurt.

After the service we headed to Broadlands, glorious in the autumn sun but almost un-bearable without my grandfather. The queen had managed, as she always did, to remain composed during the long and difficult day, but when my cousin Joanna encountered her, red-eyed and clearly weary, she asked her if she'd like to come upstairs. The queen nodded. "Yes," she said, "I think I will."

We traveled to Aunt Patricia's home in Kent the next day, for the service to bury Nick and his grandmother Doreen in the small Norman family church. In profound contrast to the pomp and circumstance of the very public funeral the day before, this was a heartbreakingly simple service for a fourteen-year-old boy and his grandmother in the quiet of the countryside. The lawns were freshly cut, flowers were everywhere—a bit of beauty amid such awful and senseless devastation and darkness.

The service was just for family, friends, and those who had worked closely with the fam-ily, but while seats had been set up outside the tiny church, there was such a crowd that people had to stand. The police and security were discreet but tight. It felt confusing to me, and I held my sister's hand tightly.

As the coffins passed by, my brother, Ashley, became very distressed. "Which is Nicky? Which one is Nicky in?" he cried out, and my mother pointed to the one on which DODO was written and then showed him the other that held his beloved cousin.

David Hicks

Perhaps inspired by my grandfather, my father had also carefully written out detailed instructions for his funeral arrangements in a little white book titled "The Demise of David Hicks." He had regularly returned to this book, updating ideas and at times

scribbling out the name of a friend whom he intended to give the eulogy but who had now irritated him, replacing it with the name of another friend, someone less irritating, perhaps.

My brother, Ashley, handled everything. Calmly, beautifully, as he always does, despite the rush to find a flag maker who could produce a proper-size flag in time to cover the coffin, which still also had to be made, as directed, in gray-stained sycamore with no handles. ("NO handles!" the little white book specified adamantly.) The coffin was lined with my father's first fabric design, specially printed in a quiet colorway of beige and gray. And my father himself was wearing his H-monogram tie.

My mother thought he might like something good to read, so she slipped into his pockets his obituaries from the *Times*, both London and New York, and press cuttings, one with the headline "Designer Plans Own Funeral" because, of course, even when dead, he was still news.

It was a crisp, clear morning in April 1998. For this last journey, the gray coffin, draped in his flag, with H-monogram-signs showing proudly on both sides, was carried across the narrow drawbridge from the pavilion where it had been laid, and loaded onto the garden trailer, properly "strewn with ivy," as specified, behind his Range Rover.

The funeral service, in the fifteenth-century church in the village of Ewelme, where my sister, brother, and I had been christened, was intensely moving, as my father had meant it to be.

Having refused to be buried at Ewelme, where the old churchyard was too full already, he had chosen a spot in the Brightwell Baldwin churchyard (where I was married many years later). This meant that after the funeral service, a long procession of cars wound its way slowly behind the ivy-strewn trailer, around the garden of the Grove one last time, and on to the other churchyard beyond.

As my brother said, "It was a gloriously romantic last farewell, a painterly scene that had doubtless played over and over in the imagination of its creator, as he read through his little white book of instructions, picturing the effect of his final work of design."

CEREMONIAL

for

THE STATE FUNERAL

of

HER MAJESTY QUEEN ELIZA

PROCESSION

Palace of Westminster to West

THE STAT

ST. GEORGE'S CHAPEL
WINDSOR CASTLE

Entrance: **NORTH DOOR**

MMITTAL OF

Mon

SOUTH QUIRE

S

WESTMINSTER

THE STATE FUNERA

of

QUEEN ELIZABETH II

Monday, 19th Septemb

Ms Inc

WESTMINSTER ABBEY

THE STATE FUNERAL
of
HER MAJESTY
QUEEN ELIZABETH II

Monday, 19th September, 2022
at 11.00 a.m.

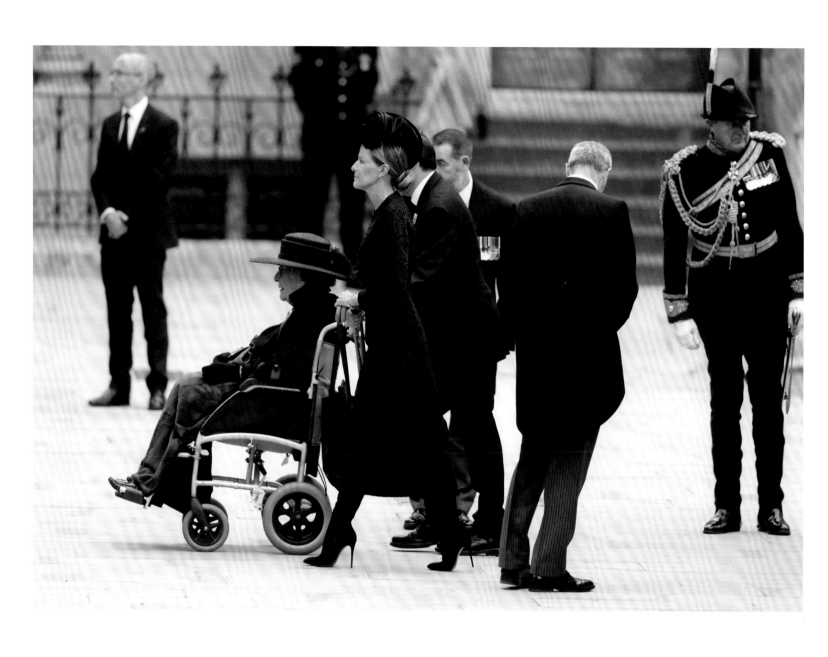

Queen Elizabeth II

Twenty-four years later, September 8, 2022, I was just about to board a plane when I heard the shattering news about the queen. I immediately called my mother to tell her that the queen had suffered a stroke and might not make it to the morning. I was concerned about my mother. "Would you like me to postpone my trip and be with you?" I asked. "My darling," my mother told me, "it's the poor queen who's had the stroke, not me." Although the news came as a surprise, as always my mother did not want a fuss made or plans changed. She told me to carry on and said she looked forward to seeing me soon.

Like most of us, my mother had seen the queen only a couple of days earlier, watching her shake a bruised hand with the new prime minister, so it was of course a shock that she should become fatally ill so quickly.

Knowing how utterly exhausting the day of the funeral was going to be, we agreed that I would push my mother, aged ninety-three, in a wheelchair. We decided to leave as early as we could manage. We were up, dressed, and in the car just after 6:30 A.M.

The roads from Oxfordshire were empty, since the day had been declared a national bank holiday. As we drove toward London, I asked my mother what she was feeling. "Acceptance," she told me. "I feel acceptance." We thought we would arrive at the Queen's Gallery, as requested by the lord chamberlain's office, in plenty of time. But

PREVIOUS PAGES AND OPPOSITE: It was my great privilege to accompany my mother to both funeral services for the queen. During the more intimate chapel service, I saw my mother summon all her strength to bend down into the deepest of curtsies, as the coffin of the queen was gently marched down the nave. Her head bent, her well-worn knees wobbling, she held that curtsy till the coffin had passed by completely. Only then, holding onto my arm, did she stand up, her final farewell to the queen complete. As the sun streamed down through the stained-glass window of St. George's Chapel, my mother lifted her head, her eyes following the sunlight. FOLLOWING PAGES: My mum in profile *(left)*. Me with Edwina and Ashley and our offspring *(right)*. As children, we were obviously expected to be on our very best behavior around the queen. My sister and I were made to practice our curtsies. We were so seasoned in the art of the curtsy that when my father's secretary, who was called Mrs. King, came over to the house, my sister got confused and went into a very deep serious curtsy.

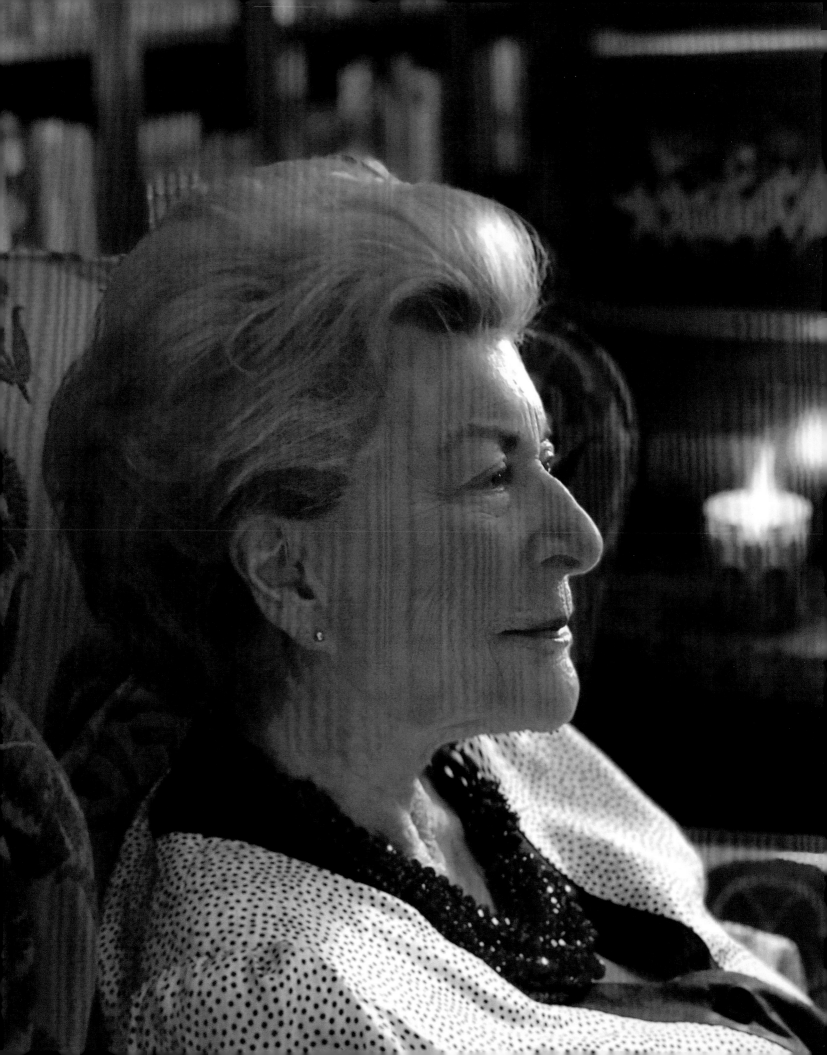

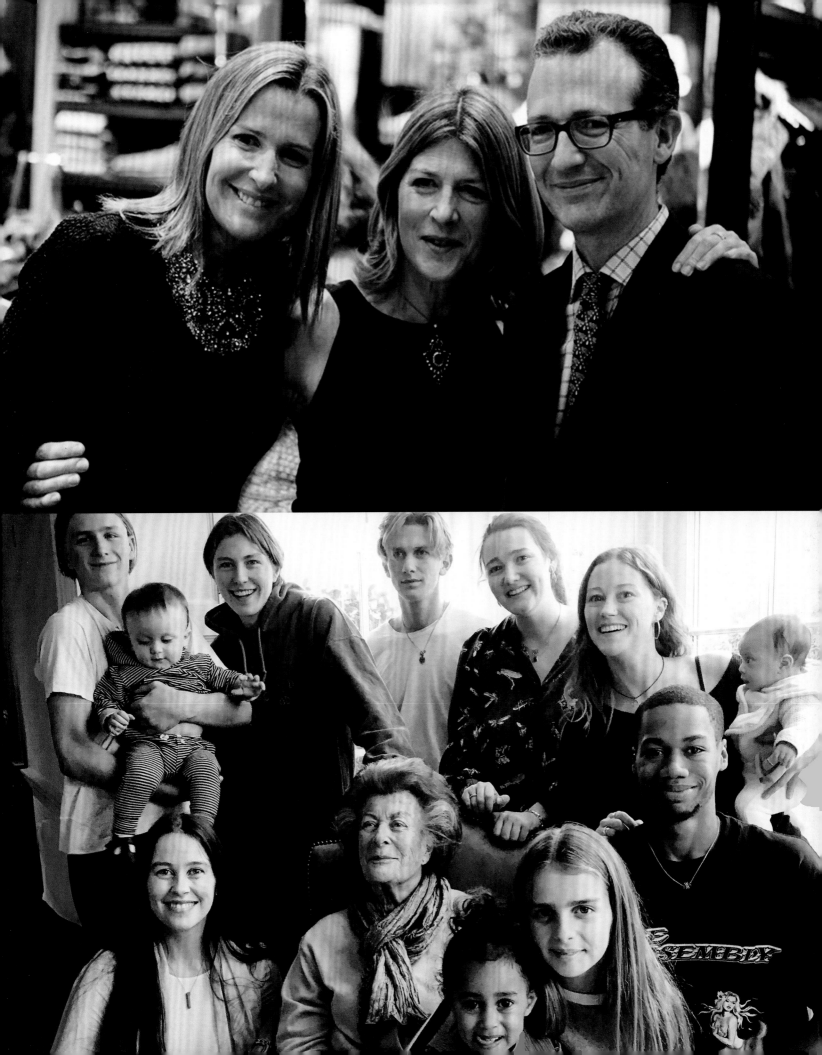

OPPOSITE: My mother and I having a quick moment together in the drawing room at the Grove on my wedding day. The pale pink-cotton wall covering and ruffled, swagged curtains have not been touched since they were installed by my father in 1980. Just after this, I picked up the bouquet of flowers on the desk behind us to head off to the church to get married. ABOVE: If you look closely here, you will see a tiny dachshund puppy stubbornly sitting in the driveway of my parents' home.

once in London, it was madness. Every road we tried to take was blocked by police, security, or the armed forces. I pleaded for us to be let through, but at every juncture we were told to turn around. Getting anywhere near Buckingham Palace was going to be impossible. We finally found a policeman who, hearing the growing panic in my voice and seeing our official passes, was persuaded to move a blockade so we could drive closer.

We were now nearer, but not near enough. I decided to abandon the car. "We are going to make a dash on foot," I told my mother. We must have made a startling sight as we raced along the Royal Mews toward the palace—my mother in her wheelchair, me pushing in my high heels, both of us in formal dress, jewels, gloves, and hats.

Arriving at the Queen's Gallery just in the nick of time, we were met by a lineup of five resplendent ladies-in-waiting, buttoned up in black, all wearing their medals, brooches, and pearls. One of them leaned down to give my mother a kiss. When my mother commented on the fine diamonds and medals they were wearing, they said, "Yes, and to think this will be the last time we get to wear everything." I noticed crumpled bags on the floor beside each lady-in-waiting, and I could not resist asking what was in them. "Sensible shoes to walk home in, of course," one of them told me.

The lord chamberlain's office had organized buses to carry not only the grand families of England but the royal families of Europe and also the leaders of the Commonwealth. It was an efficient way of getting so many people in and out of tight security areas and around those blasted blockades and, as Prime Minister Trudeau commented, there was a lot of good conversation to be had on buses.

PREVIOUS PAGES: My mother in her pink drawing room, watched over by the women of her past. These same portraits have been in the family since long before my mother was born. OPPOSITE: My mother sits every lunchtime in her Rex Whistler–painted dining room, looking out of the window and across the garden my father created for them. FOLLOWING PAGES: Inside the walled garden of the Grove, you can spy my father's hornbeam trees, now grown to a perfect height, their trunks standing like columns against the winter walls of hornbeam hedges behind them *(left)*. My father divided the garden into many small green rooms, interconnected and looping back and forth, occasionally crossing one of the long vistas that he planted out toward avenues, marching across fields, all giving an impression of a huge scale *(right)*.

My then-nineteen-year-old son was amused when I showed him the invitation's stated dress code: "No swords." Interestingly, as we boarded the bus we heard the clattering of swords carried by several men. Standing in the aisle of the bus was the queen's piper. He had woken her every morning and was now going to play her to rest. Together we traveled the short distance to Westminster Abbey, as he explained how hard it was to find the eagle feathers for his Glengarry hat.

The abbey must have brought back some dark memories for my mother, as her father's funeral had been held there.

We were shown to our seats in the choir stalls, in this ancient thousand-year-old royal church. Managing my mother's legs into the pew was less complicated than the question of where to hide a wheelchair. None of the ushers had the vaguest idea. I finally found a vaulted archway and tucked it away. I then unwrapped throat lozenges for my mother and lined them up on the pew next to the committal service program. One always needs to be ready for a coughing fit.

At 11 A.M. precisely, the queen's coffin arrived on the steps of Westminster Abbey. We watched as the procession swayed solemnly and slowly out from the assembly area into the body of the abbey and down the nave to the echoing sounds of "The Day Thou Gavest, Lord, Is Ended." The deeply moving funeral of Elizabeth II, the country's longest-reigning sovereign, was underway.

The world watched in silence as a ritual dating back to the tenth century took place in the middle of the twentieth century, but unlike the day of her coronation, where the rain fell constantly from darkened skies, this, her last day with her nation, was sunny. In the abbey, light streamed in from the stained-glass windows.

Yeoman wardens stood guard with their traditional pike staffs, elderly peers shivered in their uniforms, and plume-helmeted gentleman-at-arms stood at attention. There was significance in everything.

How fascinating it was to be seated opposite the six living former prime ministers and, of course, then-current prime minister Liz Truss seated there symbolically a few inches

above everybody else, awkwardly whispering through the carved archway separating her from her husband.

As the service ended, we walked out into daylight, boarded the buses, and drove out to Windsor Castle. It was remarkable to see how far the crowds had come from London, lining the roads, patiently waiting to see their queen on her final journey.

On the bus I produced a packet of crisps, knowing how hungry some of the more ancient guests might be; these were devoured by my mother and Lord Airlie, seated across the aisle, who my mother reminded me had once been the most dashing man in England. He was seated next to his wife, Lady Airlie, who had been the queen's lady of the bed-chamber since 1973. When we stepped out in the quadrant of Windsor Castle, we inhaled the scent of the hundreds upon hundreds of flowers that had been lovingly arranged down the long walk.

We were ushered into one of the galleries for lunch, rather deliberately choosing a table by the window so my mother could look out over the grass courtyard and think back to the times she had been there in the past. Also, a strategic move not to have to make small talk with anyone. It had already been an exhausting day.

Lunch was quite rushed because we knew the coffin and entourage were approaching. I pushed my mother in the wheelchair from the castle past the turreted walls, watching the immaculate guard of honor lining the walkways. We took the full tour round the chapel, seeing the almshouses and the display of military men on parade, then slipped in through a side door and were once again honored with seats in the front. This smaller committal service felt oddly intimate, even though it was before a congregation of several hundred.

As the coffin came past us, my mother, with those creaking knees, went down in a curt-sy to the floor and she stayed there, head bowed, until the coffin had fully passed; only then did she stand up. I suddenly understood that this was her final farewell—not just to her friend and monarch, but to a whole chapter of her life, because, amid the rituals and the carnival of costumes, this Elizabethan age had come to an end.

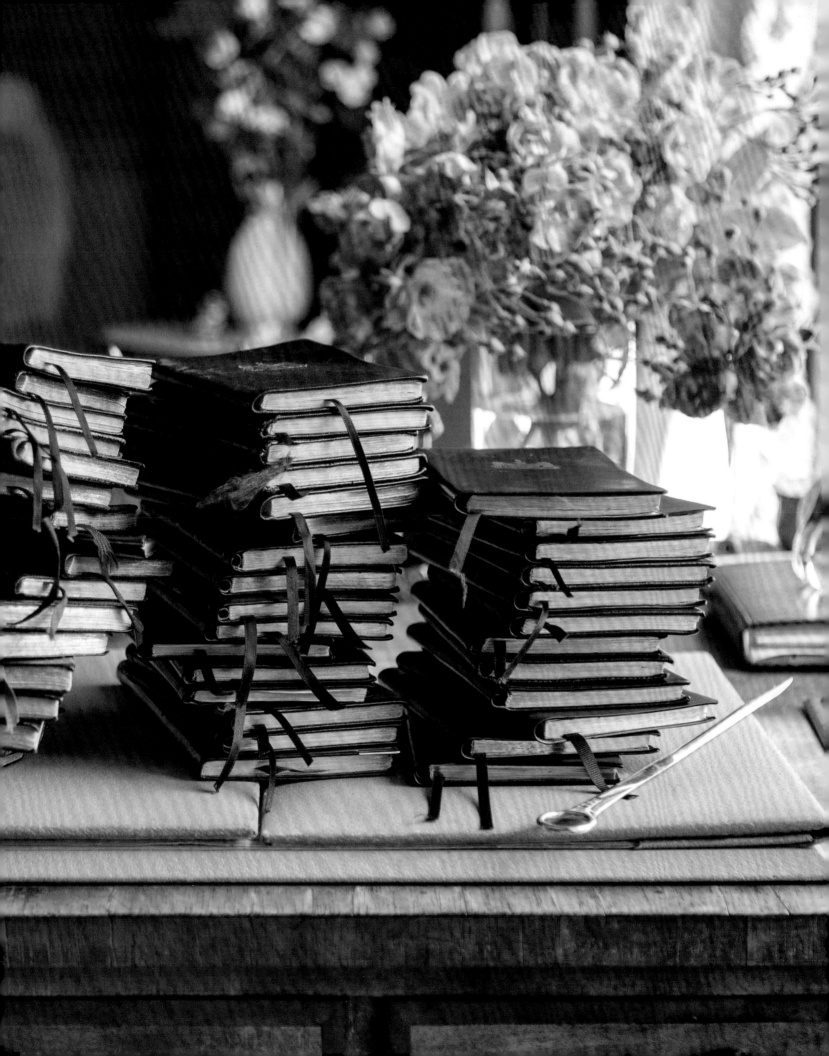

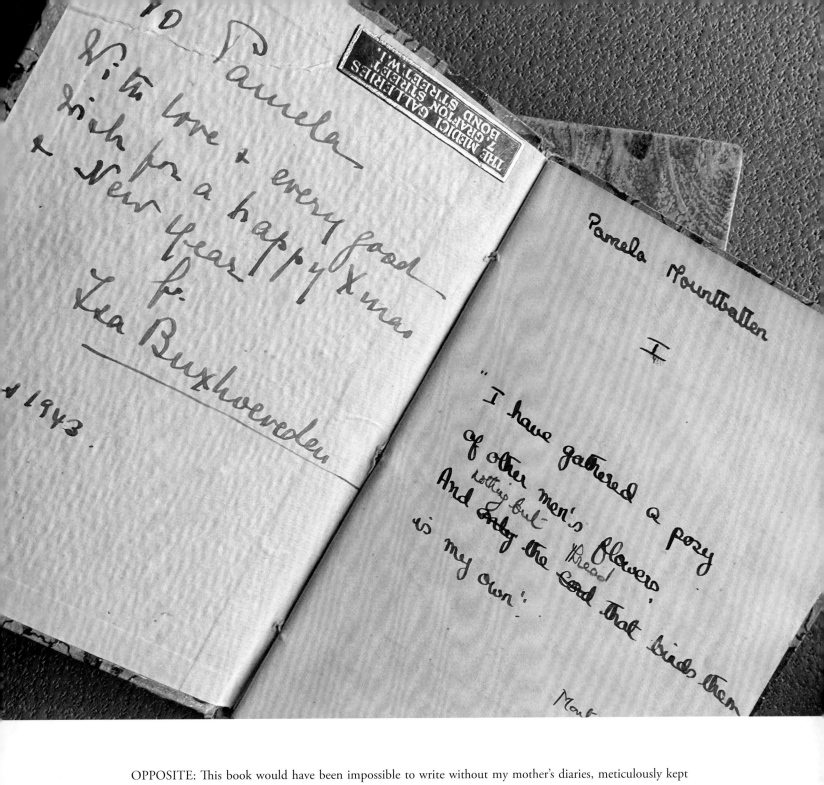

TO Pamela

With love & every good wish for a happy Xmas
& New Year fr.
Zia Buxhoeveden

1943.

Pamela Mountbatten

I

"I have gathered a posy of other men's flowers, nothing but the thread And only the Lord that binds them is my own".

Mont

OPPOSITE: This book would have been impossible to write without my mother's diaries, meticulously kept year after year after year. ABOVE: My mother also kept commonplace books, repositories of thoughts and ideas collected from other sources to reflect upon. One of her early entries, at age fourteen, was this: "I have gathered a posy of other men's flowers and nothing but the thread that binds them is my own." FOLLOWING PAGES: My mother spent so much of her life championing and chairing many causes, and this, along with all of her other extraordinary experiences, makes her truly remarkable. I found a letter to my mother, written in early 2006, from a journalist at *Time* magazine. It read, "It is one of the great pleasures of my job to meet truly fascinating people, and that you are. In spending time with you, I felt almost as if I had been transported to another better and richer realm than the one I normally inhabit. I also felt privileged to be in the presence of someone so wise, experienced, and also generous minded. I think you see things very 'straight' without illusion, but also with continuing curiosity and kindness. In those parlor games of 'Who would you like to invite to dinner?' to have the most fascinating and worthwhile evening, you would definitely be on my list."

The Future

Growing up, I was very aware of my grandfather's fame. The Earl Mountbatten of Burma was a huge, dashing character. On official duties he would be dressed in resplendent uniforms, with police escorts to whisk him through red traffic lights.

I was also aware of my father's fame. In the 1960s and 1970s my father, David Hicks, was never off the covers of magazines or out of the newspapers. His designs had set the world alight, and this, coupled with his flamboyant personality, drew attention wherever we went. My mother, on the other hand, was simply Mum.

I understood that against the backdrop of my father's dazzling, fast-paced, exotic world and my grandfather's public obligations, my mother chose a softer life of horses and dogs and the countryside. She lived vicariously through my father's relentless social life, and although she enjoyed hearing the gossip from London, Paris, and New York, she was much happier to be secluded in the company of Daphne du Maurier.

We have traveled often together, just the two of us. We have swum with dolphins, explored Russia, ridden on the pampas of Argentina, snowmobiled in Iceland, and seen wild game in Africa. She has flown to join me at all of my births, and I even once, daringly, left her to babysit. When I returned, my mother was deep in her novel, the baby unattended and screaming in his pram in the garden. "Mum! The baby's crying," I said. "Oh, really, darling? How odd. I thought that was a partridge."

Much of my mother's life has been led, as tradition dictated, in the role of dutiful daughter and supportive wife, but instantly on acquaintance, her warmth and wisdom and generous laugh reveal a legendary and disarming wit.

With her intelligent, curious mind come new ideas and attitudes, which, through the prism of a crowded past, make her incomparable company.

At ninety-five years of age, my mother maintains herself with impeccable style and an abiding charm that make her a cherished institution, and perhaps the last of her kind. Never looking back, always facing forward to the future.

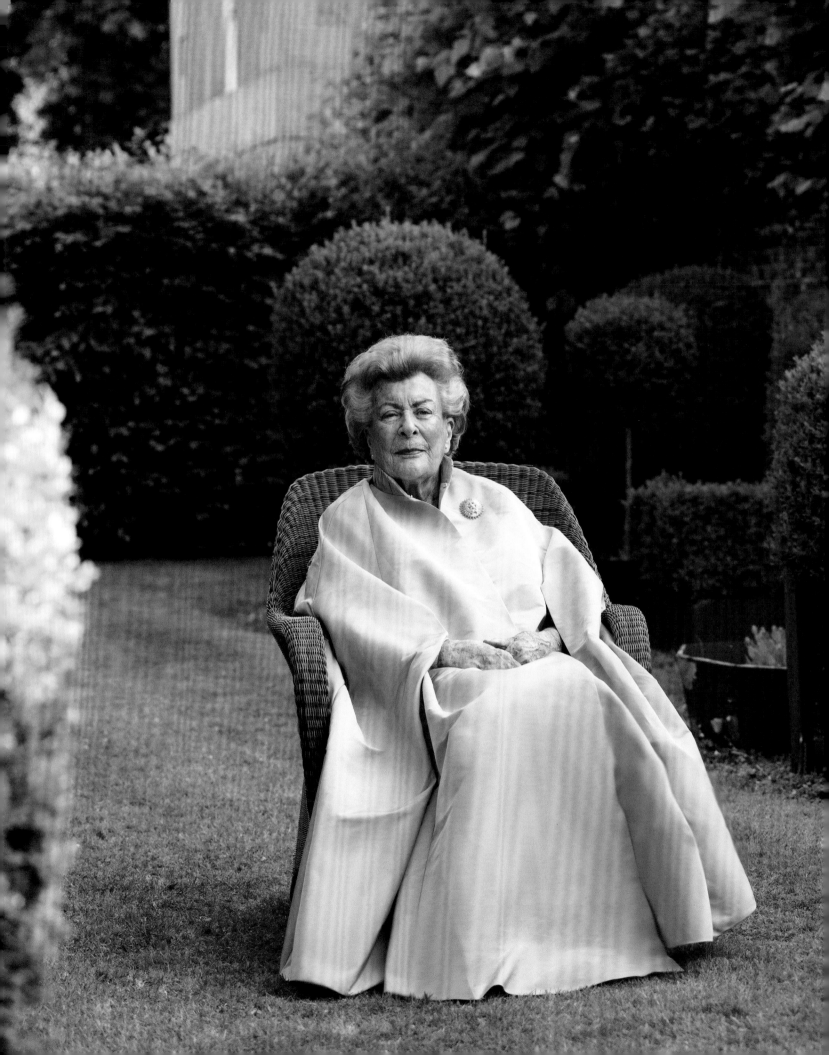

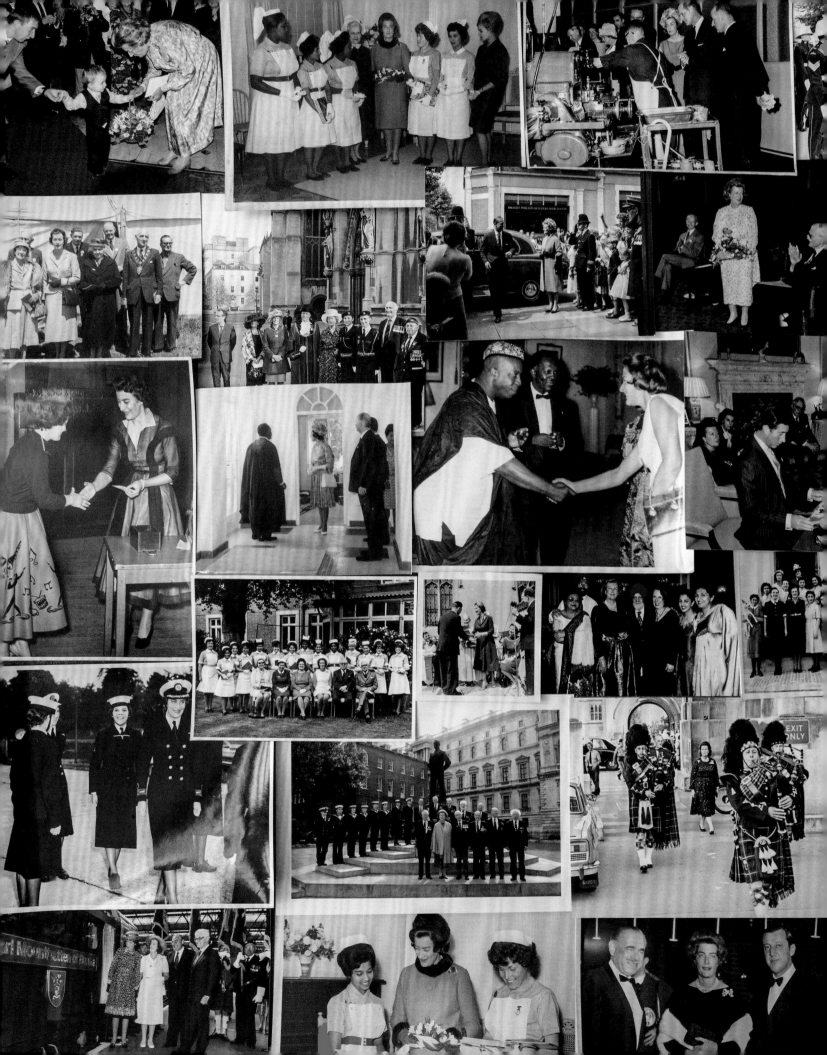

THE END

Acknowledgments

Great thanks to Charles Miers and Rizzoli, who were as eager as I to capture everything in this illustrated biography. This is my fourth book with my ever-patient editor Kathleen Jayes, who generously lets me get on with it, and Brittan Goetz, who has guided the creative direction, added in some of her own images, and put up with me. I am abidingly grateful. Gillian Stern sat on the drawing-room floor beside me, shifting through piles of letters dating back over seventy years; she also helped tame some of the words and ideas here.

I suppose, having lived through a war, Indian independence, months on tour with Queen Elizabeth, and marriage to the inexhaustible David Hicks, one would want to retire to the quiet of the countryside and hope for nothing to happen ever again. So my thanks go mostly to my mother, for letting me interrupt that quiet life with endless annoying and sometimes very stupid questions. I explained that this book will help us understand some pivotal moments in history and serve as a source of inspiration for the future. She was not convinced!

Thank you, Mum, for letting me tell your story.

PHOTO CREDITS

First published in the United States of America in 2024 by
Rizzoli International Publications, Inc.
49 West 27th Street
New York, NY 10001
www.rizzoliusa.com

Copyright © 2024 India Hicks

Publisher: Charles Miers
Editor: Kathleen Jayes
Design: Brittan Goetz
Production Manager: Barbara Sadick
Rights and Permissions: Maria Ranauro
Managing Editor: Lynn Scrabis

Printed in China

2025 2026 2027 2028 / 10 9 8 7 6 5 4 3 2

ISBN: 978-0-8478-2862-3
Library of Congress Control Number: 2024933959

Visit us online:
Instagram.com/RizzoliBooks
Facebook.com/RizzoliNewYork
X: @Rizzoli_Books
Youtube.com/user/RizzoliNY

MIX
Paper | Supporting
responsible forestry
FSC® C008047